Robert E. Fisher
completed his PhD on the Buddhist art of
China and India at the University of Southern California in
1980. He taught Asian art history, particularly Buddhist art
and religion, for twenty-one years at the University of
Redlands, California, and has lectured widely and travelled
throughout India, South-East Asia and China. His publica-
tions include numerous articles and exhibition catalogues on
the arts of Kashmir and the Himalayas, Korean Buddhist
art and Chinese Buddhist bronzes.

WORLD OF ART

This famous series
provides the widest available
range of illustrated books on art in all its aspects.
If you would like to receive a complete list
of titles in print please write to:
THAMES AND HUDSON
30 Bloomsbury Street, London WC1B 3QP
In the United States please write to:
THAMES AND HUDSON INC.
500 Fifth Avenue, New York, New York 10110

Printed in Singapore

ROBERT E. FISHER

Buddhist Art and Architecture

179 illustrations, 32 in colour

THAMES AND HUDSON

*To my wise and patient mentors
Charles D. Weber and Pratapaditya Pal
'The rock and the flame'*

ACKNOWLEDGMENTS

I remain openly grateful to all those who shared their time and expertise, such as the collector Bob Moore, and to my former colleagues at the University of Redlands, who supported a year's sabbatical leave, as well as the many students who participated in seminars on Buddhist art and religion. On the home front, I am grateful to my wife Janice for her patient support and helpful reading of the early drafts of the book. *Carmel, California*

In the illustration captions, measurements are given in centimetres (inches in brackets), height before width, unless otherwise specified.

Designed by Liz Rudderham

Printed and bound in Singapore by C.S. Graphics

Contents

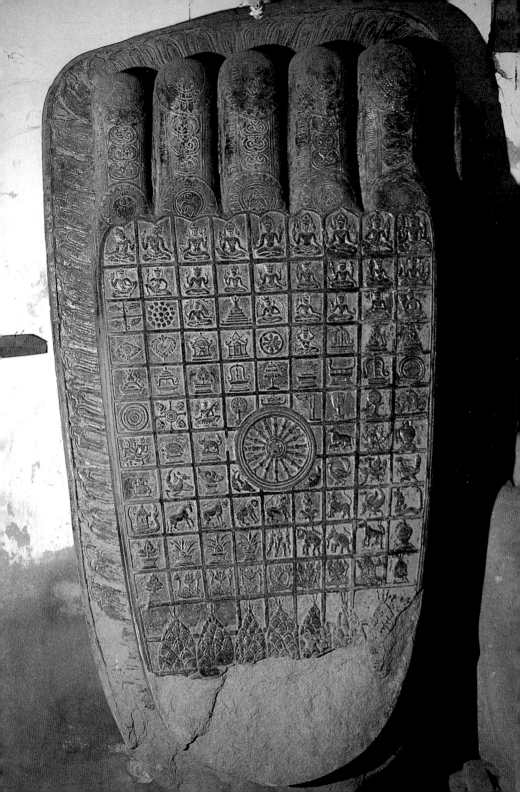

They take something that is in its essence beyond form but reveals itself in visionary forms adapted to our earthly ability for visualization and conceptualization. (Dietrich Seckel)

Buddhism enjoys a unique place in Asian history, as the single shared experience among half the world's population. No other movement, religion or event has equalled the degree to which Buddhism has affected nearly every corner of Asia. During its 2500-year history, the faith enjoyed widespread success but also suffered persecutions and competition from Confucianism in East Asia, as well as gradual absorption due to the inexorable pressure of Hinduism in India. Buddhism's greatest success came during the first millennium AD, although it became thoroughly integrated into Japanese culture and continues to be the dominant faith in such areas as Burma, Sri Lanka and mainland South-East Asia.

The development of Buddhism across Asia followed natural geographic divisions. In its Indian homeland, it flourished during the first thousand years of its existence but, by the sixth and seventh centuries, it had largely been absorbed by a revived Hinduism, except in a few regional enclaves. In contiguous areas, such as Nepal, Tibet and other Himalayan regions, and Burma and the island of Sri Lanka, the Buddhist hold on the population continued, often into the present time. The greatest complexity in ritual and imagery occurred in the Tibetan cultural sphere, which is situated geographically between India and China and, though deriving most of its culture from India, often found itself under Chinese hegemony. In general, while Buddhism declined in India, the southern areas of Asia retained the older traditions, while the northern regions, beginning along the Himalayan belt that formed India's natural northern frontier, followed the later devotional and esoteric schools. This division is clearly evident in the art of the two areas. In the north, much of the imagery depicted the polarity between heavenly rewards and

7

1 Footprint of the Buddha, *c.* 16th century, from Angkor area, Cambodia.
Stone, h. *c.* 122 (48)

personal damnations, while South-East Asian art emphasized the older, traditional subjects, especially those involving the historical Buddha and his teachings.

One of the keys to the success of the religion was the ability of Buddhism to adapt to and evolve within different cultures and their existing beliefs. This was accomplished by harmonizing with earlier practices, by claiming a common origin with native gods and also by emphasizing aspects of Buddhism that closely paralleled existing customs. Within India, both agrarian fertility spirits and earlier Vedic deities were incorporated into the newly formed religion. Even ferocious shaman gods found a place as converted protectors, while established Hindu gods, especially Shiva, appeared with little modification in the later, esoteric Buddhist pantheon. As Buddhism moved into East Asia the image of the Buddha gained in material splendour at the same time as the inherent sensuality, even eroticism, of Indian taste was suppressed. In Japan, Buddhism was able to absorb aspects of indigenous worship, Shinto, by defining native gods as manifestations of Buddhist deities. Older Buddhist deities were linked to nature beliefs, such as the Indian bodhisattva Kshitigarbha, who rose to prominence in Japan as the salvation deity Jizo, yet retained much of his native identity within the Buddhist faith.

Buddhist art serves to remind, to support and to reinforce the eternal truths of the religion, and its development and style remain integral to the history of the religion, the two not being easily separated. Since the ultimate goal of Buddhism is the transcendence of this delusory world, *nirvana* or *satori*, it required an art of highly idealized images, infinitely finer than those apparent in one's mundane existence. Because donations to temples were one of the primary means available to lay followers of gaining merit (*karma*), enormous numbers of books, images, buildings and ritual implements were created, often mass produced to meet the demands of worshippers. The resulting extensive body of material related both to ideals of the faith and to the daily lives and ultimate salvation of believers. Buddhist art remained centred on that human dimension, featuring images of individual, human endeavour and episodes of heroic, moral struggle, all designed to blend a sublime message with a mortal world.

Buddhism depended upon a number of enhancements or 'reminders' to assist the believer in understanding an often complex faith. These included genuine functional objects or relics, such as an alms bowl, or a reliquary made of gold or crystal that might contain

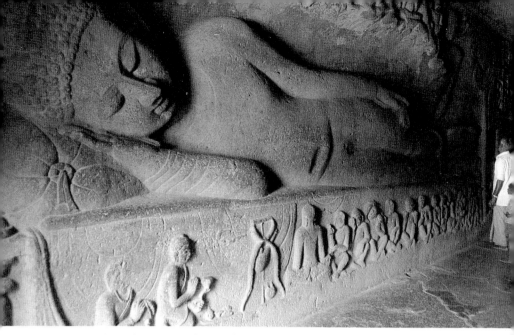

2 *Parinirvana, c.* late 5th century, left wall of Cave 26, Ajanta, India. Stone, length 7.07 metres (*c.* 23 feet)

the ashes of the Buddha or some other auspicious individual, as well as living reminders, such as bodhi trees, believed to be descendants of the original at Bodh Gaya. This system of reminders also includes canonical texts, numerous ceremonial implements and a variety of structures, such as buildings for worship and for images, libraries and residence halls for monks, as well as structures that are themselves objects of worship, the stupas, and finally, countless statues, paintings and replicas of events and places of importance. In fact, the repetition of images was considered especially auspicious and temples containing one thousand separate statues, cave-shrines with relief carvings of ten thousand Buddhas or dedications of a million small votive stupas are known. Such repetitions contributed to the invention of multiple printing, used by Buddhists, including the earliest examples of woodblock prints, from the eighth century, found in a Korean temple.

In addition to the familiar media of bronze, stone, wood, clay and paint, artists utilized materials unique to certain areas, such as dry lacquer, palm leaves, birch bark, embroidered silk, ivory, jade, gold and porcelain, even engaging in butter carving and sand painting. The objects produced ranged in size from tiny illuminated manuscripts to colossal statues and monumental wooden and stone constructions that 2

rival the Egyptian pyramids in size. Written scriptures assumed such importance that they could become objects of worship, independently of the content of their texts. In modern-day Tibetan temples, the monks still handle auspicious manuscripts as if they were treasured relics or images, and in the thirteenth century the Koryo kings of Korea commissioned the printing of thousands of manuscripts in the belief that they could offer protection against Mongol invasion.

Most revered are objects or locations associated directly with the life of the historical Buddha, which ended around 481 BC. Actual objects, such as his ashes or an implement that he used, his alms bowl or staff, as well as sites of major events in his life – eight of which became sanctified as the locations for a familiar group of episodes, such as his Enlightenment at Bodh Gaya or the scene of his first sermon at Sarnath – remained the focus of veneration. Wars were fought over possession of the tooth of the Buddha, and the early growth and prominence of the faith benefited directly from the Indian King Ashoka's celebrated distribution of the ashes of the Buddha, according to legend, placed inside 84,000 stupas. The network of holy sites was further extended to include areas that were not directly associated with the life of the historical Buddha, which had been limited to north-eastern India, but that were included as a result of the Buddhist belief in reincarnation. Stories of the Buddha's previous lives, known as *jataka* tales, were assigned to areas far from the Gangetic basin, and those locations then assumed the status of holy lands, as pilgrimage sites with their own monasteries and shrines. This was especially characteristic of Himalayan regions, such as Swat in northern Pakistan, already an important goal for pilgrims by the seventh century, according to the diaries of the Chinese pilgrim Xuanzang. Such a popular object of veneration as the footprint of the Buddha, often of colossal size and embellished with symbols, could assume a status equivalent to that of a relic, based upon the belief that the Buddha, in a former life, had once set foot upon this place so that it remained sacred and identified by this symbol. This vast array of relics and auspicious sites was increased by countless replicas of sacred objects along with images, paintings and structures that either recalled the past events or provided a setting for worship. Thus, the Buddhist religion, despite having a founder who had not supported the making of images and preached a doctrine against material possessions, acquired the world's richest and most varied system of visual support. This enormous corpus of material continues to move and fascinate Buddhists and non-Buddhists alike.

The Subject-matter of Buddhist art

PORTRAYALS OF THE BUDDHA AND THE ROLE OF THE THERAVADA AND
MAHAYANA SCHOOLS

Buddhist art is an elaborate assemblage of images of divinities and objects, ranging from a humble teacher and compassionate saviours to multi-headed, ferocious deities and extending to mysterious images and objects of bewildering complexity. There was a progression, from the earliest symbolic images (the pillars, trees, thrones, wheels, animals and stupas), to the fertility and donor figures and finally to human images of the Buddha and bodhisattvas. At this point, roughly half a millennium after the life of the historical Buddha, the content of Buddhist art was being shaped by the fundamental changes occurring within the faith.

The major doctrinal change was the development of a school of Buddhism based upon the belief that salvation was available to all, instead of one that favoured those who renounced the material world to pursue a life of monastic dedication. This schism in the faith was marked by the emergence of the Mahayana (from *maha*, great and *yana*, path) which was distinct from the older schools, known as the path of the elders or Theravada, but often referred to by Mahayanists as the lesser path, or the Hinayana. The two schools differed primarily in the importance that the Mahayanists placed upon personal devotion and the universal opportunity for salvation and in the prominence of the bodhisattva, a saviour figure whose accumulated merit could be shared with the worshipper, aiding the progress towards salvation. However, all Buddhists shared alike in the common goal, to end the cycle of rebirths, but personal faith and the intervention of the bodhisattvas distinguished the Mahayana, and its ever-growing pantheon enriched the art in its service. The Mahayana also urged a new perception of the world of the senses, or *samsara*, as being at one with *nirvana*, instead of following the traditional view that the two were separate. In other words, the Mahayana belief in the non-duality of the universe could be understood once ignorance was

overcome, freeing the worshipper to realize *nirvana* in this world. By about the middle of the first millennium that division was also assuming a geographic character, with the older, Theravada traditions continuing in Sri Lanka and ultimately into South-East Asia, while northern Asia was coming under the dominance of the Mahayana and related esoteric schools.

Although their methods differed, both schools subscribed to the fundamental belief that the suffering of life is caused by egocentric desires and the path to salvation consisted of shedding those delusions. Their images reflect expressions of serenity, revealing a transcendent state, beyond mortal weakness and selfish craving. Such an expression is found in all episodes, whether the moment of Enlightenment, the First Sermon, the initial steps of conquest by the baby Buddha or even his *parinirvana*, his ultimate triumph.

The basic difference between the art of the Theravada and Mahayana schools was in subject-matter, with the celestial Buddhas and bodhisattvas dominant in Mahayana art. For Theravadins, images of the historical Buddha, Shakyamuni, and of his former lives, the *jatakas*, were of primary significance, for they viewed him more as a human role-model, preferring episodes that would illustrate virtuous behaviour, acts of meditation and teaching that revealed the inner strength needed to triumph over evil or illusion. The art that developed around a religion that began with such modest events as a person's solitary search for life's meaning, especially in a Theravadin context, continued to feature simple human actions, though the person was one of extraordinary skills.

Symbols, such as the bodhi tree and the wheel and certain poses and gestures, were important in both schools, but the Mahayana emphasis upon the three worlds – the earthly, the heavenly and the ultimate, celestial realm – affected the manner in which many subjects were portrayed. The Mahayana conceived of Shakyamuni's role in a more abstract manner and, as with all events and beings, viewed him as an emanation of a higher, supramundane power. The transcendent images in Mahayana art presented a Buddha further removed from the earthly realm and closer to the heavenly sphere, the ultimate source of all meaning. These differences were accentuated by settings, consisting in the Mahayana of elaborate, often extravagant celestial palaces with numerous attendants and flying figures, generating an atmosphere of heavenly splendour. The Theravadins favoured solitary images, emphasizing the meditative, ascetic qualities associated with that tradition.

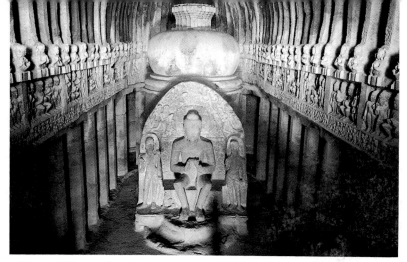

3 Cave 10, Ellora, India. The interior, 7th century

In addition, the Buddha was further distinguished by special attributes, such as the cranial protuberance (*ushnisha*), emblem of superior mental powers, or such other unique marks a a tuft of hair upon the forehead (*urna*), webbed fingers, special curled hair and lotus and wheel marks upon the soles of the feet. The emphasis on higher mental achievements called for tranquility and physical control – the goals of yoga – resulting in Buddhist images in relaxed poses and of great transcendent presence, further emphasized by a youthfulness that denied the demands of time, such as old age.

The Indian affinity for nature led to religious images with attributes shared with the natural world, such as the power of a lion, the smooth lines of a banyan tree or eyes that followed the lovely curves of the lotus. Human images that derived from these concepts could not merely resemble optical reality, but had to embody philosophical, intangible concepts common to all living things. The greatest Buddhist art balanced the two worlds, bringing a spiritual depth to physical appearances that blended the two into an art of profound range and expression.

Deities were known to worshippers by their responsibilities and most of the popular images exhibited a standard set of attributes, poses and gestures. Images of the historical Shakyamuni typically displayed a limited number of gestures, such as that of teaching (*dharmachakra-mudra*), in which both hands are held at the chest, with the fingers together. At other times both hands rest in his lap, a pose of meditation (*dhyanamudra*), or one hand is raised, palm forward, in the

3

7

13

gesture of reassurance (*abhayamudra*). The most unusual but widely favoured pose displays the right hand reaching down to touch the earth, the gesture symbolizing the Enlightenment (*bhumisparsha-mudra*). In other images, objects are typically displayed, such as a thunderbolt or the small stupa in the crown of Maitreya, the Buddha yet to come. Some objects, such as the lotus flower, were associated with several deities, as were many of the various hand gestures.

Several different episodes involving the Buddha could be portrayed in a single sculpture or painting. Of the many episodes in the life of Shakyamuni, groups of four and eight became codified as the major events for portrayal. Typically, he is shown at birth, emerging from his mother's right side, and next at the moment of enlightenment, surrounded by the forces of temptation, his noble serenity in stark contrast to their futile efforts to break his concentration. His moment of triumph is signified by his right hand reaching down to touch the earth, witness to his achievement. Also included in the four major events is his first sermon at Sarnath, showing him making the appropriate gesture of teaching and often including the wheel of the law directly below, continuing the earlier symbolic imagery. The last of the four images is the familiar reclining figure, representing his final

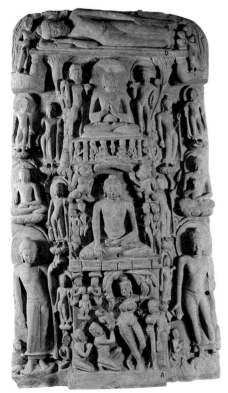

4 Life of the Buddha, stele, c. 475, Gupta period, India. Sandstone, h. 104 (41)

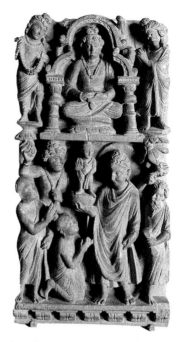

5 Presentation of a statue, relief,
2nd–3rd century, Gandhara, Pakistan.
Schist, h. 30.2 (11⅞)

triumph (*parinirvana*). The other episodes that constitute the eight
major events, also represented both singly or in groups, are his first
encounters with sickness, old age, a dead body and a holy man; the
subsequent renunciation of his princely life; his meditation in the
forest; and the miracle at Sravasti.

To these major events in the life of the Buddha and the numerous
jatakas, can be added a lesser episode but one that resulted in a
particular image destined to become especially venerated. According
to the legend, some time after his Enlightenment, the Buddha
ascended to the heavens to preach to the thirty-three gods. Distraught
over his absence, King Udayana commissioned a statue out of
sandalwood, which he presented to the Buddha upon his return. 5
Unfortunately, such an image no longer exists for it would be the
earliest likeness of the Buddha. Over the course of time, the event and
a particular image, known as the Udayana Buddha, assumed special
sanctity, and copies continued to be made, especially in East Asia.
These were standing figures, with the right hand raised in the gesture 7
of reassurance, and distinctive for their rippling drapery folds, a style
originating with Indian images but probably altered by Central Asian
art. The story gained a strong following among the Chinese and the
best-known example, dated to the late tenth century but now located

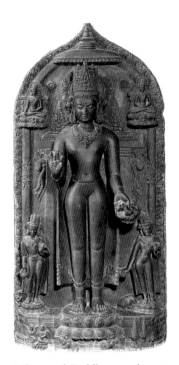 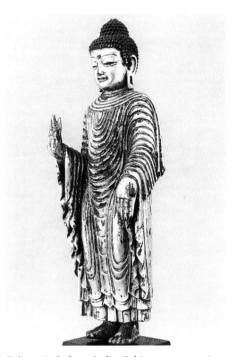

6 Crowned Buddha, *c.* 11th century, Pala period, from India. Schist, 104.1 × 50.8 (41 × 20)

7 Standing Buddha, 14th century, Yuan dynasty, from China. Gilt bronze, h. 12.7 (5)

in a Japanese temple, has enjoyed a remarkable cult status; indeed, its dedicated worshippers claim it to be the original Udayana image.

6 Another image of special note is the crowned Buddha. Examples first appeared in India, after the Gupta period (fourth to seventh century AD), and were popular in Central Asia in response to the Mahayana shift towards a more regal, celestial vision of the Buddha.

51 Likewise, the cosmic Buddha, Vairochana, was often shown crowned, the change being due in part to the growth of Mahayana and esoteric doctrines and representing a reaction to the growing popularity of the regally dressed bodhisattvas.

A similar concept is found in images of the Buddha as *chakravartin*, world ruler, which derives from early literature, and such images show him with his arm raised in triumph, the traditional gesture of a conquering ruler. Images of the baby Buddha, representing his first steps as he conquered the universe, were popular in East Asia and displayed this same gesture.

16

No aspect of Buddhist art has generated more bewilderment than the multitude of gods and goddesses that make up the later, northern pantheon, with its often unorthodox, at times bizarre, deities and numerous attributes, animals and attendants. Deriving from Indian Tantrism and Hindu imagery and known as the Vajrayana, the path of the *vajra* or thunderbolt, it was based upon the concept that the sensory, phenomenal world was not to be dismissed as illusory, as it was considered by the older schools. Such esoteric schools as Tibetan Buddhism or the Shingon sect in Japan, without denying the Buddhist belief in the absolute void, assigned ever increasing importance to the world of phenomena. They found insight in daily, physical events and through secret, complex rituals linked these events to the higher spheres of ultimate awareness; for the goal of the esoteric schools was the removal of ignorance, to reveal the pure light of knowledge. Such practices as meditation, yoga, chanting (*mantras*) and the use of gestures (*mudras*) were linked to the phenomenal world and functioned as starting points along the path towards understanding, following the Mahayana belief that the ultimate Buddha-nature resided within all beings, awaiting discovery. These often mystical ritual practices could hasten progress towards enlightenment and embraced both the celestial domain and the phenomenal world, though the worshipper often needed a personal mentor (*guru*) to interpret the connections between the two. Esoteric Buddhism was involved with bridging the gap between the phenomenal world of the senses and the higher, absolute world without form. Esoteric ritual was founded upon the belief that material images or sensory experiences could do no more than point the way. True awareness came through intuitive insight and therefore remained a personal, individual experience, aided by secret, mysterious rituals rather than orthodox learning with its prescribed, organized practices. Thus, the art was composed of arcane references supporting the secret and mysterious rituals of esoteric Buddhism. Although not directly a part of esoteric Buddhism, the various Chan and Zen sects of East Asia subscribed to a similar belief in the possibility of sudden enlightenment, reducing the lengthy process followed by traditional Buddhist schools.

The esoteric pantheon was divided into five main groups, each presided over by one of the celestial or transcendent Buddhas. All other deities, Buddhas and bodhisattvas alike, were subsumed under

17

one of these cosmic Buddhas, with the group arranged into quarters, one for each of the cardinal directions, and the centre occupied by the principal deity, Vairochana. The arrangement was extended, often using the numbers four and five, to include numerous elements such as colours and gestures, creating visual arrangements, called mandalas, cosmic diagrams of great complexity and beauty. Esoteric Buddhist art, partly in response to the number and variety of images, relied upon an almost geometric order. The pantheon was arranged, at times grid-like, into mandalas and groups of figures indicating an order greater than the many parts. A single mandala could have a thousand images, arrayed in a cosmological harmony, reflecting the ultimate organization of the universe. In one remarkable extension of this system, the Manchurian Liao Dynasty (936–1125) established five separate capitals, following the Vajrayana programme literally.

The beginnings of esoteric Buddhist imagery can be seen in the early changes in the perception of the historical Buddha, Shakyamuni. Starting in the early years of the Christian era, the Mahayana schools ceased to emphasize Shakyamuni's role as a historical figure, the founder of the faith and model of behaviour and beliefs, and began to view him as simply one in a long series of manifestations of the supreme Buddha. An indication of this shift in perception can be seen in the creation of colossal images, another example of the change to a transcendent view of the Buddha. This changing concept can be found in the popularity of representations of the Miracle of Sravasti. The episode is a magical performance, as the Buddha multiplied his form in response to a challenge by sceptics. The clear reference to superhuman powers follows the direction taken by the Mahayana and esoteric schools, although this particular episode continued to appear in Theravadin cultures as well. Once the historical Buddha was seen within this larger context he came to be viewed as one aspect of a yet greater force, a manifestation of a supreme Buddha of cosmic dimensions. This resulted in a diminution of his role in worship, which now emphasized the growing pantheon of bodhisattvas and celestial figures. These were likewise manifestations of the supreme deities but occurred in such numbers and with such varied visual relationships that a new group of individuals was needed to interpret the growing complexity. Known in Indian Buddhism as gurus, these independent, often highly eccentric, mentors explained and directed the believer through the intricacies of worship.

The most intriguing esoteric images were those sculptures and paintings of figures in sexual embrace. Despite their graphic

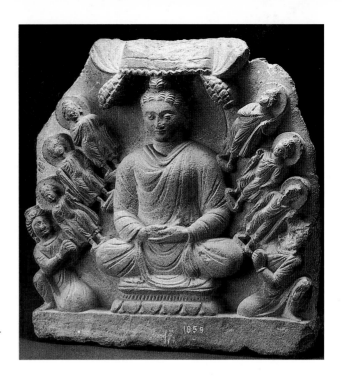

8 Miracle of Sravasti, relief, 3rd–5th century, from Gandhara, Pakistan. Schist, h. 30 (11¾)

portrayals, the underlying concept was a logical, though subtle principle, that two qualities were necessary, compassion and wisdom, to reach the ultimate goal. By assigning the means of compassion (*upaya*) to the male and wisdom (*prajna*) to the female, esoteric or Vajrayana Buddhism employed universal needs, the most elemental forces of nature, to communicate fundamental principles to the believer. The ultimate goal, the removal of ignorance, required the skilled blend of compassion and wisdom to move beyond this mundane world and overcome the illusions that blinded the believer to the ultimate Buddhist truth.

PAN–ASIAN SYMBOLS AND THEMES

Buddhist art included symbols, potent emblems that often embodied complex issues and concepts, for Buddhism utilized symbols to a greater degree than most religions. Beginning with the earliest art, which featured trees, empty thrones and wheels, instead of images of the Buddha, the faith continued to rely upon symbolic representations. Whether they were actually symbols of the Buddha or of the

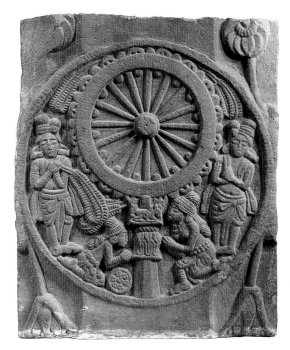

9 Worship of the
Wheel, relief, c. 100 BC,
Shunga period, from
Bharhut, India.
Sandstone

locations of auspicious events, such as his birth or Enlightenment,
these early symbols had become so well established that they
continued to appear although no longer necessary to identify the
9 image. For example, the wheel, which was the emblem of both the
Buddha's Enlightenment and of his First Sermon, represented his
action of setting the Wheel of the Law in motion, but was often
retained in later versions of the event, despite the literal portrayal of
the Buddha in the gesture of teaching. Likewise, branches of the bodhi
tree continued to appear behind images of the Buddha at the moment
of Enlightenment, despite the distinctive gesture of touching the
earth, the primary emblem of the event. Other symbols, most
13 borrowed directly from nature, such as the lotus, the *chintamani* or
'wish-granting jewel' and the thunderbolt (*vajra*), remained promi-
nent, the latter as the emblem of the entire esoteric school. The stupa,
the most distinctive of all Buddhist symbols, also endured as a potent
icon, emblem of his conquest over illusion, his *nirvana*. Few subjects
remained limited to a single geographical area, such as the unique
158 walking Buddha images of Thailand, and, after adjustments for local
traditions, such as the replacement of the Indian stupa by the East
Asian pagoda, most themes and subjects appeared throughout Asia.

20

Female imagery
The goddess, who played a major role in all Indian religions, beginning with small Neolithic fertility figures, was later over-shadowed by male deities during the Vedic period but ultimately re-emerged in a vast array of figures, benign and ferocious, in the pantheon of each Indian religious sect. Among the earliest figures in Buddhist art were the images of fertility and abundance, the *yakshas* and *yakshis*, the best-known being the frequent and sensuous images 10 carved upon the railings that surrounded a stupa. By the time of the 22 emergence of Tantrism, evident by the seventh century, female images had assumed a greater stature, ranging from gentle consorts to complex, multi-limbed and horrific visions of enormous, frightening power. In Vajrayana, the Buddhist form of Tantrism, the female, symbolizing wisdom, was portrayed as a passive figure with the male deity as the active partner, identified with the means of compassion. Some of the greatest creations in Buddhist art, especially after the middle of the first millennium, were female images. The famous Javanese Prajnaparamita embodies the same blend of wisdom and 179 inward control noted among the finest male images, such as the Sarnath Buddha of the Gupta period. In East Asia the female image 42

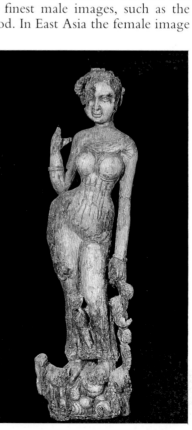

10 *Yakshi* or river goddess, *c*. 1st century AD, from Begram, Afghanistan. Ivory, h. 47 (18½)

was often identified with good luck or good fortune, as in the case of *Kichijoten*, goddess of wealth and beauty, the most popular female deity in Japan, who was represented in resplendent dress much as a bodhisattva and assigned many of the same roles as protector or saviour. Popular female deities often derived from pre-Buddhist fertility cults, such as Daoism and Shinto, and then were absorbed, essentially intact, into the pantheon as part of the Buddhist adaptation to local culture.

Cosmology
According to the Buddhist view, the centre of the universe is a mountain, Meru, from the top of which rise the various levels of the heavens. This towering mountain is surrounded by seven circular, concentric chains of mountains, each separated by one of the seven oceans. Beyond these is the great ocean, containing the four island continents, one in each of the four regions of space, with the southernmost, the island of Jambudvipa, being the realm of humans. This entire universe is surrounded by a final, huge wall of rock. The heights of Mt Meru include the residence of the four rulers of the cardinal points, the thirty-three principal gods and at the peak the abode of Indra, the king of the Hindu gods, or of the celestial Buddha, Vairochana. Above all this are the layers of the sky, varying in number according to the sect and the era.

Except for occasional drawings or paintings or the inclusion of a pillar (the *axis mundi*) within the traditional stupa, there were few attempts to illustrate this grand vision. What typically resulted were abstractions or details and guidelines for relationships among subjects, such as Vairochana atop Mt Meru or groups of figures, such as the guardians of the four quarters (*Lokapalas*). East Asian cosmological diagrams could include famous sites visited by pilgrims, such as those along the Silk Road across Central Asia, the Himalayas and the mouth of the Ganges, where many disembarked. Some of these early charts of the universe also included Korea and China, in an effort to link the known world with the larger, cosmological vision. Painted mandalas provided a two-dimensional medium for illustrating aspects of this Buddhist vision, and the concept was addressed in the largest monument in the Buddhist world, the Borobudur in Java, embodying many of the same elements. The most ambitious attempts at re-creating such a cosmology may have been Cambodian and Javanese, at Chandi Sewu. In the thirteenth century the Khmer ruler Jayavarman VII completed the Bayon as his seat of power and a

174–7

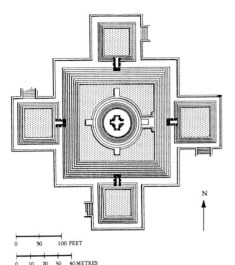

N

0 50 100 FEET

0 10 20 30 40 METRES

11 Plan of Neak Pean, 13th
century, Angkor, Cambodia

replica of the centre of the universe. The same king also created a
smaller, yet even more explicit, model of the origins of the four sacred
rivers that nourished Jambudvipa. At Neak Pean, near the Bayon, a 11
group of four square tanks are joined by water spouts to a central
reservoir, as part of an ensemble re-creating this paradise.

Water themes
In addition to playing a major role in cosmological imagery, water
and aquatic creatures had always been important in Indian mythology
as snake kings (*nagarajas*), and appeared early in Buddhism, for
serpents were worshipped as spirits of rivers and fountains. Images of
nagarajas were more prominent in early Indian Buddhist art and, 12
except for their serpent coils, differed little from *yakshas*, the fertility
images. In Central Asia *naga* kings often assumed the roles of
guardians. Serpent lore was especially important in mainland South-
East Asia where the best-known examples were the images of
Shakyamuni, seated atop the coils and under the protective hoods of 157
the *naga* king Muchalinda. Thai sacred buildings face towards the 171
water; in fact, many believe that the building itself is a boat carrying
the pilgrim to salvation. Likewise, one of the greatest East Asian
monuments, the mountain-top Sokkuram in Korea, is oriented
towards the distant ocean and the king's underwater grave. The
aquatic lotus remained one of the primary symbols of Buddhism: it
may be held in the bodhisattva's hand, or form a flower-petalled
throne or even be adapted to form the great cosmological pillar of Mt

23

13 Meru. In a brilliantly coloured Qianlong silk embroidery, half the
 composition is given over to the flower, which constitutes the lotus
 throne, while, below, the stalk and leaves assume the shape of Mt
 Meru itself. The celestial heavens and palaces of the Pure Land of
 Amitabha, ultimate goal of most East Asian Buddhists, were
 portrayed in countless paintings as spectacular ensembles of wooden
 buildings, raised on pillars amidst endless lakes and streams, and
138 Japan's best-known temple, the Byodo-in, is surrounded by its own
 ponds in a literal re-creation of such a paradise.

12 (*below*) Naga group relief, late 5th century, Cave 19, Ajanta, India. Stone

13 (*right*) Bodhisattva Lokeshvara, Sino-Tibetan, Qianlong period (1736–95). Silk
embroidery on silk, 209.5 × 86.7 (82½ × 34¼)

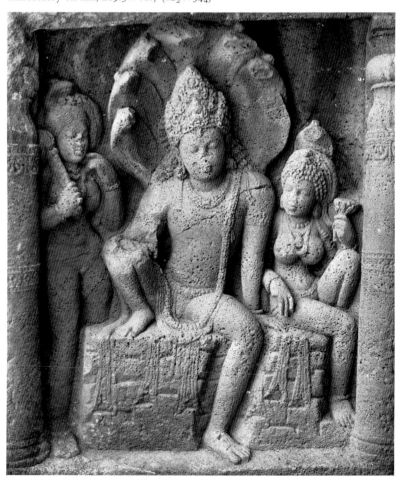

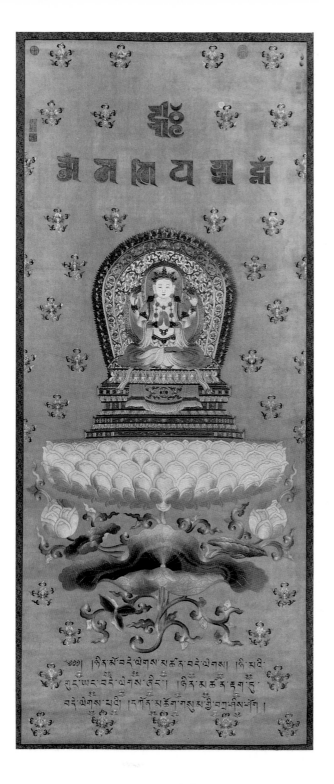

Other themes
Common pan-Asian themes include ones emphasizing important concepts, such as youth, timelessness and inevitability. Essential to Buddhism is the conviction that life belongs to an inexorable process, one that worshippers believe ultimately will result in rebirth in the Pure Land of Amitabha or, in the case of Theravada cultures, in a final end to rebirth itself, *nirvana*. This belief in inevitability is captured in the timeless, serene smile of the Buddha, reflecting the certainty of the eventual outcome, or through the creation of multiple, repeated images, such as the carving of ten thousand representations of the Buddha. The symbol adopted by esoteric sects, the *vajra* (thunderbolt), with its power of indestructibility, representing the sheer unstoppable force of nature's most powerful element, reinforced the enduring, invincible Buddhist march towards salvation. Among East Asian meditative schools, such as Japanese Zen, any subject or theme is appropriate if it helps advance the process of awareness. One of the most famous of such images consists of only six persimmons, leaving the interpretation and analysis to the worshipper.

14

Related to rural, folk customs were references to fertility, especially prevalent during the formative stages of Buddhism in India. Fertility figures were initially incorporated into the faith in the form of individual images, often of considerable size, with little or no alterations, then gradually assigned subsidiary roles, such as those of attendants. They are discussed more fully in Chapter One. Guardian images also derived from early fertility figures but rapidly increased into a variety of forms ranging from paired door guardians (*dvarapala*) to sets of eight and twelve aligned on the zodiac (*dikpala*). The most extensive elaboration of guardian images occurred in East Asia, with entire sets of guardians assigned to individual deities, such as the twelve that surround the Buddha of healing (Bhaishagjaguru), or the groups displayed on the complex mandalas of esoteric schools. In East Asia the *Lokapalas* are honoured with their own building in the monastic compound. The connection with early fertility worship remains, in the form of the gnomes and dwarfs frequently trampled upon by these guardians

As befits a religion that originated in a rural setting, animal imagery played a major role in Buddhist art. The lion was long associated with the Buddha, indicated by his clan name, 'lion of the Shakyas', and this link was reinforced by countless lion thrones. The best-known lion in Buddhism is the famous Sarnath lion capital in India, and the lion provided a mount for the bodhisattva Manjusri. Other animals, long

18

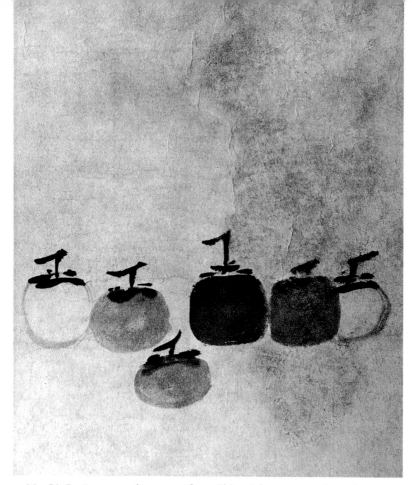

14 Mu Qi, *Persimmons*, 13th century, from China. Ink on paper, 36.2 × 38.1 (15 × 14¼)

established in Indian culture, notably the elephant and serpent, also played major roles, especially in South and South-East Asian art.

BUDDHIST ARCHITECTURE

There are two primary types of Buddhist structures: first, the various facilities needed to sustain the life of the monastery, intended for such functions as the display of images and their worship or as residence halls for monks; and, second, a structure that was itself an object of

worship, the stupa or pagoda. The latter is the best-known, most distinctive Buddhist monument and despite regional modifications was often the focal point of the monastery, befitting its customary role as container of sacred relics. Its origin and development is discussed in Chapter One and the major stylistic changes, from the Indian stupa to the East Asian pagoda, are described in Chapter Two.

The remaining structures ranged from small cells for monks, often arranged around a courtyard, forming a plan similar to that of early Indian houses; to image halls, some of enormous size, as well as facilities for group worship and instruction, libraries, and specialized buildings such as drum and bell towers. The two primary structures, the halls of worship or *chaityas* (the word means sacred object) and the *viharas*, the monks' residences, are discussed in Chapter One. This varied group of buildings was assembled into an orderly plan. In East Asia it stood within a walled compound and usually followed an axial plan oriented towards the south, with the pagoda behind the entrance gate, followed by the image hall and completed with a lecture hall and rear gate. The building placement could be altered by uneven terrain, as in a mountainous retreat, or determined by the shape of a mountain, as in the case of rock-cut shrines. These last enjoyed great popularity during the first millennium, with the largest single carved image at the Bamiyan complex in Afghanistan and the greatest number of such shrines at various Chinese sites.

Whatever the form of the structure, Buddhist worship involves circumambulation, a custom easily followed in the context of free-standing stupas or pagodas. Excavated cave shrines included a path for this purpose, as did early East Asian image hills. However, with the emergence of esoteric schools, images came to be worshipped only from the front, for the rear of the hall was enclosed and limited to secret ritual. This change in ritual necessitated alterations in the arrangement of buildings. In addition, in East Asia the image hall gradually supplanted the pagoda as the primary focus of the compound. Thus, pagodas were moved outside the central walled enclosure, becoming less sacred and more decorative and often being arranged as a pair for the sake of symmetry.

India and Neighbouring Regions

THE BEGINNINGS

The first cycle of Buddhist art lasted nearly five hundred years, until the end of the first millennium BC and the consolidation of northern India under the Kushan dynasty. Although no explicit restrictions against image-making are known, the first Buddhist art did not begin to emerge until the third century BC and, instead of figures of the Buddha or portrayals of the stories of his lives, it consisted of symbolic pillars – a continuation of ancient Indian pillar cults – with their elaborate capitals often rendered in a Persian style, and erected under the patronage of a recently converted king.

Although the Buddhist religion had been in existence by then for more than two centuries, it took the conversion of a powerful monarch to stimulate the appearance of visual imagery. Ashoka, who ruled from around 272 to 231 BC, was the grandson of the founder of the Mauryan dynasty and demonstrated his conversion to Buddhism by vigorously promulgating the religion across India, by means of edicts carved on pillars of stone and wood, from Bengal to Afghanistan and into the south. Ashoka's use of pillars followed earlier Indian beliefs, particularly the *axis mundi* ideals first expressed in the earliest Indian literature of the *Rig Veda*. This indicated the existence of cosmological aspects in early Buddhism, as well as associating the religion with imperial patronage – a typical pattern as the faith spread across Asia. The best-known of his dedications, the Sarnath lion capital, is imprinted on India's currency and the Wheel of the Law is at the centre of the national flag of India, exceptional testaments to a Buddhist king in a Hindu culture. 18

The pillars, which are crowned with lotus-petal capitals and surmounted by such Indian subjects as cows, elephants and lions, reveal the mixture of styles of the Mauryan dynasty (*c.* 323–185 BC). They are partly Persian, notably the Achaemenian stylized lions and decorative borders, yet include the naturalistic animals associated with the much earlier native Indus Valley tradition, dating from

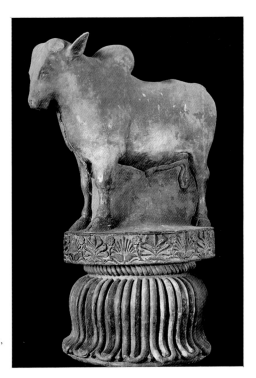

15 Bull capital, 3rd century BC, Mauryan, from Rampurva, India. Stone, h. 205 (80¾)

before 1500 BC. The sensitive observation of animal forms, clearly evident in the bull capital shown, will remain a fundamental characteristic of Indian art. Alexander the Great's destruction of the Persian empire and disruption of society, just prior to the Mauryan dynasty, caused artists to seek patronage elsewhere and, judging from the Mauryan remains, some found work further east, in India. Alexander's activity across western Asia, late in the fourth century BC, increased contacts with India and was followed by the opening of the Silk Road between China and Rome, two events of great consequence in the subsequent history of Buddhism.

Just as Ashoka's capitals provided India's earliest Buddhist sculpture, his support of rock-cut building resulted in the earliest Buddhist architecture that remains. The few modestly sized caves in Bihar were the first examples of what developed into one of India's major engineering and artistic feats, the carving of monumental shrines into the sides of mountains, a technique employed by both Buddhists and Hindus and carried along with Buddhism into Central Asia and China.

15

By the end of the third century BC, the Ashokan, Indo-Persian motifs were joined by other subjects and during the next century there emerged a wide range of imagery, now in the Indic style. Much of the early imagery was associated with the stupa, one of the three main types of Buddhist buildings. Unlike the other two, the residence hall (*vihara*) and the hall of worship (*chaitya*), which were made to be entered, this was solid and monolithic. Also unlike the other two buildings, the stupa was not patterned after wooden prototypes, but derived from Hindu burial mounds, and it continued to perform a similar role as a symbol of the Buddha's *parinirvana*, or final exit from this world. Ironically, the most widely recognized form of the stupa, the East Asian pagoda, is best known in its wooden form, as found in Japanese temples.

The early stupa consisted of several distinct parts. The main body, the *anda*, was a simple, hemispherical dome, set upon a low platform. A single pillar emerged from the top, surmounted by circular disks (*chhatraveli*), and the pillar and its umbrellas was in turn enclosed by a square set of railings (*harmika*), a miniature version of the larger fence that surrounded the stupa proper. The enclosing of the central pillar follows the traditional Indian custom of surrounding hallowed objects, such as sacred trees and temples. The umbrellas atop the main pillar at the heart of the monument (a continuation of the pillar cult employed by Ashoka), remained an essential ingredient of Buddhist cosmology, for the pillar represented the 'world mountain' or *axis mundi*, the pivot of the universe. Umbrellas are also honorific emblems, reserved for auspicious monuments as well as individuals, and the three umbrellas came to represent the Three Jewels of Buddhism: the Buddha, the Law and the monastic gathering of monks, the Sangha. For completeness, the symbolism was continued into the core of the monument where the sacred relics were buried, and the internal forms of the stupa itself were often arranged into geometric, magical designs, such as that of a wheel, then, like the relics, covered over by the body of the stupa.

The stone railings that surround the Sanchi stupa in Madhya Pradesh were based on wooden prototypes with right-angled entrance gates, which alluded to the ancient swastika emblem but were probably derived from farmer's gates used to keep out cattle. Four gateways, the *toranas*, indicated the cardinal directions and, with their crossbars and pillars covered in relief carvings, provided the

16, 17
27

17

21

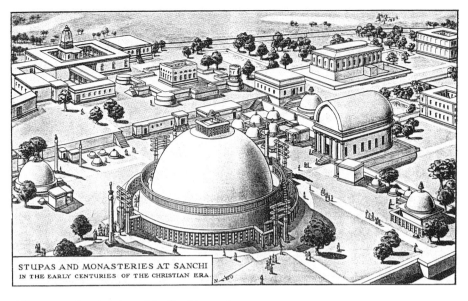

STUPAS AND MONASTERIES AT SANCHI
IN THE EARLY CENTURIES OF THE CHRISTIAN ERA.

16 Reconstruction drawing of the Sanchi complex

17 Great Stupa and North Gate, *c.* 1st century BC, Sanchi, India

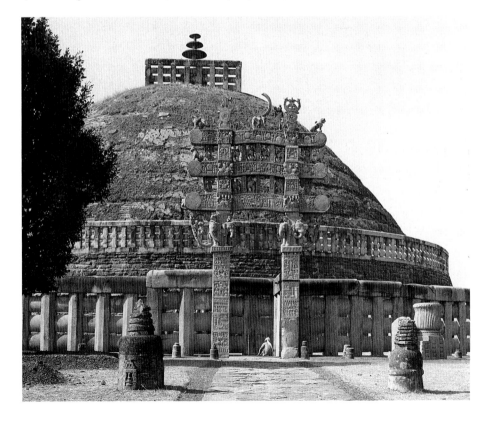

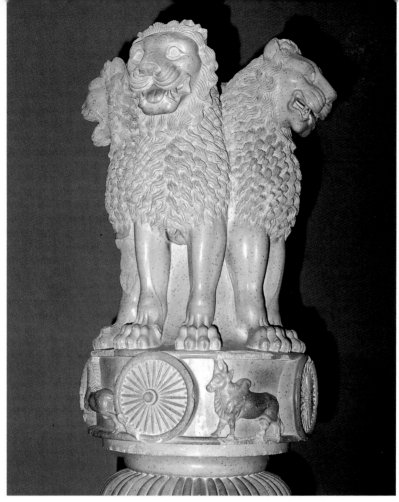

18 Lion capital, *c.* 3rd century BC, Mauryan, Sarnath, India. Polished Chunar sandstone, h. 213 (83⅞)

main instructional areas, to engage visitors with stories and illustrations as they began their worship. In Buddhism, such worship consisted of a clockwise circumambulation of the stupa. Some stupas, such as Amaravati in the south-east, added richly carved marble slabs to the body of the stupa itself. Free-standing pillars, similar to those made famous by Ashoka, were included in the sculptural programme, as well as being installed outside the gates in other areas of the compound.

27
16

The most important of the early stupas are the remains at Bharhut, once an enormous monument from about 100 BC but reduced to mounds of rubble by the time of Alexander Cunningham's excavations in the nineteenth century. Although only portions of the richly carved railings and one of the four original gateways could be reconstructed, an idea of its original design and placement within the compound can be gained from the more complete restoration of a slightly later monument at Sanchi.

The importance of these early stupas remains their abundance of imagery – the genre scenes, *jataka* tales and individual figures that have proved to be a visual encyclopaedia of early art. Recent studies have also shown the Bharhut reliefs to be rather sophisticated in their manner of presentation, with numerous variations in narrative technique that belie what may initially appear to be a naive, undeveloped style.

19 This sophistication can be seen in the well-known Deer *jataka*. In this single medallion are four separate scenes comprising an episode from a former life of the Buddha. In the centre is the Buddha, in his incarnation as a deer, facing a large human figure in a pose of adoration, while a second man prepares to fire an arrow. In the river below, a man is shown riding a deer safely to shore. In what has been called a conflated or overlapping narrative, the central deer, despite being represented only once, is involved in three of the four events. According to the tale, after being rescued from the river by the deer, the ungrateful hunter directed the king's bowmen to the prize. At this point, the deer preached the Buddhist doctrine against killing, so that, following this, the king and the others are shown in adoration, converted to the faith. Other scenes at Bharhut, and in related sites such as Sanchi, have utilized equally complex systems of representation, such as linear and continuous narration, suggesting that the developing Buddhist philosophy was supported by an artistic system of exceptional scope.

20 Different pictorial devices at Bharhut can be seen in the story of the establishment of a monastery by a wealthy lay follower, at the Jetavanarama grove. This episode was important, for it represented a virtuous act, a donation to the faith as one means for a layman to accumulate merit. In the upper right-hand part of the scene, above the two-wheeled cart, workers cover the ground with pieces of gold, to indicate that the land sold by the former owner was overpriced. In this formula of selective representation and scale, widely applied throughout Asia, prominent figures are rendered larger than the others, one or

34

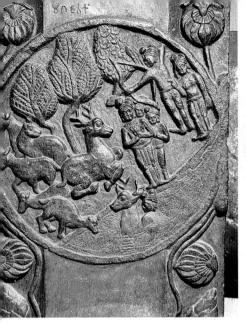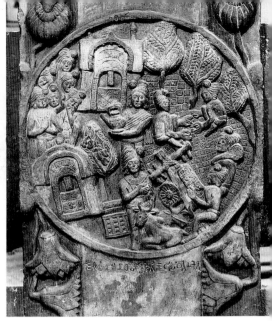

19 Deer *jataka*, *c*. 100 BC, Shunga period, from Bharhut, India. Sandstone, h. *c*. 49 (19¼)

20 Purchase of the Jetavanarama Monastery, *c*. 100 BC, Shunga period, from Bharhut. Sandstone, h. *c*. 49 (19¼)

two buildings suffice to suggest an entire complex, and selected elements take priority over detailed illusions of pictorial space. Subjects at the bottom of the scene, meant to be closer to the viewer, are more deeply carved, adding to the illusion of distance. Even the passage of time was treated arbitrarily, for, according to the inscription, one of the buildings illustrated was actually erected at a later time.

Unlike the fragmentary ruins from Bharhut, enough remained at Sanchi to permit the archaeologist John Marshall and the Buddhist scholar Alfred Foucher to rebuild most of the site. Its size and carved gates have contributed to its fame as the most complete example of the early Buddhist stupa and of the style generally followed in India. Literary sources tell of Ashoka's dedication of the original stupa, including a pillar with a lion capital, similar to the one at Sarnath, although the earliest remains are contemporary with Bharhut. Sanchi, whose rounded hill resembles the dome of a stupa from a distance, was once at the economic crossroads of northern India – one of the reasons for its continued patronage, lasting until well into the first millennium.

16, 17
21

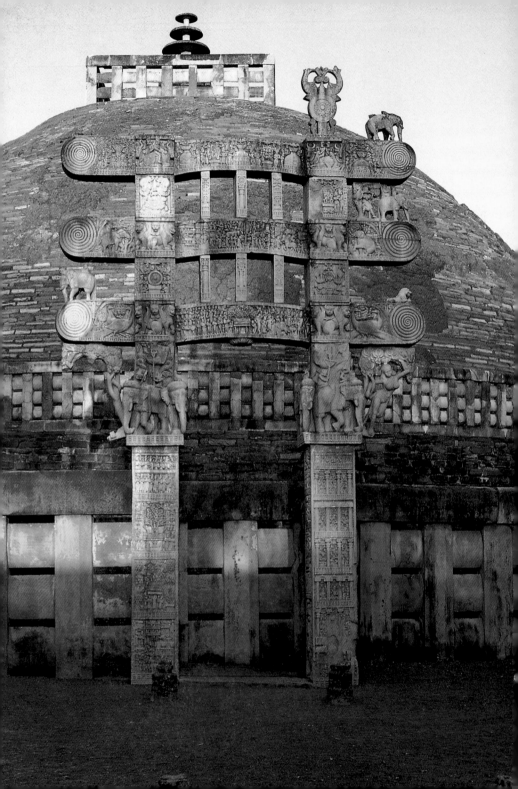

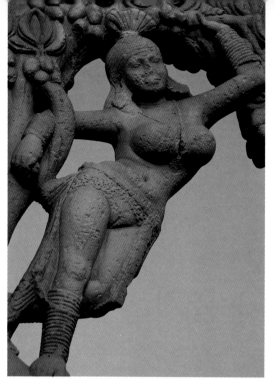
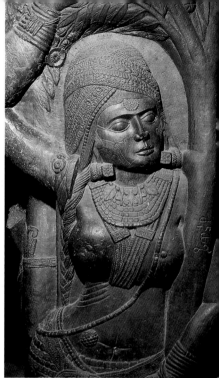

21, 22 (*left, above*) East Gate and *yakshi* detail, Great Stupa, *c.* 1st century BC, Sanchi

23 (*above right*) Yakshi (detail), *c.* 100 BC, Shunga period, from Bharhut. Note the auspicious scarification on her face. Red sandstone, h. *c.* 215 (84)

24 (*below*) Yakshis like those at Bharhut and Sanchi. Ivory plaques, 1st century, from Begram, Afghanistan

The site consisted of a complex of buildings, including at least three stupas. The largest, Stupa 1, or the Great Stupa, was rebuilt several times, the present remains probably dating from the first century BC. Sanchi's relief carvings are confined to the pillars and crossbars of the four gateways (*toranas*), unlike Bharhut, although the carvings are deeper and the style more complex, due in part to their later date. Each gate is divided into three parts. The upper section, consisting of three architraves, is covered with narrative scenes that end in volutes, stone replicas of the kind of pictorial handscrolls carried from village to village by wandering storytellers. Despite the compressed images, the deep carving is done with such refinement that the stories can still be deciphered from the ground below. The space is filled with humans, animals (real and mythical, some still in the Persian style) and Buddhist symbols, such as stupas, lotuses and trees. Surrounding the capitals that join the crossbars with the square pillars below are addorsed lions, elephants and dwarfs that serve to break the two-dimensional plane of the railings and provide a dynamic transition from the horizontal crossbars to the vertical supporting pillars. Another visual connection between the pillar and crossbars is provided by female bracket figures, among the finest examples of the *yakshi* image in Indian art. The formality and shallow carving of earlier figures has been replaced by the movement and sensuous forms of the dance, which was always a primary model for the Indian artist. The squared, lower portion of the gate consists of richly carved pillars, decorated with *jataka* tales, protective figures and details of contemporary, secular architecture. Throughout, the most common motif is the stupa fence, the same railing that surrounds the entire stupa as well as the pillar and umbrellas at the top. Such railings also form borders along the architraves surrounding the capitals and serve as spatial divisions for the many scenes on the pillars.

Among the most prominent subjects at Bharhut and Sanchi are standing male and female figures. Some adopt poses of adoration, with their hands clasped at the chest, while others carry various objects and certain sensuous female figures grasp the trunk and branches of a tree. Despite their various titles, such as *yakshis*, protectors, warriors or *nagaraja* (the king of the serpents), they share common characteristics, involving fertility in the case of the females and power and abundance in the case of the *yakshas*, the male generic type widespread in Indian art. These are the images of prosperity universally associated with agrarian cultures. Although they usually appear as subsidiary figures, they also provided models for specific

38

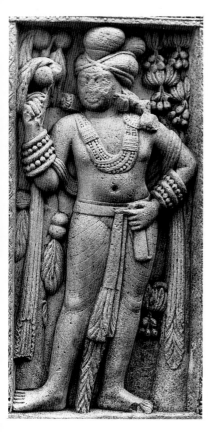

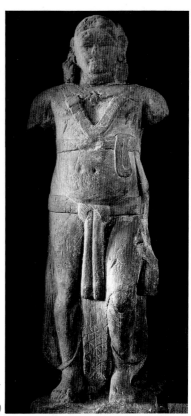

25 Male attendant
on the North Gate
of the Great Stupa,
c. 1st century BC,
Sanchi

26 *Yaksha*, 1st
century, Kushan
period, from Park-
ham, India. Sand-
stone, h. 262 (103⅛)

deities, such as guardians and bodhisattvas, as well as being one of the primary sources for the earliest images of the Buddha. The *yaksha* attendant figures from the pillars of the Great Stupa at Sanchi illustrate this formula, with their massive forms, elaborate headpieces and allusions to the abundance of nature, an image that often appears after the first century AD.

A different style of Buddhist art, with a substantial influence upon developments in South-East Asia, appeared along the eastern coast, along the Krishna River. Beginning in Ashoka's time, this region was the home of renowned monastic centres and some of Buddhism's greatest teachers. In addition, it was a region of vigorous commercial activity which ensured the dissemination of the Buddhist religion, especially along the sea routes to the east. Although none of the early monuments stand, carvings on the marble slabs recovered from Amaravati and Nagarjunakonda illustrate stupas of enormous size

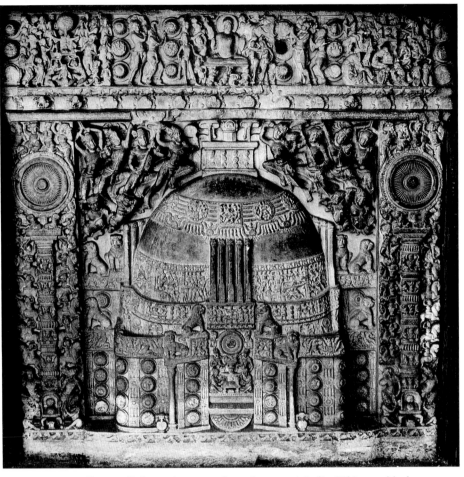

27 Stupa, relief, c. 2nd century, from Amaravati, India. White marble, h. 170 (66⅞)

and far greater decorative richness than those of the north. Reconstructions of the Amaravati stupa, based upon these carvings, indicate not only elaborately carved gateways and fences but also carved panels on the body of the stupa, making this the most richly decorated stupa known.

The earliest Amaravati reliefs repeat many of the subjects familiar from Bharhut and Sanchi – the empty thrones, bodhi trees and crowds of worshippers – and they too are still without images of the

Buddha. However, the style is notably different. Compared with the northern works, their figures are more attenuated and sensual, their decoration more abundant. Empty space is anathema, so that the entire surface is filled with figures in motion, the only respite among the crowded scenes being provided again by railings that arbitrarily divide one group from another, as they did at Sanchi. By comparison, the crowd scenes from the north seem almost static, the figures evenly spaced, often lined up in rows, while the Amaravati figures twist and move, crowded into limited areas and at times spilling beyond borders, making them in many ways closer to the mural compositions at Ajanta than to those at Bharhut and Sanchi. Even among the later reliefs, from the second and third century, which now include images of the Buddha, the style changes little. The marble reliefs from Amaravati remain a distinct, regional style, among the most artistically successful in early Indian art and with a direct influence upon the art of Sri Lanka and South-East Asia.

THE DEVELOPMENT OF THE BUDDHA IMAGE

The human image of the Buddha does not occur during the early centuries of Buddhist art. In the scenes illustrating his prior lives, he is portrayed in non-human form, for example in his earlier existence as a deer or other animal. When an episode from his most recent historical existence, as Shakyamuni, was illustrated, he was represented symbolically, such as by an empty throne, a stupa or a tree, with the most popular symbols continuing to be included even after the introduction of the Buddha in human form.

The traditional explanation for the initial absence of human images of the Buddha has been that it reflects an early preference for aniconic imagery, that is the substitution of an emblem or symbol for the primary figure, much as early Christians substituted the cross for an image of Christ. A more recent proposal is that these images of trees and thrones may actually represent places of pilgrimage, sites of events associated with the Buddha rather than the specific event, thus not requiring his presence, in actual or aniconic form. Certainly the act of pilgrimage remained an essential religious practice throughout Buddhist lands and many of these images may well celebrate auspicious sites, following the lead of Ashoka who visited many and enhanced their prestige with dedications, encouraging continued patronage. Whether these early images were actually aniconic representations of the Buddha – and it would appear many were not –

the absence of human images of the Buddha is conspicuous during the first 150 years of Buddhist art.

The debate over when and where the first images of the Buddha occurred is about to enter into its second century, with few issues resolved. What can be concluded is that image-making was known by the end of the third century BC, with the first images of the Buddha appearing by the first century BC. The sources of the figural style were primarily Indian, a combination of the ancient meditative, yogic ideal and the earlier *yaksha* figures seen at the Bharhut and Sanchi stupas. In the context of sectarian beliefs, the Sarvastivadin strongholds in the north-western, lower Himalayan areas of modern-day Pakistan and Kashmir may have been among the first regions to produce images of the Buddha. The reasons for the popularity of image-making are linked to the traditional Buddhist desire to earn merit. In this case, merit is accumulated by causing images to be created, not only for oneself but for ancestors and relatives as well. While mendicant, wandering monks and devout priests had little use for images, lay followers needed both initial guidance and continued visual reminders of the religion they followed. Therefore, it was this lay patronage that provided the impetus for most of the Buddhist art that was to follow.

In the absence of direct Hindu prototypes, this development can be viewed as the inevitable result of a process that began with Ashoka's columns, and was continued by the narrative reliefs, the *jataka* tales and events from the life of the Buddha portrayed on the gates of stupas, and finally the numerous male and female fertility images. The fertility figure became especially prominent during the Kushan period (late first century BC to late third century AD), sometimes portrayed as a life-sized attendant figure but most often carved on the

29 pillars of stupa gates and railings. The depth of carving, abundant forms and remarkable details of these images place them at the peak of early Indian sculptural achievement. They illustrate the practice widely followed in Indian art, by each of the major religions, of using such images as protectors and emblems of abundance, perhaps even as reminders of the mundane world. The most spectacular example of the early female figure, carved fully in the round, is the famous

28 chowrie-bearer (a type of fly-whisk) from Didarganj, near Pataliputra (modern Patna). This smoothly polished image, originally a side figure for a colossal triad, is the largest and among the finest of these female images, a lineage beginning at Bharhut and Sanchi. The *yakshi* image remained prominent throughout Indian art, but such sensuous

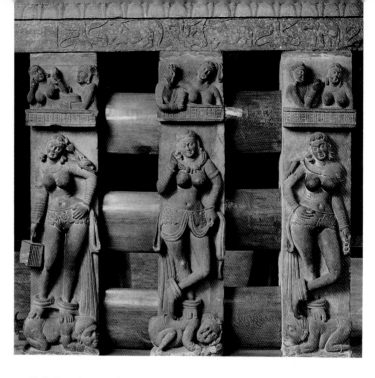

28 (*left*) Female attendant, *c*. 1st century, from Didarganj, India. Polished Chunar sandstone, h. 162 (63¾)

29 (*above*) Railing figures, *c*. 2nd century, from Bhuteshvara, Mathura, India. Red sandstone, h. 151 (59½)

forms, in this instance enhanced by the high polish given to the stone, for such voluptuous females seldom appear in Buddhist art unless under direct Indian influence. Equally powerful, although less consciously sensual, were the male *yakshas*. These monumental representations of abundance first appeared on pillars of early stupas and by the Kushan period were also carved as free-standing images, representing both individual deities and attendants. They provided the ideal for subsequent images in the Buddhist pantheon, including Buddhas and bodhisattvas.

With the growing schism in the religion, resulting in the development of the Mahayana schools, the need for additional images

26

43

increased and this process was aided by the political and cultural changes brought about by the mixture of peoples migrating into the area, most notably the Kushan peoples from Central Asia.

The Kushan kingdom was centred in two areas, one around Mathura, in north-central India near Agra, and the other in Gandhara. In the Mathura region there appeared sandstone images of the Buddha, similar in style to the attendant *yaksha* figures on the pillars at Bharhut and Sanchi. These images, with their broad shoulders and simplified forms, remained very much in the Indic tradition, capturing in stone the ideals of yogic control – viewed as containers of a 'vital breath' rather than mere visual replicas of the physical body. Such attributes of spiritual transcendence are described in the early scriptures and can still be seen among the holy men and devotees worshipping along river banks and at shrines across India today. The early literature specified particular attributes, called *lakshanas*, as reserved for images of the Buddha, such as the *ushnisha*, the protruberance on top of his head, or a torso shaped like the body of a lion. These thirty-two *lakshanas* were one visual method of separating portrayals of the Buddha from those of others. Despite the addition of a halo and nimbus and the fanciful details of many *lakshanas*, such as webbed fingers, early images of the Buddha retained their human dimension, blending the miraculous aspects of divinity with his mortal appearance. In fact, his divinity was further accentuated by what Dietrich Seckel, the eminent scholar of Buddhist art, has described as a negative fashion, by eliminating decorative embellishments, in contrast to the other numerous, richly adorned images in the Buddhist pantheon.

At the same period, in the north-western region of Gandhara, the area where Alexander the Great had ended his eastern march, there appeared a different stylistic version of the Buddha image. These Buddhas were a product of the aftermath of Alexander's campaigns, their provincial classical styles deriving from Roman colonies and from the commerce between West and East, which passed just to the north of the region, influencing cultural life from city building to coinage. Although Gandharan art remained outside the mainstream of Indian development, Gandhara's location at the foot of the Himalayan passes caused it to have a significant impact upon the development of Buddhist art in Central Asia and China.

Much attention has been given to these two contemporary, yet contrasting styles, the one so Indian, the other aptly described as provincial Roman. The contrast could hardly be greater, given the

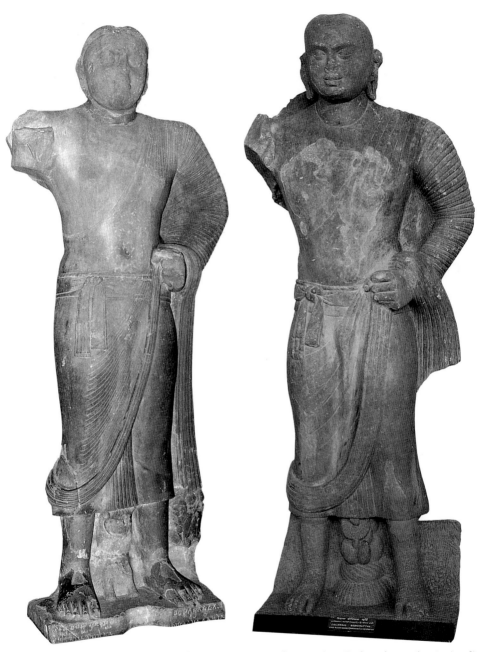

30 Buddha dedicated by Friar Bala, late 1st century, Mathura region. Red sandstone, h. 289 ($113\frac{3}{4}$)

31 Standing bodhisattva, *c.* 2nd–3rd century, Mathura. Red sandstone, over life-size

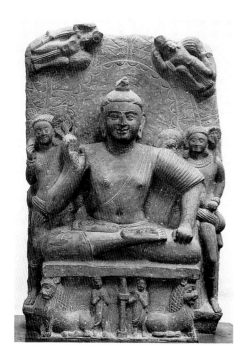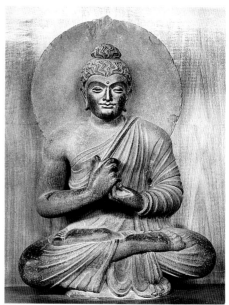

32 shared subject-matter. The Indian Buddha image portrays the traditional figure of the meditative yogin, transcendent in his mental powers yet very much a part of this world, with his earthy, massive form rendered in a rough, unpolished sandstone. At the same time he is surrounded by images of radiance and abundance, the sun disc and trees, and supported by lions, emblems of his royal position. While his placement atop a lion throne, and the presence of two attendants holding chowries, serve to emphasize his regal position, at the same time, his yogic posture, humble robe and gesture of reassurance embody the spiritual nature of his message. This image remained the primary source for subsequent figures of the Buddha throughout Asia, including the celestial Buddhas in their heavenly realms so far removed from earthly concerns. One of the consistencies of Buddhist art was the retention of this essentially humble image, even when it was surrounded by an array of figures and images of wealth and abundance, an effect that combined an earth-bound simplicity with the splendour of celestial rewards.

33 By contrast, the Gandharan Buddha, despite having many of the same attributes – the lion throne, yogic posture and radiant nimbus – remained a mixture of Roman styles. Its most striking characteristics

46

are the toga, an inappropriate garment for the climate of India, and the facial features, with a combination of realism about the mouth and cheeks but with deeply cut, stylized eyes. Without a Roman equivalent for the Buddha's *ushnisha*, the Gandharan artists could only arrange the hair into a variant consisting of wavy curls tied into a round topknot. The Roman love of portraiture and dramatic realism appeared in the form of images of the emaciated Buddha, a favourite subject of the region but one seldom found in Indian art. 34

Gandharan art continued throughout most of the first millennium – in Afghanistan at least until the end of the eighth century. The early reliance on stone gave way to the use of more easily manipulated stucco and terracotta, and the total production was enormous. The area had become a second holy land for Buddhists, visited by pilgrims from south and east Asia, enhanced by the belief that events from the Buddha's former lives had occurred there. The monasteries and Buddhist centres hidden away in pockets of the Himalayas often survived some of the destruction visited upon the establishments in the plains, while the nearby trade routes carried Gandharan styles into the northern areas of Asia.

32 (*far left*) Seated Buddha, early 2nd century, from Mathura. Red sandstone, h. 66 (26)

33 (*left*) Seated Buddha, *c.* 2nd–3rd century, Kushan period, from Loriyan Tangai, Gandhara, Pakistan. Schist, h. 68 (26¾)

34 Emaciated Buddha, *c.* 2nd–3rd century, Kushan period, from Gandhara. Schist, h. 85 (33½)

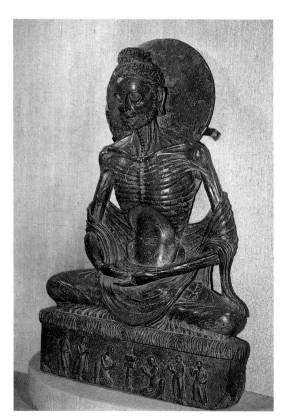

35 Many of the earliest images of the Buddha were accompanied by pairs of bodhisattvas (enlightened beings), most of whom later became the focus of their own cults. Their main features were their garments and adornments, since the bodhisattvas were depicted as symbols of wealth and affluence, in contrast to the simply dressed Buddha, the antithesis of material wealth. In addition, objects were often carried or worn to identify each bodhisattva. Thus, the future Buddha Maitreya displayed a stupa in his crown, while other attendant bodhisattvas, such as Vajrapani, held a thunderbolt, and Avalokiteshvara had a seated Buddha in his crown and held a lotus. Soon these figures appeared alone, as objects of worship: for example, Avalokiteshvara as the protector of travellers, saviour of souls and ultimately to

36 become identified with ruling dynasties. Maitreya assumed a special status, as individuals contemplated their future, hoping to be reborn in paradise.

37 Bodhisattvas play several key roles in Buddhist worship. They were viewed first as virtuous individuals, possessed of enormous amounts of accumulated merit, *karma*, only one step from Buddha-hood itself. In seeking the merit of a bodhisattva, not just for themselves but also for the salvation of others, believers were acting in

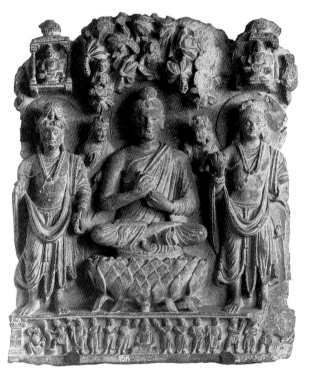

35 Preaching Buddha on lotus throne, 3rd–4th century, from Gandhara. Schist, h. 59 (23¼)

36 (*right*) Maitreya, 2nd century, from Ahicchattra, Uttar Pradesh, India. Red sandstone, h. 66 (26)

37 (*far right*) Bodhisattva, *c.* 2nd century, Kushan period, from Gandhara. Schist, h. 120 (47¼)

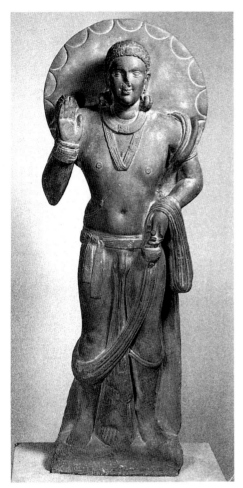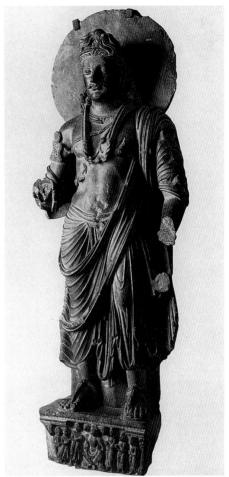

a generous manner, and so behaving like bodhisattvas. With this
emphasis on the ultimate goal of salvation and with the use of
bodhisattvas as both models and sources of additional merit, these
once secondary figures rapidly assumed major positions in the
pantheon, often becoming of greater importance than the historical
Buddha, who remained distant, less approachable than the materially
splendid figures of the bodhisattvas.

As the bodhisattva's role evolved and grew in importance, a
parallel change appeared in the portrayal of the Buddha. Mahayana
beliefs required an image beyond mere human dimensions, a

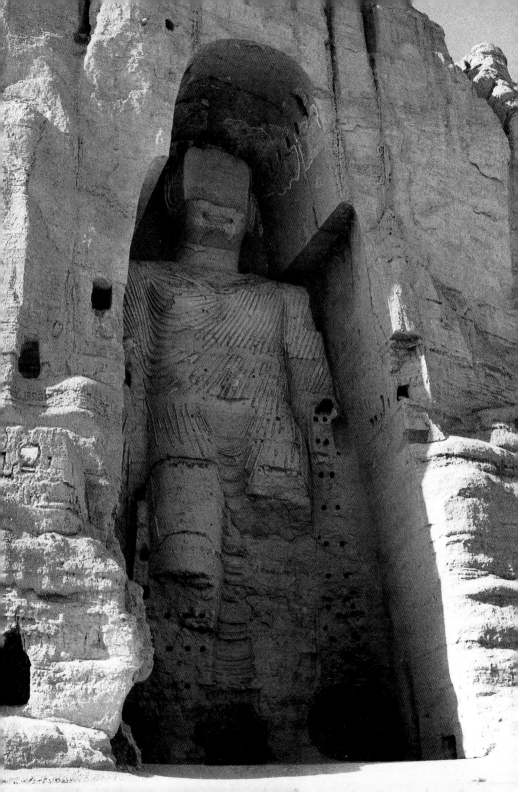

supramundane figure, seated atop Mt Meru and linked with the heavens, a truly celestial Buddha. Unlike in the Theravada countries of Burma, Sri Lanka and parts of South-East Asia, where the singular, historical Buddha continued its central role, the imagery of northern Buddhism came to emphasize cosmic Buddhas. Four occupy the heavens that surround the central deity, the ultimate Buddha Vairochana, embodiment of the totality of the universe. This change occurs early in the first millennium, with the appearance of colossal Buddhas in India, as at Kanheri, and is evident throughout northern 39
Buddhist countries from Afghanistan to Japan.

 The two colossal images from Afghanistan are the most spectacu- 38
lar, visible to approaching pilgrims from miles across the valley, the larger being 53 metres tall. Originally with their gilded figures and copper masks attached, they created an entirely different impression from that of a humble, meditative teacher. The sense of splendour was enhanced by the spectacular wall paintings that surrounded each as well as by the various grotto-shrines arranged behind the figure, also richly decorated. Now the Buddha had become an awesome, transcendent vision, both in size and splendour, reflecting the importance Mahayana Buddhism placed upon the heavenly realms

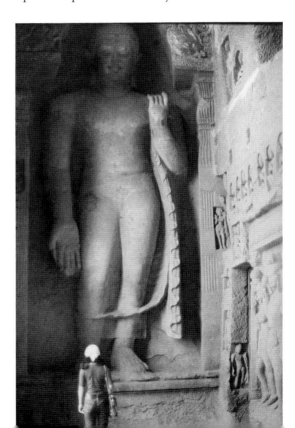

38 Colossal Buddha, 5th–6th
century, Bamiyan, Afghanistan

39 Colossal Buddha, *c.* 5th century,
verandah of Cave 3, Kanheri, India

and suggesting the richness of the rewards awaiting those who managed to be reborn in such a paradise.

Much of our knowledge of early architecture is second hand, coming from the buildings portrayed in reliefs, such as those at Bharhut and Sanchi. The most dramatic examples of early Buddhist architecture, however, still remain among the rock-cut sanctuaries of western India, most in an area south and east of Bombay. This building technique took advantage of a rising plateau of mountains that ended abruptly, creating steep walls of hard stone for several hundred miles along the western side of the subcontinent. The trade routes connecting the cities of India provided many of the specific locations, for Buddhism cultivated the support of travellers and caravans, a practice that would also lead to similar cave building along the trade routes of Central Asia. Typically, these cave sanctuaries were constructed near enough to trade routes to attract donations, yet sufficiently removed from urban centres to allow the pursuit of a semi-monastic life.

Despite their remarkable fidelity to the traditional wooden construction of early Buddhist buildings, these colossal excavations were the work of the sculptors and engineers rather than of architects. The earliest, from around 100 BC, at Kondivte and Bhaja, were on a far greater scale than their modest predecessors, Ashoka's caves in Bihar province. Not only did the cave facades include carved columns and railings in close imitation of wooden models but, inside, the commitment to wood was extended beyond copying to include actual wooden inserts. Those wooden timbers can still be seen, their fragments visible after two thousand years, laboriously inserted between the carved stone ribs of the ceiling, in a type of enhanced trompe-l'oeil effect, emulating wooden construction. In accordance with their monastic origins, cave excavations corresponded to each of the main types of Buddhist buildings. The greatest number of caves were monks' residence halls (*viharas*), complete with individual cells surrounding an open area for group instruction, and the less frequent but larger *chaityas*, communal places of worship. The interior of *chaitya* halls, such as Karle, consisted of a rounded, closed end or apse, imitation barrel-vaulted ceiling and flanking rows of pillars. Although other structures were added to house additional images or for the specialized occupations necessary to sustain the daily life of the

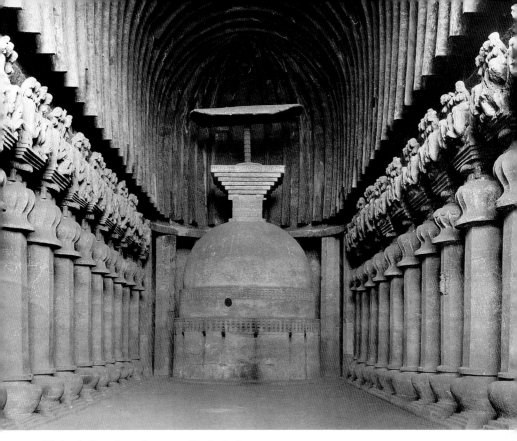

40 *Chaitya* hall, early 2nd century, Karle, India

institution, these two buildings remained essential for a Buddhist
establishment. The third primary structure, the stupa, was moved
inside the *chaitya* hall, to the rear, with adequate space around it for
ritual circumambulation. Stupas in the earliest caves, such as 9 and 10
at Ajanta, were similar to those at Sanchi and Bharhut: simple,
monolithic shapes without images. By Gupta times (fourth to seventh
century), however, the shift to the more transcendent Buddha image
resulted in the lower half of the stupa being given over to this celestial
figure, merging the two formerly separate conceptions, the Buddha
and the stupa, into one unified vision.

Architecture from the Gandharan region seldom included rock-cut
temples and differed in style from that of the rest of the Kushan
kingdom. The blending of Western classical motifs with a number of

3

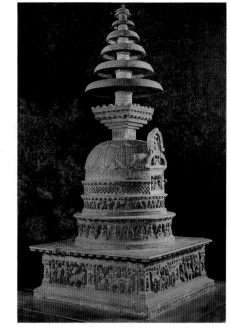

41 Stupa, *c.* 2nd century, Kushan period, from Loriyan Tangai, Gandhara. Schist, h. 145 (57$\frac{1}{8}$)

41 regional elements created a distinctive style, well illustrated in the Gandharan stupa. Unlike the early bell-shaped mounds of Sanchi or the later, more elaborate synthesis of image and stupa, Gandharan examples emphasized architectural details. They consisted of a series of round and square sections, faced with shallow, arched niches and rows of classical pilasters with Corinthian capitals, topped with a strongly vertical tower of umbrellas. Excavated monasteries, such as Takht-i-bahi near Peshawar, reveal this mixture of styles that formed a regional architectural programme, one widely dispersed throughout the western Himalayan region and into Central Asia. Buddhist temples and Hindu shrines of the eighth to tenth centuries in Kashmir continued this formula, extending the life of Gandharan architectural styles on the subcontinent.

THE GUPTA AGE (4th–7th century)

The Gupta dynasty, like its Kushan and Mauryan predecessors, was established in northern India. Beginning in 320, it lasted into the seventh century and remains the best-known period of Indian art, forming the standard of comparison between India and the rest of

54

Asia. For Buddhism, however, the Gupta period signalled the beginning of its decline within India: its monastic establishments were attacked by marauding tribes but primarily the ever more powerful, dynastically supported Hinduism steadily assimilated the Buddhist faith. The Mahayana emphasis upon salvation by faith had actually served to bring Buddhism closer to Hindu practice and the fewer differences between the two religious systems aided the eventual absorption of Buddhism by the larger Hinduism. By the end of the Gupta period, most Buddhist growth and development was taking place outside the borders of India, in nearby areas such as Nepal and Sri Lanka and, with increasing vigour, in East and South-East Asia. By the end of the first millennium, except at a few sites such as in the western Himalayas or at Nalanda in the north-east, Buddhism's once vital role in the Indian subcontinent had ended.

The most famous Gupta image is the late-fifth-century Buddha, in 42 the teaching gesture, from Sarnath. We are confronted with a figure of great spiritual bearing, far removed from the earlier, heavy, *yaksha*-derived images. Now attention is directed to the meaning of the faith, instead of to the person of the Buddha. His form is highly abstracted, extraneous details are eliminated and our attention is drawn to the

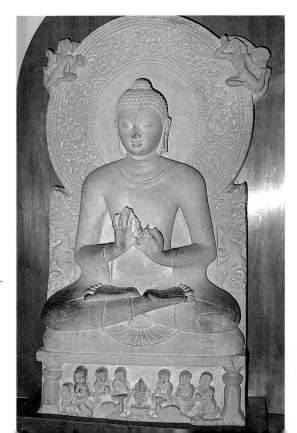

42 Preaching Buddha, *c.* 475, Gupta period, from Sarnath. Buff sandstone, h. 160 (63)

focused gaze and to the face and hands, areas surrounded by smooth, unadorned surfaces. These combine to convey a meaning extending beyond the episode of the First Sermon, and on to the transcendent dimensions of Mahayana Buddhism. The transcendent effect equals that found in the colossal images at Kanheri and Bamiyan, but without recourse to overpowering size. Clearly, by the fifth century, the evolution from an earthbound Shakyamuni to the ethereal, highly spiritualized figures of Mahayana Buddhism is complete.

Just as Bharhut and Sanchi provided the most complete picture of early Buddhist art, one site most fully displays the Gupta idiom. Ajanta, a horseshoe-shaped cliff of twenty-nine caves, was occupied twice, initially in the first century BC and again in the fifth and sixth centuries AD. Its rediscovery early in the nineteenth century and its continuing restoration and preservation in the late twentieth have drawn attention to one of the grandest displays of Buddhist art in Asia.

The caves contain the two primary types of buildings, the *vihara* and the *chaitya*. During the initial occupation, perhaps as early as the Bharhut stupa, around 100 BC, the caves in the centre were excavated, including the two early *chaityas*, Caves 9 and 10. The remaining caves belong to the late fifth and the early sixth century, during the period of the Vakatakas, one of the competing dynasties contemporary with the Guptas, which actively supported rock-cut building. According to Walter Spink, the leading expert on Ajanta, despite their size and complexity, the length of time required for completion of this later group of caves was quite brief, perhaps fifty to sixty years, with work completed by the end of the fifth century. Whatever the time frame, the total artistic achievement must rank with some of the most remarkable in the world's art.

The most complex remains at Ajanta are the *chaitya* halls, dominated by large, inflected arched openings and projecting porches (originally protected by additional wooden structures) with their elaborate, exterior screen-walls crowded with Buddhas and bodhi-sattvas, the irregular sizes and placement of the figures being the result of donations over the course of time. The architectural details typically follow wooden forms, including fluted pillars and the large *chaitya* windows. The latter are also found at Bharhut and elsewhere, even in Japan, as small, decorative motifs. The fidelity to wooden forms is even more complete inside the *chaitya*, with a continuous row of free-standing columns, capitals and a decorative cornice, as well as a ceiling of imitation wooden ribs.

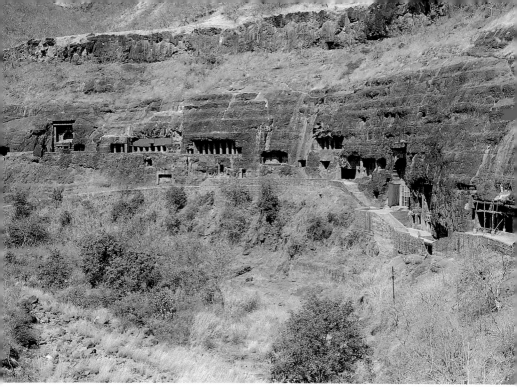

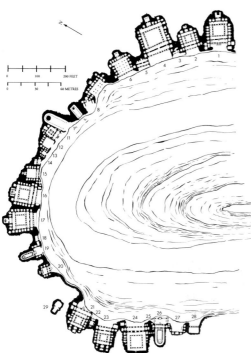

43 View of Ajanta, 1st century BC and 5th century AD, India

44 Plan of Ajanta's caves (numbered according to sequence, not chronology)

57

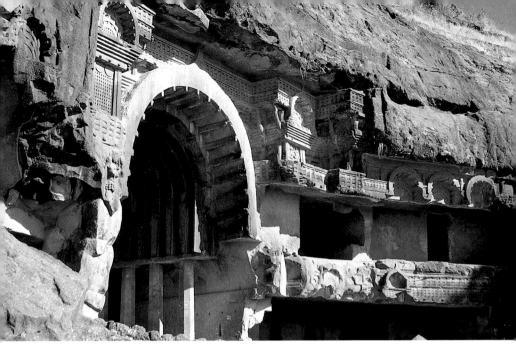

The stupa continued to be the focal point of the worship hall, and
was now embellished and extended with carvings and additional
motifs in keeping with the increased complexities of Mahayana
46 worship. The body of the stupa, the *anda*, is moved upwards and the
base extended to accommodate a large image of the Buddha. The
figure is placed between richly carved pillars and surrounded by
subordinate figures and elaborate, decorative motifs, typical of Gupta
taste. The pillar and umbrellas at the top (*chhatraveli*) also gain in
complexity, assuming greater prominence, nearly doubling the
stupa's height in Cave 19. The once simple, earthbound stupa has
evolved into a complex of images and symbols, not only attached to
the earth but also extended vertically. The older emphasis upon the
historical, earthly Buddha is giving way to the celestial, mystical
realms of esoteric belief.

The majority of Ajanta's caves are traditional *viharas*, a combi-
nation of residence and lecture hall, but they were also modified to
conform with changes in Mahayana doctrine. They now included
images in recessed niches at the rear, extensive wall paintings of *jataka*
tales and ceilings painted as symbols of heavenly realms. With this
increased imagery, the residence hall now embodied much of the

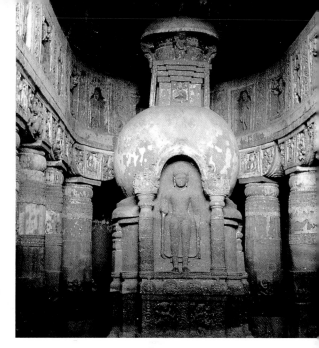

45 *Chaitya* entrance, 1st century BC, Bhaja, India

46 *Chaitya*, late 5th century, Cave 19, Ajanta

broad Mahayana vision by surrounding devotees with reminders of past deeds of the Buddha, images of the growing pantheon and visions of paradise (as well as reminders of the temptations of this mundane world, perhaps to explain the numerous sensuous female figures scattered throughout the various scenes). Except for their pillared entrances, the reliance upon wooden models, so evident with the *chaitya* halls, is less apparent here. Exploiting the *viharas'* broad walls, artists produced the earliest known Indian paintings, whose extent and quality make them the finest examples of Buddhist painting.

The earliest paintings date to the first century BC, and, like the reliefs at Bharhut and despite their poor state of preservation, indicate an early sophistication in narrative presentation and pictorial style and an interest in psychological states. The majority of Ajanta's paintings (in Caves 1, 2 and 17) are of the late fifth and early sixth century but are remarkably well preserved. They feature *jataka* tales, individual 47 bodhisattvas, *yakshis* and numerous decorative motifs, which are especially elaborate on the ceilings. The imaginative colours and freedom of expression used in depicting floral and animal forms, as well as the arbitrary spatial treatment, give these 1500-year-old murals a decidedly modern flavour. Unlike the pictorial scenes at

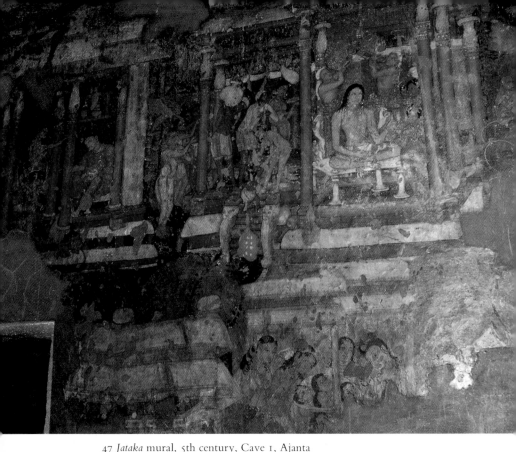

47 *Jataka* mural, 5th century, Cave I, Ajanta

48 Worship of the Buddha, 5th century, painted on a pillar, Cave 10, Ajanta

Sanchi, which are organized and divided by railings and fences, the murals at Ajanta flow into one another, forming an endless kaleidoscope of colour and motion, and so are closer in spirit and movement to the reliefs at Amaravati. Although the *jataka* tales predominate, it is the larger, individual figures that attract the eye with their fine line-work and bold, flat colours, and the entire complex bursts with colour and exuberance. The advanced pictorial devices and aesthetic sophistication of Ajanta's painting remain a largely isolated phenomenon, however, for only fragments of other Indian mural paintings remain. The Ajanta legacy occurs outside India among the frescoes of Central Asia and the Far East.

48

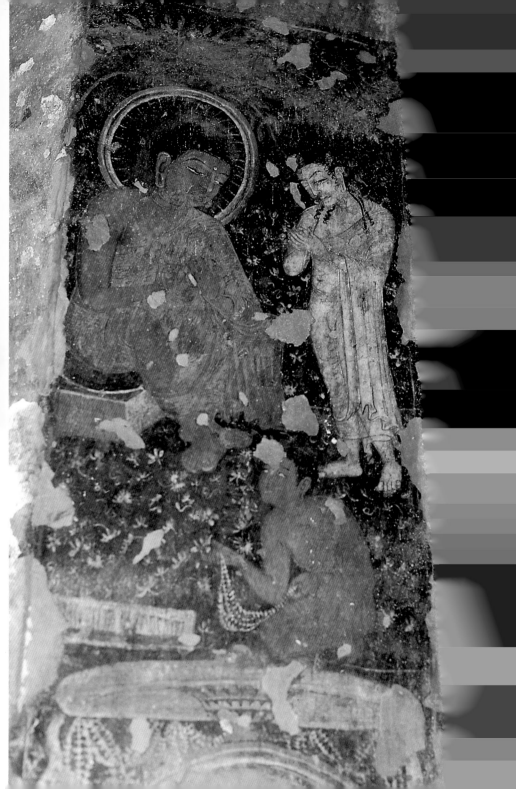

THE MEDIEVAL PERIOD (after the 6th century)

The incursions of the White Huns, related to the infamous Attila who ravaged the West, hastened the seventh-century collapse of the Gupta dynasty, and northern India again slipped back into regional kingdoms, the subcontinent's unfortunate but traditional political pattern. Hinduism remained dominant, with continued royal patronage, while the already weakened Buddhism was soon inhibited further by Islamic incursions, and its influence relegated to a few areas, such as the Pala kingdom in Bihar, Nagapattinam in the Tamil area or secluded and protected Himalayan regions. The reports of the Chinese testify to the size and importance of the remaining monastic centres, notably in Kashmir and Nalanda in the north-east, as well as the pilgrimage sites, such as Bodh Gaya, which had always been important sources of Buddhist learning and whose artistic styles remained influential outside India.

Although its religious influence was diminishing, medieval Buddhist art continued the technical brilliance of earlier centuries, especially in its bronzes, and even the later medieval images, although no longer the product of major religious centres but of smaller, isolated enclaves, continued the graceful forms of the Gupta tradition. A complex, inlaid bronze altarpiece from Sirpur remains one of the finest examples of medieval Indian art. Its richly decorated architectural elements and patterned clothing recall the splendours of medieval courts, while the hierarchy of deities illustrates the growing influence of esoteric schools. Along the top is the transcendental Buddha Amitabha, flanked by the bodhisattva Vajrapani, holding the thunderbolt, and Avalokiteshvara with a lotus in his left hand. Instead of a Buddha being the primary figure, however, a female deity occupies the central lotus throne. She has usually been identified as Tara but may actually be Chunda, a goddess of wisdom, who holds the citron fruit instead of the lotus associated with Tara (probably the figure to the left, holding a lotus). Typical of Buddhist images is the figure of the donor at the bottom, in a prayerful pose.

Hinduism dominated the architecture of medieval India, although the great stupas of the north-east, at Nalanda and Paharpur, with their rows of niches filled with stucco and terracotta statues and their mandala forms and multiple gates and terraces resembling the Borobudur in Java, directly inspired centuries of building throughout Burma and South-East Asia. Their images became the primary source for subsequent styles in greater India, especially in Burma, Indonesia,

49 Altarpiece, c. 800, from Sirpur, India. Silver and copper inlaid bronze, h. 38.1 (15)

50 Lokeshvara, 8th
century, Pala period,
from Nalanda, India.
Sandstone, h. *c.* 120 (47¼)

Nepal and Tibet. Although the more slender form of an eighth-
50 century, life-sized figure from the north-eastern region follows the
Gupta idiom, it primarily reflects the style of the Pala dynasty, patrons
of the finest Buddhist art during the medieval period.

Medieval Buddhist art was dominated by the later phase of the
Mahayana, known as Vajrayana, which formed part of the broader
Tantric movement that gave the art of the medieval period much of
its distinct character. Due to the esoteric, secretive nature of Tantrism,
with its mysterious incantations, rituals and enigmatic language, most
of the art is complex and other-worldly. The shift in emphasis from an
earthly teacher to the image of a heavenly, highly abstract and
omnipotent deity had been the prelude for the changes occurring in
the art of the medieval period.

51 These differences can readily be seen in an inlaid brass image from
the Kashmir region, portraying the cosmic Buddha Vairochana. At
the centre is a Buddha image, surrounded by familiar symbols such as
the stupa, complete with free-standing 'Ashokan' pillars, lotus, deer
and wheel, all displayed with great richness and elaboration.
Vairochana wears a tri-lobed, tasselled cape, an elaborate crown and

64

jewels with details accentuated by silver inlay. The universal role of Vairochana is emphasized by the 'all-seeing' eye painted on each stupa, a motif also well known in Nepal, and by the giant lotus stalk emerging from the great ocean between two *naga* kings. The bottom third is clearly the earthly realm, consisting of stylized rocks that shelter protective deities and the traditional Wheel of the Law and two deer, symbols of the First Sermon in the Deer Park. Donor figures are shown in adoration at either end. In addition to the traditional cosmological references, there are elaborate details and numerical divisions, such as the five points of the crown (five levels of knowledge) and the three levels of the statue (the three levels of existence), making this complex sculpture also a comprehensive representation of medieval Buddhist thought. It also remains one of the finest examples of medieval casting: delicate surfaces, intricate details and silver inlay are all carefully contained between the solid horizontal form of the base and the pair of slender stupas. The entire composition is linked together by the tendrils and stalk of the large central lotus. The pictorial richness of Ajanta's murals is continued in

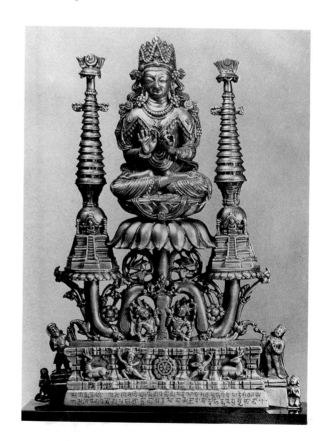

51 Crowned Buddha, *c.* 9th century, from Kashmir. Silver and copper inlaid brass, h. 31 (12¼)

this tour-de-force of metal craft, an example of the finest technical skill in the service of a grand religious vision.

THE EXTENSION OF BUDDHIST ART: Sri Lanka, Nepal, Tibet

At about the time Buddhism was declining in India, it was developing elsewhere. This process was well under way by the end of the Gupta period and involved both major branches, the Theravada and the Mahayana with its related esoteric systems. In East Asian cultures, civil unrest and dynastic patronage played major roles in the initial acceptance of the faith. In the nearby areas of Sri Lanka, Nepal and Tibet, all culturally similar to the Indian model and in the early stages of development, Buddhism was able to evolve from within – in fact to help shape the emerging culture, rather than providing an alternative during times of civil and political strife. In almost all cases, however, political support from the rulers was essential in establishing the faith, in advance of popular support which developed more gradually.

Sri Lanka

Sri Lanka has remained a Buddhist enclave for more than two thousand years. Local legends tell of Shakyamuni's three visits to the island, the king's conversion by Ashoka's son and the celebrated bodhi tree at Anuradhapura, the ancient capital, believed to have originated from a cutting delivered during one of those visits. In fact, Sri Lankan Buddhism is best understood through such a living link with the Buddha, for the greatest veneration is reserved for relics, often literal objects of worship, such as the Buddha's tooth, still kept in its shrine in Kandy, rather than for the subjects and abstractions of Buddhist art. In the case of the bodhi tree, the primary symbol of the Enlightenment, represented by a tree in early Indian art, Sri Lankan Buddhism preferred to maintain a living association with the event that had taken place beneath it, paying the greatest veneration to the descendant of the original tree. To the usual group of monastic buildings, Sri Lankan Buddhists added a special shrine, dedicated to the bodhi tree, called a *bodhi-ghara*. This consisted of a shrine erected around the sacred tree, open to the sky at the centre and surrounded by four seated images of the Buddha. However, instead of making the usual gesture of enlightenment (*bhumisparshamudra*), these images are shown in the gesture of meditation (*dhyanamudra*), with both hands resting in the lap. Thus, in this Theravada stronghold, the abstraction has been replaced by an actual tree, with the Buddha images

portrayed in poses of meditation: calm, inward-turning and serene, in keeping with the Theravada emphasis upon the solitary, individual path to enlightenment.

Throughout its history, several schools of Buddhism enjoyed the support of Sri Lankan kings, and the earliest Buddhist scriptures known are written in its Pali language. Early in the second millennium the various sectarian differences were resolved, resulting in the primacy of the Theravada. By the time of the shift of the capital to Polonnaruwa, at the end of the first millennium, with Buddhism all but eliminated in India, the Singhalese enjoyed a religious renewal, including a surge of active propagation into South-East Asia, which established Sri Lanka as the major centre of Theravada belief, especially for the Burmese and the Thai.

The most distinctive Sri Lankan monument was the stupa and the best-known example is at Anuradhapura. Despite the greater 52 proportion of space given to the hemispherical body (*anda*) and to the large *harmika*, the basic shape and details of this monumental stupa follow the famous examples at Sanchi and Amaravati. According to some, the enlargement of the traditional spire, which seems as much like the graceful towers of medieval Hindu temples as the columns and umbrellas atop early Indian stupas, is due to an effort by Singhalese builders to join two symbols, the pillar of the world and the heights of Mt Meru. Despite its numerous rebuildings, the Anuradhapura stupa retains much of its original shape. Similar proportions, the dominant bell-shaped *andas*, prominent *harmikas* and tapered spires are retained in later stupas in Burma, Thailand and Cambodia. 53

Another important difference between the Sri Lankan and Indian stupa was the system of decoration. Indian stupas are notable for their abundance of relief carving, while the Sri Lankan version is conspicuous by its absence, for neither elaborate *toranas* nor carved railings are part of the design. The smooth, hemispherical body appears to hug the earth, the entire structure being set atop low platforms without a surrounding fence. Instead of the latter, small shrines or relic chambers were often attached directly to the *anda* at the cardinal points, while similar, free-standing pillared shrines or relic halls were also placed away from the structure, at the outer edge of the square base, especially at the main entrance to the east. Without the surrounding fence, the exposed, squat, bell-shaped *anda* appears to press directly into the earth. The large, square *harmika* arrests this downward thrust and the spire again reverses the direction with a

52, 53 The traditional form of the Sri Lankan stupa at Anuradhapura (rebuilt several times) was followed for a small votive stupa of the 12th–13th century in the Preah Khan, Angkor, Cambodia

powerful, vertical push into the heavens. The total effect is one of simplicity and strength, inspiring in its clarity and directness rather than through the complex images and details of some Indian models. Theravada Buddhism, with its more limited pantheon and emphasis upon direct action, unlike the salvationist beliefs and spectacular heavens of the Mahayana, is perfectly served by the clean, uncomplicated forms and geometric harmonies of the Sri Lankan stupa.

Sri Lankan builders also constructed pillared halls, open to the sky, following the formula of the first bodhi-tree shrine at Anuradhapura. Remains from the second capital at Polonnaruwa indicate extensive reliance upon this hypostyle form of construction, marked by circular rows of pillars around a stupa. Another favourite architectural motif, and vehicle for some of the finest Sri Lankan relief carving, was the moonstone. These semi-circular stones were placed at the foot of the 54 steps leading into a variety of buildings. The subjects portrayed were arranged in concentric circles and consisted of repeated images of animals, including cows, elephants, lions and geese, and vine scrolls, lotus petals and fanciful flowers and leaves. The exquisite carving and attention to detail on these humble thresholds are among the most elegant of relief carvings. Perhaps the limited subject-matter within the Theravada tradition caused creative artists to seek new vehicles of

54 Moonstone (detail), *c.* 5th century, Anuradhapura, Sri Lanka. Granulite

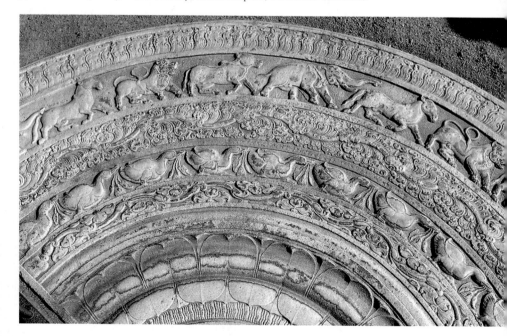

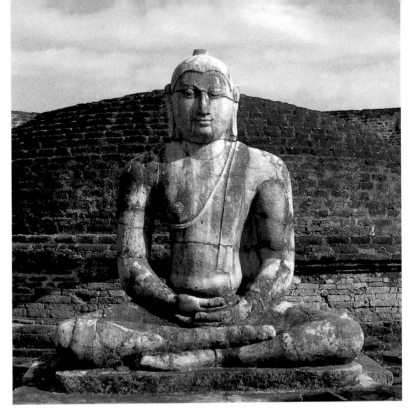

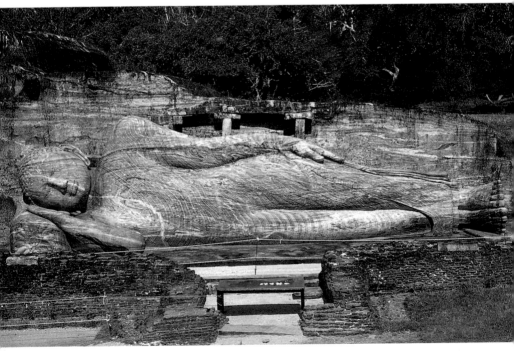

expression, resulting in superb decorative achievements in such unlikely places.

The primary image remained that of the Buddha, with little change over the centuries. Even the later works, such as the well preserved, twelfth-century group at Gal Vihara, continue to reveal their Gupta and Amaravati sources. The Sri Lankan artists' ability to capture the sense of meditative serenity, of focused energy, has seldom been exceeded, and the utter simplicity of these images parallels the simple clarity of the great Singhalese stupas in capturing a direct, uncomplicated route towards the Buddhist truth. 55 56

Nepal

Nepal is a fairly large region, bordered by the Himalayan mountains, yet its artistic achievements are almost entirely confined within the Kathmandu valley, and to the three city-states of Patan, Bhaktapur and Kathmandu. Its culture derived from India, although the native population is mainly of Mongoloid stock, with origins similar to those of the Tibetans, who also migrated from the north and whose early civilization also derived from India. As in the legendary traditions of other Indian-dominated cultures, such as those of Sri Lanka and Kashmir, the introduction of Buddhism was attributed to Ashoka in the third century BC. Buddhism enjoyed its greatest success between the eighth and thirteenth centuries, as it did in Sri Lanka and South-East Asia; thereafter Hinduism became ascendant in Nepal.

In many ways, Nepal is a smaller version of the vast Indian realm. Hindu and Buddhist worship coexisted, with few sectarian distinctions among the populace and with the same general stylistic characteristics applying to both. Esoteric Buddhism was especially widespread, resulting in the portrayal of both benign and angry forms of the same deity, with multiple heads and arms and numerous attributes, such as the lotus and the weapons appropriate to a being with a cosmic nature and the ability to repel evil.

The design of the stupa remained faithful to early Indian models, with a large hemispherical dome, often punctuated by small chapels, similar to those in Sri Lanka, surmounted by either a series of thirteen steps or a like number of diminishing circles, symbols of the thirteen heavens. The most distinctive and startling Nepalese addition is the face painted on each side of the *harmika*. The eyes are partly closed, as if following the pilgrim circumambulating the monument. This face may also represent the eyes of the four protective *lokapalas*, residing inside, or perhaps the 'all-seeing' gaze of the omnipotent Buddha 57

55 Seated Buddha, 12th century, Polonnaruwa, Sri Lanka

56 Colossal *Parinirvana*, 12th century, Gal Vihara, Sri Lanka

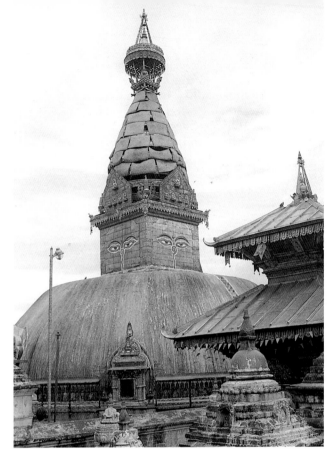

57 Swayambanath stupa,
Kathmandu, Nepal.
Originally *c.* 5th century,
it has been rebuilt several
times

51 as found on the pair of stupas on the ninth-century crowned Buddha
from Kashmir.

While the haunting eyes remain something of an enigma, they are
of minor importance in architectural terms. The major achievement
of the Nepalese is their brick and wood construction, including
57 extended wooden eaves, similar to those of the East Asian pagoda.
The popularity of these designs, long associated with Far Eastern
cultures, is widespread in Nepal, among Hindus and Buddhists,
leading some to claim an Indian origin for the pagoda form of
wooden construction. Like their Chinese counterparts, Nepalese
buildings were often raised upon stone and brick plinths, and had tile
roofs, but instead of the Chinese systems of bracketing the Nepalese
favoured brightly painted and carved wooden struts to support the
overhanging eaves.

72

Nepalese architecture is noted for its rich and varied ornamentation, especially the wooden windows and supporting struts, massive brass tympana and various mythical, gilt–metal door guardians. The most impressive element, however, is the wall treatment. The elaborate, carved wooden door surround and window frames are not 58
simply set into the brick walls but extend beyond their functional role, into the wall itself, transforming the flat surface into a system of patterns and textures and providing additional areas for carving and decoration. This complex joining of carved wood and fired brick, the one integrated into the other, is unique in the world's architectural vocabulary.

Buddhist sculpture in Nepal embraced the full range of deities, with a repertoire extending from traditional images, such as the Buddha's birth, to the complex schemes demanded by esoteric 59
practices, including some of the finest images of the goddess who gradually assumed an increasingly prominent role with the growth of Tantrism. The primary female deities were the goddesses Prajnaparamita, representing wisdom, and Tara, the female counterpart of the bodhisattva Avalokiteshvara. Tara's attributes closely matched those of Avalokiteshvara, as did her function as protector from dangers, such as fire, thieves and dangerous animals. The most popular female deity in Nepal was Vasudhara, goddess of abundance. She is the 60

58 Peacock window, detail of wood and brick wall construction, from a palace in Bhaktapur, Nepal

59 (*left*) Birth of the Buddha, *c.* 10th century, Nepal. Black limestone, h. 83.5 (33)

60 (*right*) Vasudhara, 16th century, from Nepal. Bronze, h. 19 (7½)

Buddhist counterpart of the Hindu goddess Lakshmi, and her attributes point to her dual role as a goddess of farmers, indicated by her sheaf of grain, and her appeal to merchants, indicated by her bundle of jewels. Her importance to those in commerce and trading activity was typical of Buddhism, for the merchant class remained a constant source of patronage.

The greatest artistic losses in south Asia have been in painting, for, with the exception of the fifth-century Ajanta murals, little else of significance remains from before about AD 1000. Among the earliest, as well as the smallest, paintings are the illuminated manuscripts, and Nepalese works are among the most varied and finest examples of this distinctive art form. Nepalese manuscripts were made from pressed palm leaves, cut into long narrow strips, generally about 5 centimetres high and 35 centimetres long, both sides of which were written on and decorated, and which were tied together with cords into books. Some of the finest paintings appear on the wooden covers, which were without text and completely filled with illustrations. Without the

61, 62

74

61, 62 Detail and three leaves of an illuminated manuscript (of the *Gandhavyuha* text), 12th century, from Nepal. Ink and colours on palm leaf, each 5.1 × 55.2 (2 × 21¾)

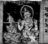

76

need for scripture, the covers continued the episodic, narrative tradition first noted at Bharhut, featuring themes such as scenes of the life of the Buddha.

Most illustrations, due to their small size, are of individual figures, with limited settings, featuring such elements as thrones, trees, rocks and animals. Yet many still retain the colourful, dynamic forms of the large-scale painting seen at Ajanta. Often the diminutive figures possess a monumentality that suggests that they could be effectively enlarged and readily conform to the epic scale of a wall painting. Figures were clearly outlined against flat backgrounds, usually red or blue, then rendered with a fluency that recalls the sensuous sculptural forms of the early *yakshi* images at Sanchi. Since manuscript paintings seldom relate to the adjacent text, individual panels stand alone as complete compositions, at once forcing the artist to compose immediately recognizable scenes as well as permitting creative latitude in such details as decorative borders and the variety of plant forms surrounding the primary subjects.

These miniature Buddhist paintings properly belong to a larger tradition, appearing in differing versions throughout most of Buddhist Asia, and often labelled as 'art of the book'. They owe their unusual format to the use of the palm leaf, yet their widespread importance and the conservative nature of religious art ensured the retention of the palm leaf shape even in cultures using paper, such as China and Tibet.

Tibet

Buddhism arrived late in Tibet, in comparison with most of the rest of Asia: it was not present before the seventh century and did not become firmly established for another three centuries. Once in place, however, Buddhism flourished, integrated within the culture to such a degree that to the outside world Tibet and Buddhism are synonymous.

Tibet remained independent into the mid-twentieth century, when it came fully under Chinese rule. However, Chinese influence appeared early, at least by the end of the Yuan dynasty in the thirteenth century, and became ever more noticeable in the arts from the Ming dynasty in the early fifteenth century onwards, from which time the term Sino-Tibetan art is more apt than simply Tibetan. A graceful and delicate bodhisattva figure reflects the composite nature of much of Tibetan art by that time. The pose and hand gestures are similar to those of Nepalese images, while the heavy casting, gilding

61

22

63

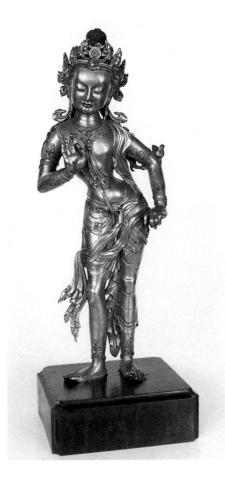

63 Sino-Tibetan bodhisattva, 15th-16th century, from Tibet. Cast copper gilt, h. 45.8 (18)

64 Wheel of the Law, 18th century, from Tibet. Silver, h. 51.5 (20¼)

and attention to the details of dress and decoration suggest Chinese influence.

Tibetan Buddhism is a unique form of the religion, known as Lamaism, after the Tibetan name for a monk; resulting in part from extremely harsh natural conditions and also from the continued influence of early shamanistic practices, it produced the most varied and complex pantheon in the Buddhist world. This combination
68 often resulted in brutal imagery and powerful colours with fierce deities transformed into protectors of the Buddhist faith, making them no longer such frightening images to the believer.

The quintessential example of Tibetan religious art is the ritual
64 object, including sophisticated, decorative works, such as magical

78

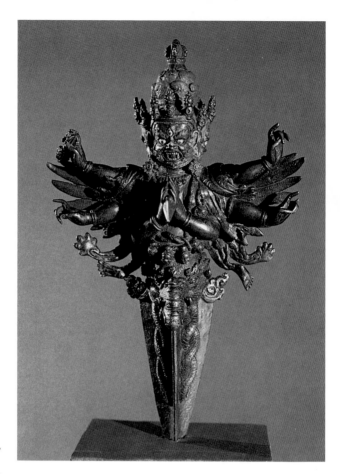

65 *Purbhu* (magical dagger),
16th–17th century, from
Tibet. Polychromed bronze,
h. 30.5 (12)

daggers and jewelled altar implements of great richness. Such objects 65
were brought directly into daily ritual and included such unorthodox
items as intricately carved human bones made into small plaques, and
then linked together to form a lama's apron, or tops of human skulls
made into ceremonial drums. With their combination of raw ferocity
and technically skilled casting, such implements are as impressive in a
museum display case as during the candle-lit ceremonies in which
they were employed.

Tibetan painting, with its variety of techniques and subjects,
executed on items that ranged in size from tiny manuscripts to
colossal, 20-metre-high wall hangings, represents the best-known 66
Tibetan art form and, as a whole, may be the most varied and creative

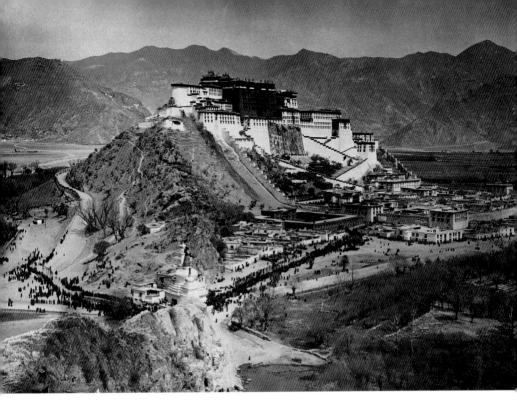

medium of expression in the world's religious art. The walls of monasteries were covered with colourful murals and from the rafters hung cloth *thankas*, painted with opaque distemper, similar to watercolours, but so vivid that they rival oil painting in their intensity. Portions of wall paintings, such as an image of the goddess Tara, continued the style and format established by illuminated manuscripts, a pan–Asian art form of enormous ritual and aesthetic importance. To the occupant, the walls of these monastaries are unrelenting in their visual assault, with no relief from their forms, colours and geometric patterns. The works of art produced by so-called primitive cultures, such as the Oceanic, or the tent-yurts of Central Asian nomads, whose inside walls were covered with intense, multi-coloured carpets, serve to remind the modern eye of the visual power of shaman customs. Nowhere is the transition from the secular to the religious world more dramatically illustrated than in the passage from the bleak, wind-blown Himalayan landscape to the vivid colours and images within the Tibetan monastery. In the

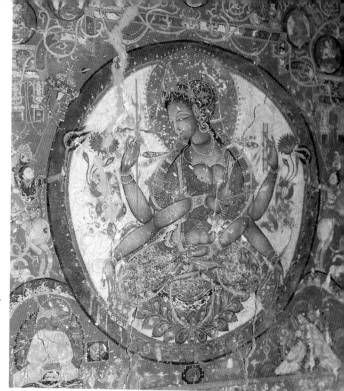

66 (*left*) The Potala palace, Lhasa, Tibet. Note the large *thankas* hanging on the palace walls

67 The goddess Tara, detail from a mural, *c*. 12th century, from Alchi, Ladakh

68 Tibetan saddle cover, on which the protective goddess Lhamo would ride. Its imagery is suitably fierce: the flayed skin of her son on the 'sea of blood', bordered by skulls. 18th or 19th century. Cotton with silk appliqué, gilded leather and painted details, length 150 (59)

Buddhist world this was the antithesis of the Japanese Zen temple, with its understated, nearly monochromatic, gardens that fronted the even more austere meditation halls.

The subject-matter of Tibetan painting is vast, including historical figures, portraits of lamas, individual deities of the esoteric pantheon, ferocious protectors, and mystics, and depictions of the historical Buddha Shakyamuni and events from his past lives. These diverse subjects are joined by a myriad of supporting figures, set within elaborate palaces, decorative scrolls and floral motifs, or surrounded by rich landscapes with colourful foliage and fantastic rock formations.

70 No subject in Tibetan art has drawn more attention than the mandala. These works have an appeal beyond their original liturgical role: to psychologists they are universal images that reflect fundamental human instincts, while, for many, they attract through their blend of order and harmony and their multiple levels of mystery, as well as their expression of a range of profound emotional and intellectual meanings. The word mandala derives from the words for essence and container, and so is akin to the definition of a stupa, as a container of religious essence. Mandalas functioned as an aid to meditation but were also commissioned, in typical Buddhist fashion, as a prayer for the welfare of others. Mandalas also represented the cosmos, in a diagram that gave order to the vast universe, including the central element as the 'world mountain', where the aspirant is to find his or her own place and realize reintegration with the vast powers of nature and the gods.

The most important deity was Avalokiteshvara, patron of Tibet and, since the fifteenth century, linked to the Dalai Lamas, who are held to be his reincarnations. In keeping with the complexities of 71 Tibetan imagery, the eleven-headed, six-armed Avalokiteshvara can be noted as of particular importance. This version is rarely found in India but was widely represented in Central and especially East Asia. The brilliance of Tibetan art is captured in what initially appears complex, yet is founded upon the most basic of Buddhist themes, the calm, meditative figure. As one moves from the rich details of the flying banners and flaming aureole, the multiple heads of Avalokiteshvara and the various attributes in his hands, what emerges are the traditional, familiar elements – a figure in yogic control, atop a lotus pedestal, supported by a lion throne. The ensemble remains balanced by rhythmical patterns that begin with a solid foundation and move upwards within a triangular form, softened by the curving aureole. It

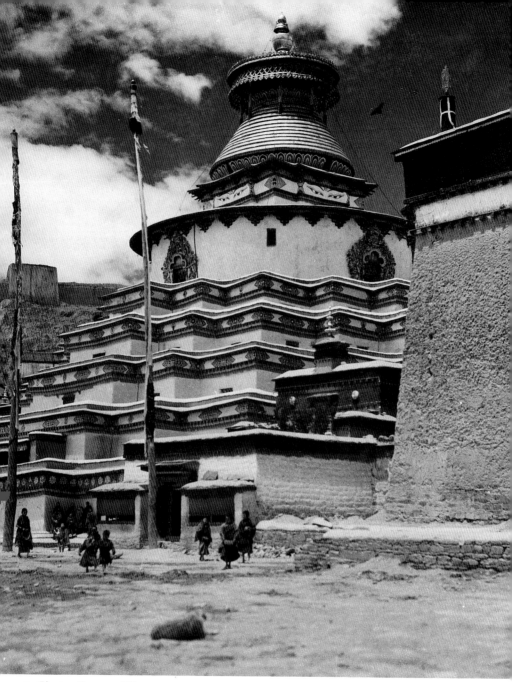

69 *Chorten*, Gyantse, Tibet

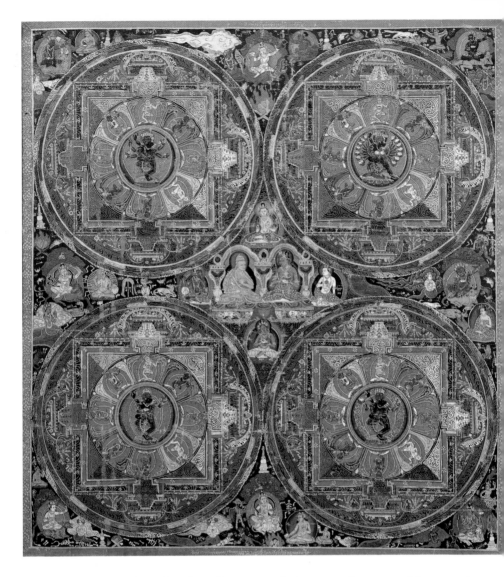

71 is completed by the tall stupa, with the sun and moon emblems, at the top.

The most purely Buddhist element in Tibetan architecture is the *chorten*, the Tibetan version of the stupa. These structures served as tiny reliquaries and were also built on a larger scale, to be 69 circumambulated in worship. In some cases, such as at Gyantse, they

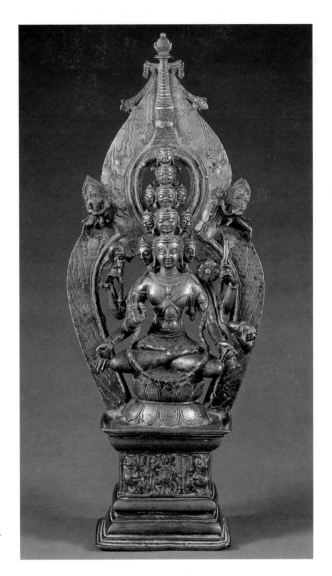

70 *Hevajra* mandala, 15th–16th
century, from Tibet. Gouache
on cotton, h. 52 (20½)

71 Eleven-headed Avalokitesh-
vara, *c.* 11th century, from
Ladakh. Brass, h. 39.3 (15½)

included functional interior chapels and areas for wall paintings.
Unlike in India, where stupas assumed regional characteristics,
Tibetan *chortens* were remarkably consistent in form. Evidence of
Nepalese influence is noted in the spire of circular rings; and,
occasionally, the haunting eyes of the Nepalese stupa are also added to
the *harmikas*.

CHAPTER TWO

China

THE ROLE OF CENTRAL ASIA

Central Asia, the vast area of small kingdoms and caravan routes between India and China, played a major role in the development of Chinese Buddhism, for nearly all the early Buddhist scriptures were translated in Central Asia. The art itself was eclectic, including such diverse traditions as those of India, especially Gandhara, the Parthian styles and Sassanian Iran, as well as of China, to the east. Remarkable achievements, especially in painting, reveal an impressive pattern of continuity and level of skill over this vast area. In addition, due to the periodic destruction of Buddhist institutions across China, the remains in Central Asia have assumed an ever greater importance in the broad understanding of Buddhist art, at times providing evidence for destroyed Chinese art or, in the case of the Miran wall paintings, examples of Gandharan painting. The faces of the monks from Miran match those of Gandharan sculptures and provide a rare glimpse of how Gandharan painting must have looked. Likewise, some elements of East Asian Buddhist art originated in Central Asia. An example of the Central Asian role can be seen in the portable wooden shrine, which drew many of its stylistic features from Gandharan sources, yet the distinctive armour of the four guardians, brandishing their weapons, originated in Central Asia, and these martial figures were to assume prominent roles in East Asian Buddhism. Its mandala-like arrangement, particularly with the eight bodhisattvas surrounding the central Buddha, was a theme that began in India and was continued in Central Asia, remaining popular in Korea and Japan.

Despite centuries of commercial activity along the Silk Road, bringing Chinese goods to the Roman Empire and causing numerous cities and small independent states to flourish, knowledge of the artistic heritage of this vast area remained largely unknown until the early twentieth century. The publication of the seventh-century Chinese Buddhist pilgrim Xuanzang's compelling account of adventures in the region and the expeditions and acquisitions of explorers

72

33, 35

73

110

119

86

72 Buddha and monks, *c.* 3rd century, mural from Miran, Central Asia

73 Triptych shrine, showing an eight-bodhisattva mandala, *c.* 8th-9th century, from Central Asia. Sandalwood with traces of colour, 31.7 × 35.6 ($12\frac{1}{4}$ × 14)

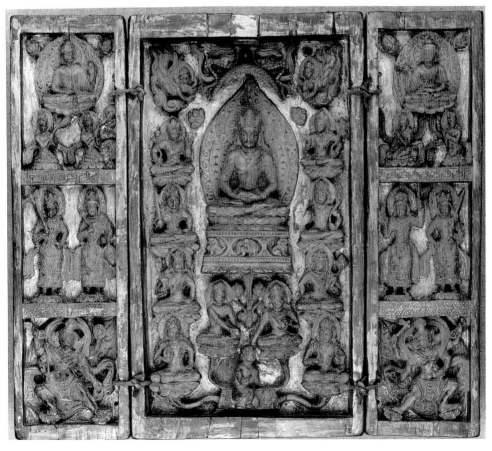

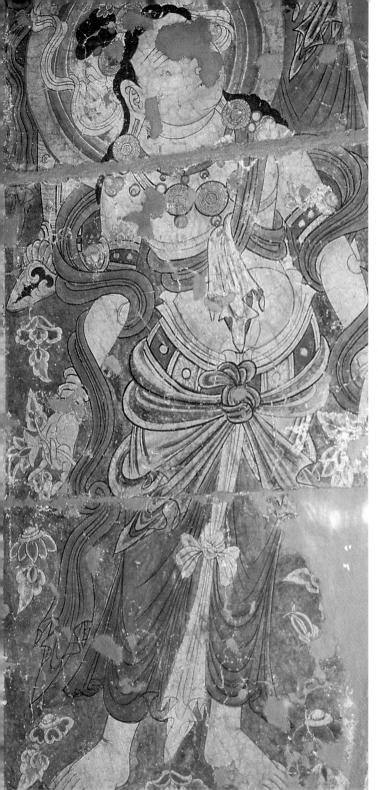

74 Bodhisattva, detail from a mural, 8th-9th century, from Bezeklik, Central Asia

75 General view of Bezeklik

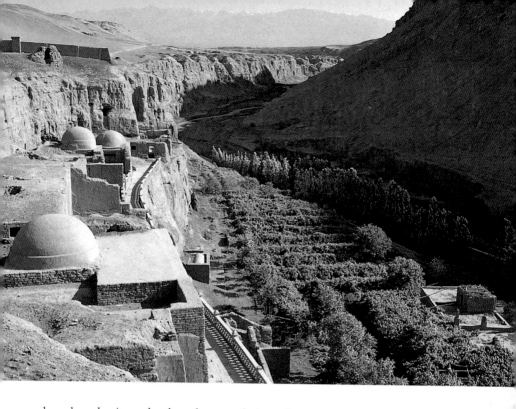

and archaeologists, the best-known being the Englishman Aurel
Stein, revealed a thousand-year subculture of remarkable achieve-
ments, with artistic remains of surprising range and quality. Most of
this material was created, from one end of Central Asia to the other
and, whether under the various Western, Indian or Chinese
influences, in the thousands of caves cut into cliff faces. Unlike the 75
stone at Ajanta, with its elaborate carved facades and intricate
architectural details, the fragile sandstone of the Central Asian deserts
prevented direct, detailed stone carving. For their sculpture, the artists
built up forms with crude wooden armatures, covering them with
layers of clay, to which colours were added after drying in the arid
climate. Despite the fragility of this technique, the process remained
in use across northern China and in Japanese temples. Although the
soft sandstone hindered carving, it did not limit painting. Central
Asian artists achieved their greatest success in the colourful murals 74
spread across the walls and ceilings of countless grottoes along the
caravan routes around the Tarim Basin, mostly along the northern
sector. These were executed in an Indo-Iranian style at Kucha and in

89

76 Deer *jataka*, detail from a mural, 4th-6th century, Dunhuang, China

Chinese styles near Turfan, with the greatest display at the eastern
terminus, at Dunhuang.

Only fragments of Central Asian art have survived in one of
nature's most hostile environments, and little of this material can be
assigned to the formative period, the early centuries of Chinese
Buddhist art. With few exceptions, most Central Asian wall paintings
and clay statues belong to the second half of the first millennium and
the majority are reflections of the styles of the Chinese heartland,
especially those of the expansive Tang dynasty (AD 618–907), when
Central Asia came under more direct Chinese influence.

THE FORMATIVE PERIOD (4th–6th century)

From its introduction, around the beginning of the Christian era,
Chinese Buddhism depended upon accommodation and adjustment
to survive within an established Confucian system that favoured
practical, secular paternalistic values, as well as the magical tendencies
of popular Daoism. In an interesting process, aptly described as one of
grafting on or convergence, Chinese Buddhists emphasized the
similarities between these doctrines. For example, the Mahayana
belief in the need to accumulate merit was equated with the Chinese
love of ancestor worship, and Daoist eremitic tendencies were likened
to Buddhist monasticism. Buddhism's emphasis upon *karma* and the
accumulation of merit, with its theme of accountability, suggesting
that one could shape or affect one's own destiny, had a direct appeal to

the business ethic of the merchant classes, providing a connection with an important segment of Chinese culture. The growth of Buddhist esoteric schools benefited from parallels with traditional Daoist sorcery and magic.

The process of adjustment and adaptation is illustrated in the story of Shakyamuni and Prabhutaratna, a legend often illustrated in Chinese art. Its popularity derived mainly from its compatibility with both the Confucian veneration for the past and with the Daoist love of magical events. According to a Chinese text, the *Lotus Sutra*, the historical Buddha Shakyamuni wished to prove his eternal existence and called upon a Buddha from aeons past, Prabhutaratna, to move through time and return to this existence, to engage in discussions of the philosophical subtleties of the faith. The previous Buddha arrived inside a stupa, accompanied by a host of garland-bearing, celestial deities who dispensed gold and jewels while heavenly musicians serenaded the assembly. Shakyamuni entered the stupa and the two Buddhas then engaged in the traditional Chinese custom of discussion. The entire event suggested that Buddhist customs were little different from those of the Chinese: both placed the highest value upon connections with the past and upon reasoned discourse as the path to knowledge. The numerous images of this event consisted of little more than two seated figures facing one another or of the two 79, 85 figures inside a stupa. The popularity of this particular episode also led to the creation of a unique variant of the pagoda, known in Japanese versions as the *tahoto*, which corresponds to the Sanskrit word 80 *prabhutaratna*. With the dome of a stupa emerging from the first-floor roof, the *tahoto* retains the meaning and symbolism of the traditional stupa yet adheres to the form of the East Asian pagoda.

The early growth of Buddhism was further aided by civil unrest across China, beginning with the collapse of the Han dynasty in the third century. By the sixth century, the Wei empire of northern China had some thirty thousand monasteries while Buddhist art had moved beyond the introductory phase and assumed a distinct Chinese character.

The earliest images suggest Gandharan sources. A Buddha figure, 77 with its moustache, topknot, toga, flaming shoulders and lion throne, could even have been made in Gandhara and carried to China. When compared with the earliest dated image of the Buddha, the well-known seated Shakyamuni in the Brundage Collection in San 78 Francisco, the Chinese tendencies are immediately clear. Despite its Gandharan-style hair and robe, this youthful figure, with its hands

held horizontally instead of flat in the lap, reveals Chinese characteristics, noticeable in the face and, most importantly, in the two-dimensional treatment of the whole. The traditional Chinese preference for two-dimensional art forms has often been noted and among these early images the flatness of the body and dominance of linearity is unmistakable. Two centuries would pass before the emergence of fully three-dimensional Buddhist sculpture, more akin to the Indian styles. In later times, with the decline of influence from India and the diminished role of Buddhism within China, artists would typically return to such traditional linear tendencies.

81, 82
83, 84
The formative phase of Buddhist art is well represented in two groups of cave shrines in the north, at Yungang in Shanxi province and at Longmen, near the city of Luoyang. The images at the former site are examples of the first Buddhist art styles, while the sixth-century figures that followed at Longmen indicate stylistic changes, to a more purely Chinese manner. The major works at Yungang were created in a short time and were contemporary with the major phase at Ajanta, from around 460 until the capital moved to Luoyang in 494. They consisted of over fifty caves, of which some twenty are important for their inscriptions and statuary. The five oldest caves

77 Seated Buddha, *c.* 4th-5th century, from China. Gilt bronze, h. 32.8 (12$\frac{7}{8}$)

78 The Brundage seated Shakyamuni, 338, from China. Gilt bronze, h. 39.4 (15$\frac{1}{2}$)

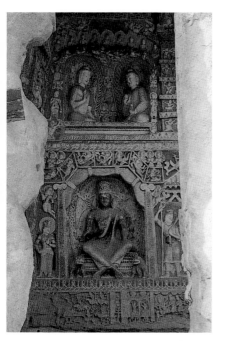
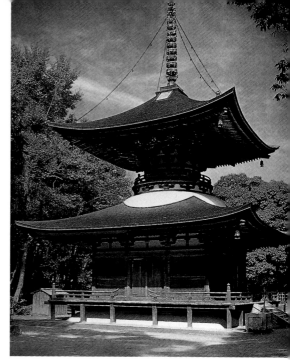

79, 80 Shakyamuni and Prabhutaratna depicted with Maitreya below them, late 5th century, in the Yungang caves, China, and symbolized in the *tahoto* pagoda of 1194 at Ishiyamadera, Japan

each featured a colossal image, the largest nearly 18 metres tall, and all dedicated by Tuoba Wei rulers. The giant figure, nearly 14 metres high, from Cave 20, was once protected by a multi-storey wooden facade (as were the contemporary cave-shrines at Ajanta), a replica of early Chinese architecture, including traditional bracketing and tiled roofs. Except for later rebuildings at a few caves, all that remains of the wooden facades are their stone pillar bases. However, replicas of the early architecture can be seen among the colourful reliefs inside several of the caves. 81

82

The squared faces and bodies of the figures in Cave 20, and their linear drapery folds, indicated by little more than incisions and raised lines, suggest that the artists may have worked from drawings or sketches carried back by pilgrims from holy sites in India, especially in the north-western Gandharan regions. The pupils drilled into the eyes are a later addition. The paired bodhisattvas and flaming mandorla with multiple Buddhas emphasize the Mahayana vision of the Buddha as a transcendent, supramundane figure, a subject well suited

to the spaciousness of cave shrines. Yungang serves to indicate the rapidity of Buddhism's growth, for these caves were not only contemporary with Ajanta but predate most of the rock carvings of Central Asia, including the fifth- to sixth-century colossi at Bamiyan in Afghanistan.

In 494, the Wei rulers who had patronized Yungang shifted their capital south to Luoyang and began another programme of cave shrines at nearby Longmen. This spectacular setting, with hard stone cliffs descending steeply on both sides of the Yi river, corresponded more to Indian sites, such as Ajanta, than to the sandy cliffs of Central Asia. With hard stone available, Chinese artists created large-scale images and detailed relief carvings, in the thoroughly sinicized style that was found throughout East Asia. Details of heads and arms are more rounded than those at Yungang, while, at the same time, loose-fitting robes assume a life of their own, rhythmic and patterned, in a system of surface decoration repeated in the elaborate mandorlas and opulent ceilings. The same qualities are found in the numerous early-sixth-century gilt bronze images that reveal the particular Chinese genius for combining a linear, calligraphic surface decoration with sculptural form, in the elegant drapery of the figures and the elaborate flame nimbus that surrounds them. The flowing garments and scarves portrayed in the reliefs of the Guyang cave are remarkably similar to paintings of the time, indicating the compelling attraction of linear form for the Chinese artists.

84

83
86

85

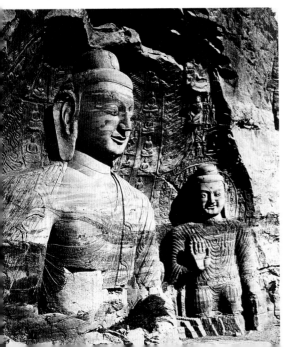

81 Colossal Buddha with attendant Buddha, late 5th century, Cave 20, Yungang, China

82 Temple roof-bracketing, late 5th century, detail of the wall, Cave 9, Yungang

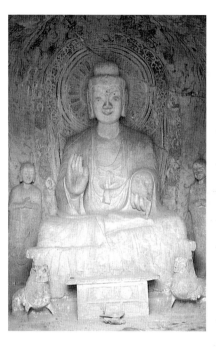

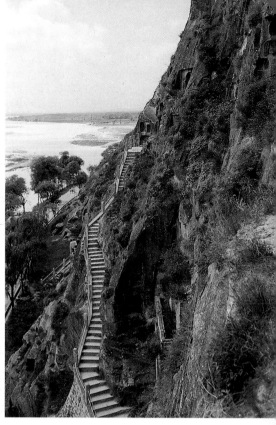

83, 84 The Longmen caves, China, with Cave 3, 'Binyang cave', early 6th century

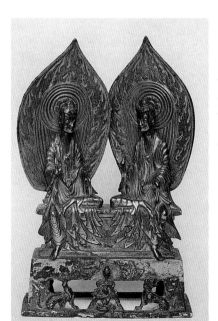

85 (*left*) Shakyamuni and Prabhutaratna, 518, from China. Gilt bronze, h. 26 (10¼)

86 (*above*) Guyang cave relief, *c.* 500, Longmen

The Chinese pagoda

Instead of being filled by enormous images, the centre of many of the
Yungang caves was occupied by a single square tower, cut from the
cliff to form a square pagoda. Except as regards their solid core and the
space for circumambulation, these multi-tiered towers show little
resemblance to their ancestor, the Indian stupa. Their several storeys
consist of a series of figures within niches or, in some examples such as
at Dunhuang, of a single large figural group filling each side. The
short, overhanging eaves were carved in imitation of roof tiles and the
spire, the single pillar symbolizing the 'world mountain', disappears
into the ceiling of the cave.

Although the Chinese pagoda (the word was coined by the
Portuguese in India) derived from the Indian Buddhist stupa, its shape
has little in common with the range of stupas found throughout south
Asia. In areas linked more closely to India, such as Sri Lanka and
Nepal, regional variations did occur but the basic components
remained. In the north-western regions of Gandhara the upper spire
was extended, reducing the proportion of the bell-shaped main body
to less than half. In addition, the form changed from a circle to a
square, and the pedestal grew into a multi-layered base, incorporating
rows of niches for images. Just as many early Chinese images derived
from Gandhara, the development of the Chinese pagoda was also
influenced by this particular design. However, the vertical, rectilinear
shape and use of overhanging tiled eaves can be more directly

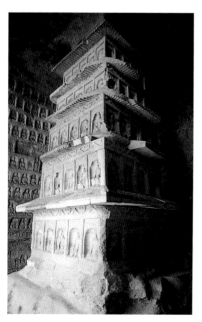

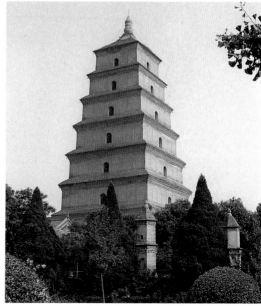

attributed to earlier Chinese wooden architecture. There is ample evidence of such styles of construction in the watch-towers dating from at least as early as the Han dynasty (206 BC–AD 220).

The Chinese erected pagodas in a variety of shapes and of wood, stone and brick – the latter materials being used in imitation of wood – but variations of the square, multi-tiered type seen at Yungang continued to be the favoured design. This form can be seen near Xian at the well-preserved early eighth-century Great Goose Pagoda, part 88 of Xuanzang's home monastery of Zuensi. From a distance, the pagoda's receding storeys present an image of clarity and even rhythm, in stark contrast to the complex bracketing and coloured tiles of temple structures. Its multiple levels, accessible by interior stairs, followed the early Tang custom of surmounting a square, functional base with a series of narrow storeys, usually seven but sometimes as many as fifteen, divided by shallow eaves that accentuated the gently curving tower. Although larger, overhanging eaves were possible only in wood, the masonry construction does result in a gain in

87–90 Variations on the pagoda: in the centre of Cave 39, Yungang, late 5th century; the brick Great Goose Pagoda, *c*. 700, Tang dynasty, near Xian; a stone pagoda, 8th century, Unified Silla period, Kyongju, Korea; the wooden pagoda of the Horyuji, late 7th century, in Japan

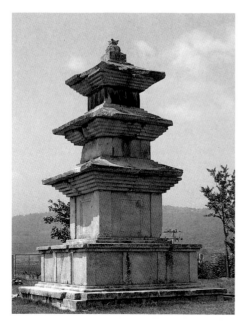
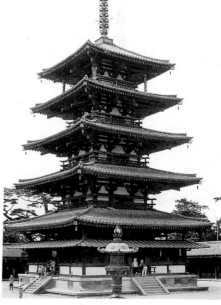

simplicity, as the scholar Alexander Soper has observed, leading to a massive directness and clarity of surface, with shallow pilasters dividing each wall, akin to Italian Renaissance taste. By the Tang period, the Chinese pagoda bore little resemblance to the Indian model. In fact, a quite different monument emerged, inspired by its wooden models, with elaborate doors and paired guardians, a functional interior and images conforming to cosmological schemes. Like the Great Goose Pagoda, many assumed something of the appearance of Indian Buddhist temples, such as the famous shrine at Bodh Gaya, which was the goal of pilgrims and probably contributed to this particular Chinese style. A survey of East Asian pagodas reveals a preference for a particular material in each culture, which in turn affected the design. The Chinese preferred this basic shape and brick construction with elaborate surface details that emulate wood. The Koreans favoured stone, while the Japanese, with their abundant supply of timber (and relative lack of granite), constructed pagodas of wood.

89
90

A monastic plan was established by the Chinese (followed by the Koreans and Japanese as well) along a straight axis, with the pagoda directly behind the inner gate and immediately in front of the image hall, and the assembly hall at the rear. This continuous row of buildings gave the pagoda and its sacred relics a prominent place, as the first building encountered upon entering the central courtyard. During the Sui and early Tang periods (AD 581–907), however, the more affluent temples began to alter this plan, adding a second pagoda and placing the pair outside the central enclosure, in front and to either side of what was now the primary building, the image hall. This duplication and shift away from the primary axis reduced the pagoda's importance, while the image hall was elevated to the dominant position. It meant a victory for Chinese secularism, for the design of the image hall, aligning the images frontally across the platform, was based on that of the imperial throne hall. These architectural changes might be seen as a case of art preceding life, with the pagoda's dimished role foreshadowing later social changes whereby the secular realm, under a revived neo–Confucianism, resumed its dominant role in Chinese culture. After the Tang period, although many temples did return to the single-pagoda plan, the pagoda continued to be relegated to one side and did not resume its former importance, while the dominant Chan and Amitabha sects placed less emphasis upon the veneration of relics or mystical rituals, further diminishing the pagoda's role.

By the middle of the sixth century, both Buddhist art and ritual practices had been well assimilated into Chinese culture. The end of the formative period for Buddhism generally coincided with the return of central political control, in 589, after nearly four centuries of civil war, and with the beginning of one of China's greatest cultural epochs. Imagery of the mid-sixth century, defined as a transition period by many, reflected both local sectarian developments and stylistic influences from India. The earlier dominance of linear patterns began to give way to an interest in three-dimensional structure, closer to the Indian sculptural aesthetic. This growing interest in form over decorative rhythms began to emerge in the sculpture of the Northern Qi dynasty (550–77), as the primary subjects now stood out in deeper relief, rounded and tall, with the subsidiary figures, the decorative scrolls, dragons and mountains, pushed aside or gathered at the top of the stele. Individual figures were no longer hidden beneath cascading drapery or lost in crowded scenes, with Amitabha and his entourage now emerging from amidst

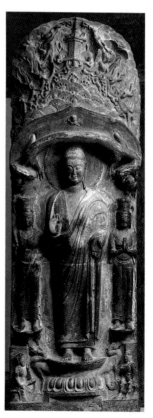

91 Stele, 569, Northern Qi dynasty, from China. Polychromed limestone, h. 232.6 (91½)

a host of celestial figures and the surrounding palaces and foliage, with each major figure visible within the complex setting. The new awareness of sculptural form results in greater simplicity for the 93 primary subjects, despite the often complex settings, a process that distinguishes this transitional phase of Buddhist art and leads to the more fully sculptural shapes of the Tang dynasty that follows.

One major theme, shared among most schools, involved a belief in 92 the Western Paradise of Amitabha. The Indian cosmology divided the universe into sectors with particular deities assigned to each. The southern region, surrounded by oceans and by mountains, with Mt Meru rising in their centre, was the domain of the gods and of humankind. In Chinese Buddhism, influenced by the importance assigned to the western regions by the Daoists, the focus of devotion shifted to that sector. Countless versions of this paradisiacal land were painted, even carved, upon walls of temples and cave shrines, especially during the Tang period. These scenes included an array of supporting figures, such as bodhisattvas, protectors and monks, occupying richly adorned palaces, while the skies above are filled with flying deities who carry banners and scatter jewels upon those below. The imagery related to this concept emphasized three major figures. The first was Amitabha, the ruler of the paradise, while the other two were bodhisattvas, with clearly distinguished roles. Avalokiteshvara, or Guanyin in Chinese, in addition to having many duties associated with saving those in distress, functioned as the intermediary, escorting the soul of the believer into Amitabha's Pure Land. The bodhisattva Maitreya, the Buddha of the future, in his heaven awaiting his eventual appearance in this world, also shared in the popularity of the Western Paradise concept, as believers prayed directly to him, reflecting their concern for the future.

Most of the art and ritual was inspired by three schools of 94 Buddhism. Some popular subjects, such as the preaching Amitabha, flanked by bodhisattvas, monks and guardians, or Amitabha presiding over the Western Paradise, were common to many sects, while 95 others, such as monk portraits, were particularly favoured by certain schools. A few subjects were limited by particular sectarian needs, such as the mandalas of esoteric schools or the Chan subjects designed to provoke original thinking. It remains difficult to attribute each work to a particular sect or a specific sutra, but some awareness of the beliefs of the major schools of Chinese Buddhism is helpful in understanding the wide range of art that falls under the umbrella of Buddhist art.

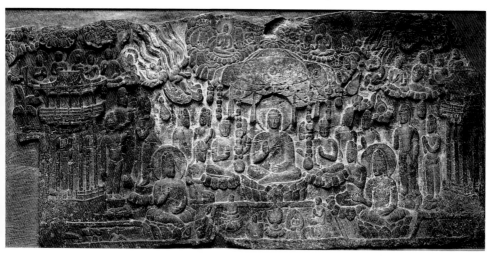

92 Paradise of Amitabha relief, 6th century, Northern Qi dynasty, from China. Stone, h. 40 (15¾)

93 Vairochana, c. 675, Fengxian-si cave, Longmen

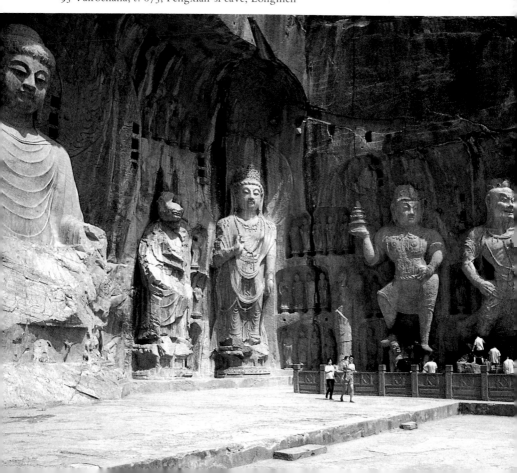

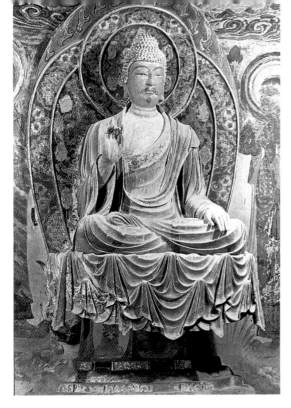

94 Preaching Buddha (detail), early 8th century, Cave 328, Dunhuang. Clay

By the sixth century, the most important influence upon Buddhist art was essentially a Chinese creation, the Tiantai, a comprehensive doctrine that preached a belief in the Buddha-potential within all beings. Hui-si, the sixth-century founder of the Tiantai, moved south to a mountain retreat near Ningbo and formed a monastic sanctuary, which became a place of pilgrimage, a typical sequence for East Asian Buddhist sects. The Tiantai school derived its doctrine from the *Saddharma-pundarika* or *Lotus Sutra*, not the first sutra to be translated but the most important for the development of Far Eastern Buddhist art. The *Lotus Sutra* emphasized faith, advocating a firm devotion that exceeded good deeds or personal sacrifice as the primary means to salvation, and also allowed women among the elect, contributing to its growth in popularity. The goal was not the vague *nirvana* of the older, Theravada schools but the splendid, materialistic wealth associated with the Western Paradise of Amitabha, and the florid descriptions of this paradise portrayed a heaven of riches beyond any mortal's imagination. The details and colours in a well-preserved

painting, carried back from Dunhuang by Aurel Stein, give some 97
sense of the once spectacular wall paintings and hangings that adorned
the grandest of China's temples. The preaching Buddha, either
Shakyamuni or Amitabha, is surrounded by four bodhisattvas and six
monks, with a female donor in the lower left of the picture, but only
the hat remaining from her missing male counterpart to the right. The
rich colours and fine brushwork of the canopy and delicately rendered
flowers frame the bright crimson robe of the central figure, like the
others, given dimensional form through the use of arbitrary shading.

Another splendid set of such paradise scenes was located in Japan,
inside the primary image hall at Horyuji, outside Nara. Unfortuna-
tely, only photographs remain, for these masterpieces were accidently
burned during restoration work in 1949. They were probably created
by Chinese artists, using the finest of Tang characterization and
brushwork. In each of the four major compositions, devoted to one of
the primary heavens of the Mahayana pantheon, the artists displayed a
special skill in illustrating a range of expressions from the supramun-
dane to the human. This can be seen by comparing the central, seated
figure of Maitreya, large and transcendent in bearing and gesture, 96
with the two standing bodhisattvas, semi-divine in their jewelled
finery, and finally with the two monks to either side, just behind the

95 Meditating monk, c. 900, from Cave 17,
Dunhuang. Ink on paper, h. 46 (18⅛)

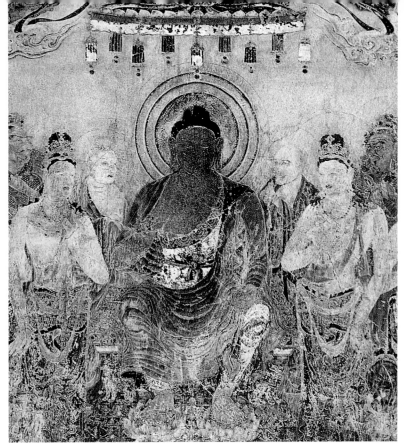

96 Preaching Maitreya, early 8th century, mural destroyed by fire in 1949, Horyuji *kondo*, Nara, Japan

central image. These two are all too human, emotionally expressive and filled with devotion, in poses appropriate to their mortal level of existence.

96 Flanking the group are two guardians, among the most interesting deities in the Buddhist pantheon; they are typically dark-skinned, for they were viewed as foreigners, from India or Central Asia. Their importance had increased during the Tang dynasty, especially as uncertainty and unrest continued, for people turned to the protection that they represented. They were often represented as a group of twelve but became best known as the guardians of the cardinal directions, the *lokapalas*, part of the entourage of Mt Meru. They gradually emerged from their role as a supporting group and assumed

97 Buddha preaching the Law, early 8th century, from Cave 17, Dunhuang. Ink and colours on silk, h. 139 (54¾)

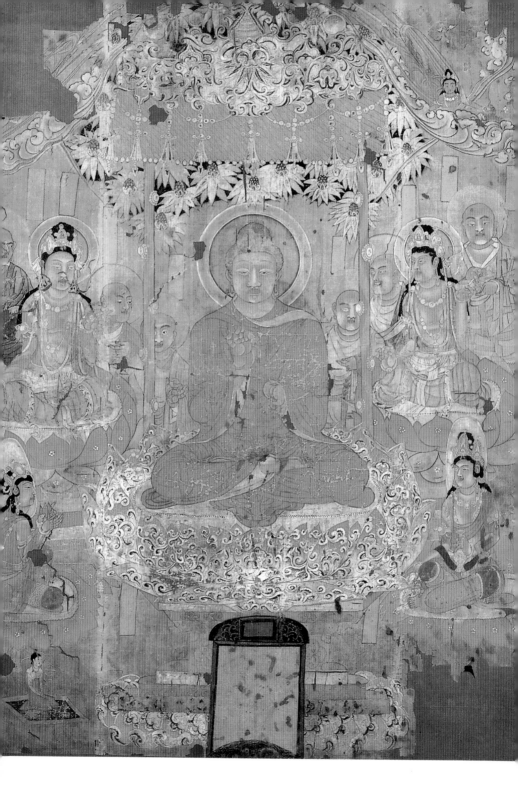

a separate identity, ultimately acquiring their own hall of worship. The model for these colourful figures was the Indian *yaksha*, but their ferocious demeanour and martial attire derived from Central Asia, their armour and boots being associated with the nomadic warriors of the steppes, although the continued presence of the writhing, gnome-like figures, being trampled beneath each of the *lokapalas*, recalls their pre-Buddhist, *yaksha* origins.

The attainment of heavenly rewards was facilitated by the efforts of bodhisattvas, particularly Avalokiteshvara and Samanabhadra, the latter portrayed atop his six-tusked elephant. Their intercession on behalf of the believer ensured a secure route to paradise. By the late Tang dynasty Avalokiteshvara had assumed such stature that he was worshipped as a solitary figure, his image being in such demand with worshippers that it contributed to the rise of block-printing, a Chinese invention of enormous consequences extending beyond the popularization of Buddhism. Avalokiteshvara also became the central figure in grand compositions, occupying a position of greater importance than the historical Buddha Shakyamuni and, in much of the popular imagination, equal to or exceeding that of Amitabha.

The *Lotus Sutra* begins with Shakyamuni preaching from the Vulture Peak, propounding the Law and, according to the Chinese sutra, introducing the tenets followed by the Tiantai. This rather modest event came to be treated pictorially in a manner akin to the heavenly displays reserved for Amitabha. A spectacular silk embroidery presents Shakyamuni in iconic fashion, with his right hand by his side, the emblem of this event. Folds have destroyed most of the two monks. However, the bodhisattvas remain intact, as does the canopy and the group of donors below. Of special interest is the device used to represent the Vulture Peak itself: instead of a mountain under the Buddha's feet, the artist has enclosed the mandorla with fantastic, colourful rocks. Fabulous rock formations appeared in Indian art, at Ajanta, and the motif came to play a prominent role in later Chinese, Sino-Tibetan, and Japanese painting and in garden art, but rarely with more inventiveness or dynamic force than in this version. The special appeal of the Vulture Peak theme continued to inspire ingenious creations in East Asia, such as renderings of the mountain as a stylized vulture's head on illuminated manuscripts, floating above an otherwise traditional version of the preaching Buddha.

Other important influences upon Buddhist art were the Pure Land schools, also refined in the early sixth century, but in the southern regions about the Yangzi basin. Deriving from the *Prajna* (wisdom)

texts, translated into Chinese by the fourth century, the movement was given its distinct form by a Daoist convert who, like the Tiantai, emphasized the rewards of Amitabha's Western Paradise or Pure Land. However, Tanluan's (476–542) method consisted of a more intense focus upon Amitabha, concentrating upon a continued recitation of his name, rather than on the programmes of good deeds or meditation techniques favoured by most other Buddhists. Most Pure Land imagery supported the belief in rebirth in the paradise of Amitabha, with scenes of great material splendour, contrasted with detailed images of the tortures of the hells awaiting non-believers. As in Tiantai art, the compassionate saviour bodhisattva, Avalokiteshvara, played a prominent role and was represented, in Japanese versions, as literally descending from heaven to welcome the soul of the deceased. 139

The esoteric schools developing during the Tang period relied upon other types of imagery. Their mystical speculation and secret rites required complex images and symbols and encouraged an ever-growing pantheon, although nearly all the extant mandalas, ferocious deities, sets of protectors and guardians and the vast array of ritual objects from esoteric practices date from later periods.

The other major group of importance for Buddhist art, also fashioned during the Tang, although again little of their surviving art is earlier than the Song period (960–1279), were the meditative branches, known as Chan and in Japan as Zen. These schools fit well into the Chinese contemplative tradition, with their emphasis upon insight, self-discipline and intuitive comprehension. They were especially concerned with lineage, again in harmony with Confucian traditions of ancestor worship, tracing their origins to the Indian monk Bodhidharma, said to have arrived in Guangzhou via the sea route around 470. Despite several sectarian divisions, the group as a whole maintained its identity following the ninth century anti-Buddhist persecutions, due mainly to their choice of mountain retreats. The Chan schools utilized the portrait to emphasize the importance of the lineage of their masters, as well as to document authority, employing them as emblems of the passing of leadership from one master to the next. Their emphasis upon intuitive insights 14 led to a need for aids to meditation, and enigmatic images, including brief, but inspiring works of calligraphy, were developed to challenge and provoke adherents to greater awareness.

Although the Tang dynasty era was one of Buddhism's great periods of artistic achievement it was also the beginning of its decline.

98 Avalokiteshvara, 10th century, from Cave 17, Dunhuang. Woodblock print, h. 40 ($15\frac{3}{4}$)

99 Shakyamuni preaching on the Vulture Peak, 8th century, from Cave 17, Dunhuang. Silk embroidery, h. 241 ($94\frac{7}{8}$)

There had been sporadic incidents of anti-Buddhist persecution earlier, but the ninth-century wave of destruction exceeded them all and signalled the end of expansive growth for the faith. The causes had little to do with issues of religion but chiefly involved xenophobic and economic concerns. The Buddhists' accumulated wealth generated resentment and once a ruler with anti-Buddhist beliefs assumed the throne, as occurred in 841, the latent pressures spilled over, and the country-wide destruction resulted in enormous material losses, especially for Buddhist art. By the close of the first millennium, with Chinese Buddhists in disarray, and India no longer providing fresh inspiration, the faith was additionally challenged by the revived forces of neo-Confucianism. Several of the schools that had emerged during the period of development had ceased to exist and except for occasional imperial support, it was mainly the semi-reclusive Chan sects, secure in their rural retreats, that maintained autonomy and continued to develop.

Chinese temple architecture
Buddhist architecture, with its distinctive wooden temples and pagodas, has become one of the best-known subjects of Chinese art, with several motifs, most notably the graceful tiled roofs and elaborate bracketing systems, continuing to appear in buildings to the present time. However, except for the unique pagodas, most buildings repeated the same conventional style, with few obvious differences between them, while the Chinese customarily avoided prominent or towering groups of structures and preferred a single-axis alignment. Thus, the temple complex consisted of similar structures that differed in little more than size and placement. As is often pointed out, despite its aesthetic qualities, East Asian Buddhist architecture was not integral to the religion, in the way in which Gothic or Baroque churches functioned in the West. In East Asia similar-looking buildings served secular and religious needs and what was placed inside constituted the primary difference among this assemblage, leading Seckel to describe them more appropriately as 'precincts', rather than buildings. Most were dedicated to specific deities and to major concepts, such as heavens and hells. A modest-sized monastic complex during the Tang dynasty would include buildings dedicated to the Buddha, to Guanyin, to the Luohan (*arhats*), and to the Kings of Hell, as well as a hall of the four protectors and structures with particular functions, such as a meditation hall or a sutra library and residence for the abbot. The usual single-axis plan

followed traditional secular arrangements and, like the imperial palaces that inspired it, was oriented towards the south.

The typical wooden Buddhist hall, a form repeated in Korea and Japan, followed a type of construction well suited to the needs of a temple complex. It could easily be enlarged, and its non-bearing walls and overhanging eaves served to moderate bright sun and heat as well as torrential rains. These temples were raised upon a base, usually of brick, and faced south, while the heavy roof-supports were carried by elaborate and aesthetically interesting systems of bracketing.

The anti-Buddhist destructions of the ninth century virtually eliminated most of the structures built during the first millennium. No more than a handful of wooden temples of Tang date remain today, and most material evidence for early temples comes from buildings that remain in Japan, erected in emulation of now lost temples from China. Fortunately, the Japanese determination to match the grand achievements of the Asian continent motivated them to erect replicas of China's great temples, culminating in the eighth-century complex at Todaiji, in Nara.

Just as the pagoda derived primarily from pre-Buddhist gate towers, the origins of the Buddhist temple can also be found among traditional secular, wooden buildings. The Buddhists never moved far from this earlier tradition and after the Tang dynasty, as neo-Confucian interests rose and Buddhism declined, temples and their placement within the compound more closely reflected the designs of imperial architecture. This similarity can be seen in the Tang period as Buddhist image platforms came to resemble royal audience halls with all statues facing the worshipper, much as the ruler and his entourage faced their subjects. Individual Buddhist temples followed the traditional scheme for important secular buildings, having a frontal axis with multiple doors, and overhanging eaves, and being raised upon stone or brick platforms. The supporting posts were joined to the roof by a system of brackets that both reduced the direct weight of the heavy roofs and also provided an attractive transition from the vertical pillar to the horizontal plane of the roof. Although the Egyptians and Greeks had also chosen a post-and-lintel system, instead of the bracket they had used the capital, a solid form that appeared to belong more to the pillar. The Chinese bracketing system created a separate visual element, distinct from other structural components, and, at its best, provided an aesthetically intriguing ingredient between the dominant vertical and horizontal orientations of the other principal architectural forms, the roof and the pillar.

100
101

102

100, 101 Tang dynasty temple design and roof-bracketing, seen in Japan at the late 7th-century *kondo* (reconstructed) of Hor-yuji, Nara

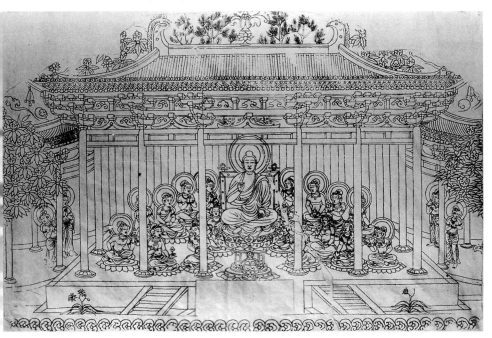

102 A Tang dynasty temple, c. 700, engraved on a pediment from the Great Goose Pagoda, near Xian

Tang Buddhist architecture can be seen in a survivor from the eighth century, an engraving on a stone lintel from the Great Goose Pagoda at Xian. Instead of the more elaborate hip-gable, the typical roof was of the simpler and dignified hipped type, usually a single-storey structure with the supporting elements fully visible from inside, at times made more interesting by the addition of a coffered or lantern ceiling. The exterior, column-head bracketing was already more complex than that known from the previous Six Dynasties period, but had not yet reached the elaboration of later times. The bay system along the front gave the widest space to the central opening and the non-weight-bearing walls were filled in with brick and plastered. Often the attention to symbolic detail was extended to the stone pillar bases, with delicately inscribed lotus petals. Inside, unlike the earlier platforms, whose images faced in various directions and allowed space for ritual circumambulation, the rectangular dais was now pushed against the rear wall, with all the images, including the large central figure, facing forwards. Worship, as always not designed for large numbers, was now conducted from in front only, with the

102

113

103 The South Gate,
Todaiji, 12th century,
Nara, Japan

back wall moved forwards to close off the rear portion of the hall,
creating a separate area, unavailable to the worshipper – an
arrangement suited to the needs of esoteric schools, which required
separate, isolated areas for their secret practices and images.

Later architecture essentially followed established styles, expanding
or refining details, for example by modifying bracketing systems or
enlarging proportions to achieve monumental effects. Song temples
(960–1279) are recognizable by their slightly curved eave-ends or
their often greater height, as well as by the refinement and technical
brilliance of their glazed roof and floor tiles. One of the unusual Song
characteristics was a fascination with miniaturization. This took the
form of small replicas of wooden buildings, constructed inside
temples, such as the sutra cupboard of the Lower Huayan-si at
Datung. These were complete miniature shrines, including elaborate
bracketing and with sections connected by arched bridges. This
doll's-house effect formed an appropriate background for the
precious documents that the shrines contained. A rare survivor of this

period is the large South Gate at Todaiji, in Nara. This unique construction, of an older type otherwise unknown, is a product of southern China, and survives today only because of its location in Japan. Its massive simplicity separates it from Song courtly taste, while its rarity is a reminder of the enormous losses suffered as well as of the considerable differences between the artistic tastes of northern and southern China.

BUDDHISM IN LATER CHINESE CULTURE

The many political changes in China during the tenth and eleventh centuries were accompanied by changes in the role Buddhism played in society. The interests of urban dwellers, of aesthetes and scholars now opposed those once represented by Tang warriors and the limited horizons of provincial, peasant values. Just as Buddhism had flourished during the invasions and subsequent rule of northern peoples during the Six Dynasties period, the faith again profited from northern invasions, first during the Liao dynasty (907–1125), then at the hands of their conquerers, the Jurchens. However, the now weakened condition of the religion and a more stable political environment prevented a repetition of the growth and success of the scale of the Six Dynasties period. By the thirteenth century, the neo-Confucianists were firmly in control, and the second millennium can be seen as largely one of Confucian success and Buddhist decline. The major exceptions were the interest in and patronage of Tibetan Lamaism that began with the Mongols, during the Yuan dynasty (1280–1368), and persisted into the Qing dynasty, especially during the reign of Qian Long (1736–95), as well as the Chan and Pure Land schools, which continued their activities, even if they no longer played a major role. The absence of inspiration from India and Central Asia meant that now China's Buddhists had to look within, and the result was a religion that was moved into a secondary position, behind the traditional, Confucian secular concerns that had always been the strength of China's culture.

The later images
The traditional groups of images, such as Shakyamuni or Amitabha surrounded by bodhisattvas and monks, continued to appear, especially in Pure Land temples, although their role was diminishing in favour of subjects related to contemporary values. The groups in the Huayan-si temple at Datung are among the finest of these.

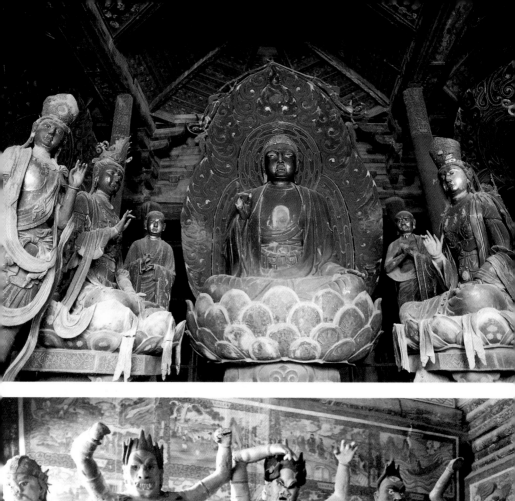

104, 105 (*left*) Painted clay figures, Liao dynasty, Datung, China: a group in the Lower Huayan-si temple, 1038, and detail of the nine spirit kings in the Guanyin temple

106 (*above*) Avalokiteshvara in more feminine form (known as Guanyin, the bodhisattva of mercy, in Chinese), 12th–13th century. Polychromed wood, h. 241.3 (95)

The materials changed to the more pliable media of clay and wood, which permitted an increased degree of realism, a distinctive feature of the post-Tang phase of Buddhist art. A number of once lesser
105 subjects, such as luohans (*arhats*) and patriarchs, now rose in
109 importance, especially among the Chan schools, reflecting the
110 increased reliance upon individual effort as opposed to total devotion.

In an interesting shift in emphasis from a role as the guide of souls and aid in the final passage to Paradise, the bodhisattva Avalokiteshvara came to be seen more as a saviour of those in distress, from a variety of threats, from fire to robbery and shipwreck, and even as an aid for those seeking children, especially male offspring. By the end of the Song dynasty, in 1279, despite textual sources noting the irrelevance of gender for a bodhisattva, images of these beings had
106 become noticeably more feminine, and to the traditional standing pose was added a seated, languid posture, with the right hand resting upon the raised knee. Known as *lalitasana* (the pose of royal ease), it suggested the confidence of royalty, the self-assurance of imperial power. In Song China, however, these images assumed both a delicacy, apparent in the details of the extended right hand, and a softness in the modelling that more accurately matched the descriptions of the confident, culturally sophisticated, but politically inept and troubled, court. Aesthetic concerns came to dominate portrayals of such traditional images and, while these large, brightly painted sculptures lacked the power and directness of those of the Tang period, they revealed a sensitive eye for form and detail. Many belong among the finest achievements in Chinese sculpture.

While a case can certainly be made for the artistic merits of later images of Avalokiteshvara, the same cannot be said for the more startling changes undergone by the Buddha to Come, the bodhisattva Maitreya, whose metamorphosis into the laughing, pot-bellied Budai was a purely Chinese invention. Initially, when portrayed as one of a pair of bodhisattvas, except for such attributes as the stupa in the crown or the water pot held in the hand, Maitreya differed little from the other bodhisattvas. During the formative period of Chinese
79, 107 Buddhism, Maitreya was usually portrayed seated on a chair or throne in what has come to be known – because of the chair – by the awkward label of the 'European' position. In India, during the Kushan period, Maitreya also appeared seated with one leg across the other, the elbow resting on top of the crossed leg with the fingers held to the cheek, in a pose of contemplation, as if pondering the future, a pose also well known in Chinese art (and of major religious and

108 The Chan master Bu-kong, 13th century, Southern Song dynasty, from China. Colour on silk, h. 120.9 (47½)

109 Luohan, 1180, from China. Marble with traces of pigment, h. 110.8 (43⅝)

adaptation by Buddhism, this implausible character, a symbol of naive simplicity, came to be identified with Maitreya, the Buddha to Come. He retains this position to the present time, and ink paintings that capture his itinerant ways and spontaneous behaviour remain especially popular with Zen artists.

One of the most intriguing post-Tang images is that of the luohan. Beginning in the Tang period, these figures were portrayed as intense, often bizarre individuals, humbly dressed but always with an expressive, focused gaze, reflecting their profound spiritual attainments. They would typically be placed in a cave, or the middle of the forest or even meditating in a tree. At times, their images are more caricatures than actual portraits, although, as their stature rose in the pantheon, they also came to be portrayed much as were ordinary monks, distinguished mainly by their forceful expressions. These

109

individuals had always been important, especially in early Buddhism, for they represented the concept of individual effort, achievement through self-control, study and individual striving. Initially, they were contrasted with the compassionate bodhisattvas, who were distinguished by their aid to devotees in sharing their accumulated good *karma*. The arhats did not directly benefit others through such generosity, but came to function instead as a model of individual striving – though in East Asia they did assume a function something akin to that of a bodhisattva, by helping others through their actions as role models. They enjoyed their greatest popularity outside India, in northern Mahayana cultures, especially in Tibet and China where they gradually assumed a quasi-deified stature. They were portrayed in groups: in Tibet of 16 and 18, after Chinese influence; and, in China, in groups of 100 and 500 as well.

The Buddhist arhats found a parallel in the reclusive, eccentric Daoists whose solitary habits appealed especially to the adherents of Chan and Zen, with their belief that insight is gained through individualistic, unorthodox practices. With their eccentric behaviour and appearance, the arhats also fit well into the esoteric pantheon, which enabled them to assume a role in each of the major schools of Chinese Buddhism, so that halls dedicated to the five hundred arhats, their images often rendered life size, were included in many later temples. Their combination of picturesque features and concentrated expressions was immediately attractive to artists, and some of the greatest painters of East Asia devoted their talents to the subject of the arhat, an ascetic type of figure that remained an ideal and also acted as a model for some images of Shakyamuni.

Monks and patriarchs had been a part of Buddhist iconography from the early periods in India. It was in East Asia, however, that the image of the monk became a major aspect of Buddhist art and, in addition to the countless idealized images, there began to appear portrayals remarkable for their realism. As if to emphasize the contrast between the roles of the traditional monk and the unconventional, often caricatured arhat, portraits of monks and patriarchs were rendered with remarkable realism, in Japan even extending to the addition of human hair on the faces of wooden sculptures of Zen masters. In keeping with the importance assigned to lineage, included among these portraits were legendary or mythical figures, such as Nagarjuna, patriarchs who never visited China and who were known only through their biographies and writings. Most portraits were of the monks and abbots involved with individual

110 Luohan, 10th–13th century, from China. Three-colour glazed pottery, h. 118 (46½)

temples and included images of living members, enhancing the sense of continuity required in each sect. The greatest need for portraits was among the Chan schools, where they served especially to affirm the bond between master and pupil, to emphasize the passage of the spirit, the intuitive understanding, from one to another and from generation to generation. Chan portraits ranged in style from humour and caricature, such as those of the founder, Bodhidharma, to the idealistic images of earlier patriarchs and, finally, to portraits of striking realism for living masters.

The once vigorous creativity of Chinese Buddhist art was gradually eroded by the renewal of Confucian values, and, as Daoist practices were revived and imperial patronage diminished, the religion slipped into a secondary position in the culture. Despite Buddhist activity in the early part of the second millennium, in the Liao and Song dynasties, the faith never fully recovered from the persecutions of the ninth century. By the return of native Chinese rule with the Ming dynasty, in 1368, the religion had gained widespread popularity among the populace but not the support and patronage needed to continue the grand artistic displays of former eras.

111 Shakyamuni as an ascetic, 18th-19th century, from China. Jade, h. 26.2 (10½)

Korea and Japan

Despite their different ethnic backgrounds, Korea and Japan shared in a crucial process, the inheritance of Buddhism from China, with the early Japanese material filtered through Korea much as Chinese Buddhism had passed first through Central Asia. There is evidence of Buddhism in Korea by the fourth century, but it was nearly two centuries later that the first Korean Buddhist monks and their images entered Japan, by the end of the fifth century.

In addition to the Buddhist images, wooden architecture and sectarian divisions, Korea and Japan were affected by other important Chinese legacies, most notably a written language, as well as the Confucian social system, which ultimately played a major role in shaping the course of East Asian Buddhism. Shamanism, the pre-Buddhist belief system of both cultures, known as Shinto in Japan, with its beliefs in astral divinities, nature spirits and the power of wandering ghosts or spirits of the dead, would also gradually influence the development of Buddhism.

After its introduction, Buddhism grew rapidly in East Asia and although well integrated into each culture, it was continuously influenced, challenged and ultimately dominated by Confucianism. The second millennium featured the emergence and growth of the meditative Chan and Zen sects. In Korea, Son Buddhism, a similar school built upon local traditions, also emerged in a strong position and remains Korea's most successful form of Buddhism. In one important regard, Korean Buddhist art diverged from the others, with the rise of folk traditions during the second half of the Choson dynasty (1392–1910), a return to what had always been one of the fundamental forces in Korean culture.

KOREA

The Three Kingdoms period (1st century AD to 668)
The Koreans originated in the Siberia-Manchuria region and their Altaic racial background distinguished them from both the Chinese

and Japanese. Korean political history began about the time of the Christian era with the peninsula divided primarily among three kingdoms. Their consolidation into the Unified Silla dynasty in 668 began Korea's long history of unified rule, essentially unbroken until the twentieth century. Buddhism first appeared in the fourth century, although the oldest images date from the early sixth century and come from the northernmost of the three states, the Koguryo (37 BC–AD 668). The Paekche kingdom (18 BC–AD 660) was located along the western coast and, due to its closer proximity to southern China, via the sea, remained more receptive to Chinese influences and became the primary link to Japan. The third kingdom, the Old Silla (57 BC–AD 668), located along the north-eastern side, ultimately gained control of the peninsula, beginning Korea's dynastic history. Buddhism was introduced and developed in an environment of civil unrest, realizing a strengthened position upon unification brought about by the Silla kingdom, as it did in Tang dynasty China.

The images of the Three Kingdoms period retained aspects of their Chinese origins as well as incorporating native features, the characteristics that would remain in Korean art. The youthful face, overly large head and hands, and the sturdiness of a Paekche standing Buddha figure was typical of Korean art, along with a high degree of abstraction, due to the shallow carving and simplicity of the form. The primary goal remained the expression of spirituality rather than a physical presence, stylistic traits evident when compared with sixth-century Chinese works, such as the bronze Shakyamuni and Prabhutaratna of AD 518. The more abstract Korean images capture a greater transcendent, spiritual character, while the Chinese figures are dominated by the linear, rhythmical patterns that reflect concerns born of a calligraphic, two-dimensional artistic tradition.

The most distinctive of the early Korean images is the seated, contemplative bodhisattva, with one leg across the other and the fingers at the cheek. These images were widely popular in East Asia, especially in Korea. The figure has been most often identified as Maitreya (Miruk-bosal in Korean), pensively awaiting his eventual rebirth to save this world, although the pose is found also in early Chinese images of Shakyamuni, prior to enlightenment, as well among images of Avalokiteshvara from the Kushan period in India. In Korea, the worship of this contemplative bodhisattva had become popular by the end of the sixth century and increased in importance during the Unified Silla dynasty (668–935), although, judging by an absence of images, its worship had declined by the end of the eighth century.

Nothing of Buddhist painting or wooden architecture remains from the Three Kingdoms period, although excavations of foundation stones in the Kyongju area revealed traditional Chinese axial plans, as well as pagodas and halls of enormous size. As with the Chinese material, the best early examples can be found from the better preserved remains in Japan.

The Unified Silla period (668–935)
The Silla capital remained at Kyongju, like Kyoto a city modelled on the great Chinese capital of Changan (modern Xian). Continuing excavations have resulted in the discovery of some of Kyongju's splendour, and reconstructions allow visitors a glimpse of what was once one of East Asia's three great cities, in the eighth and ninth centuries. As work continues, interest has centred around the reconstruction of Anapchi Pond, a man-made lake surrounded by pavilions and temples, a replica of a Chinese pleasure garden. More than fifteen thousand objects have been recovered, mostly Buddhist, dating from the early years of the Unified Silla dynasty. The other major reconstruction has been of the Pulguksa Temple, spread along the lower slopes of the mountains outside the modern city. Stone pagodas have been reassembled, as well as the extensive, at times elaborate, reconstruction of numerous halls and corridors of what had been the great temple for the capital. As with all of Korea's early buildings, these had been damaged in invasions, first by the Mongols and then by Hideyoshi's attacks of the sixteenth century.

114
123

The Korean wooden temple repeats the basic forms of its Chinese sources, including the wide flaring roof line and elaborate bracketing system. The pastel colours, applied during the most recent rebuilding, reflect later Korean taste, as do many of the details painted about the doors and some of the stone gates and corridors that today enclose the site. Directly in front of the main hall stand two stone pagodas, but in quite different styles, one an elegant and traditional three-storey tower, the other an elaborate complex of carved stones unique in Buddhist art. The four stairs and pillar with umbrellas in the Prabhutaratna pagoda recall aspects of the early Gandharan stupas, although the open centre, with its solitary seated lion (probably from a group of four) and elaborate top sections, remains an imaginative but singular creation. Some of the stones are carved in imitation of bamboo and lotus petals, and the miniature storeys are enclosed by carved railings, one square and one circular, corresponding to the railings of early Indian stupas.

115

A short distance over the crest of the hills behind Pulguksa is a small monument, constructed of cut stones, a replica of traditional Buddhist rock-cut cave shrines, including a domed ceiling, which contains some of East Asia's finest stone images. It was begun in 751 but not completed for another twenty-five years, following the death of Kim Tae-song, the initial patron. As reconstructed by the Japanese during their occupation, the Sokkuram is a domed chamber, circular in plan, with a narrow vestibule preceded by an antechamber. The shrine originally held thirty-nine monumental relief carvings, consisting of sets of various guardians, including the four lokapalas, arhats, monks, bodhisattvas (one a rare Korean version of the eleven-headed Avalokiteshvara) and a layman, Vimalakirti, ranged along the walls of the three parts and in the recesses above the central figure. From its dais, the colossal granite Buddha gazes towards the east, out across the valley to the distant ocean, in the direction of potential Japanese invaders. The Buddha displays the *bhumisparshamudra*, a gesture which apparently did not appear in Korean art until late in the seventh century and then became widely used in stone images, due in part to the fame of the great Sokkuram Buddha.

Many of the Sokkuram figures are in animated postures, with legs crossed, or are enlivened by fluttering scarves and jewelry. Their varied poses are in stark contrast to the serenity and equipoise of the image of Shakyamuni, portrayed at the moment of enlightenment, and one of the masterpieces of Asian stone sculpture. This image continues the tendency towards abstraction noted in Three Kingdoms sculptures, with its shallow, incised lines indicating drapery folds, and minimal cutting of the stone. Few images in Asian art better express the transcendent nature of divinity, of a spiritual presence that lies within the body of a mortal yet is clearly beyond the reach of a mortal's powers. In scale and presence, the Sokkuram Buddha remains one of the finest expressions of the Buddhist ideal.

While the stone Buddha figures were in a more clearly Korean style, the Silla bronze images of bodhisattvas retained more of their Tang Chinese stylistic sources. Typically, these are fully robed, standing images, displaying the gesture of benevolence, many with the stylized, cascading drapery folds associated with the Udayana Buddha (discussed in the Introduction). Due to its esteem, as the legendary first image of the Buddha, this figure remained especially important, its stature enhanced by the numbers of monks returning from pilgrimage to India during the Tang and Silla periods. The influence of these pilgrims and the number of Korean monks increased.

116

117
118

128

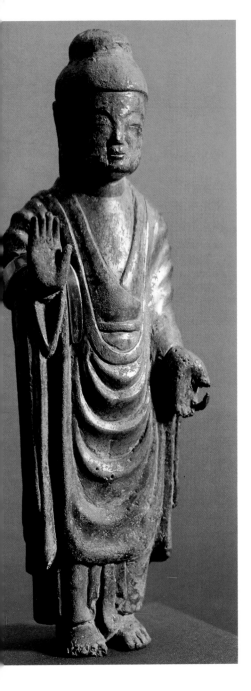

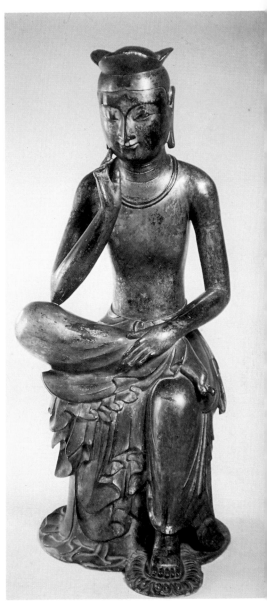

112 Standing Buddha, 7th century, Paekche kingdom, from Korea. Gilt bronze, h. 26.5 (11)

113 Contemplative bodhisattva, early 7th century, Three Kingdoms period, Korea. Gilt bronze, h. 91 ($35\frac{7}{8}$)

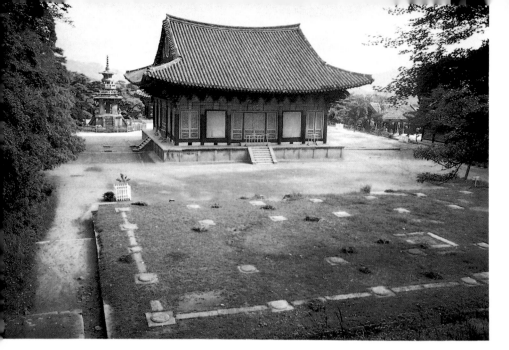

114, 115 The 8th-century Pulguksa temple, Silla dynasty, Kyongju, Korea: the main hall (behind stone bases for what may have been the lecture hall) and the stone Prabhu-taratna Pagoda

116 (*right*) Shakyamuni Buddha, 751, Sokkuram, Korea. Granite, h. 350 ($137\frac{7}{8}$)

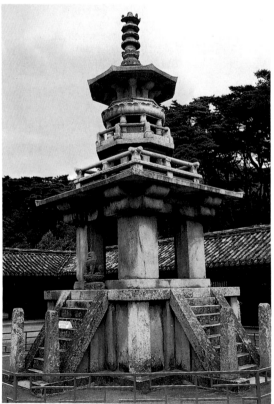

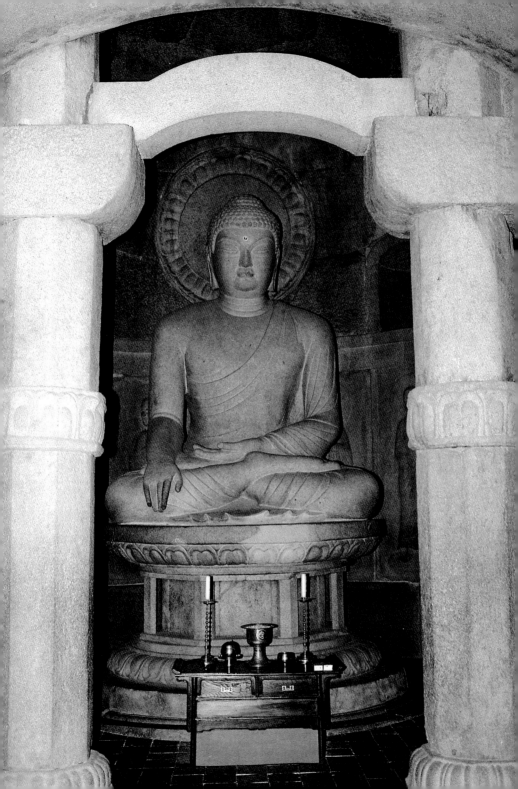

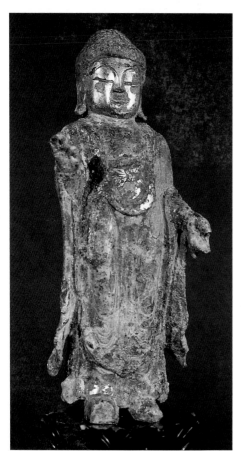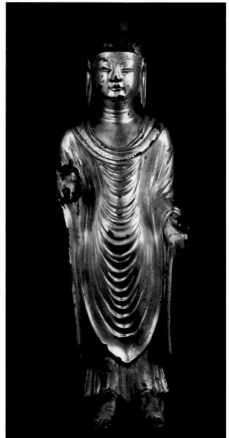

117 Standing Buddha, 9th-10th century, Korea. Gilt bronze, h. 27.9 (10⅞)

118 Udayana Buddha, 8th century, Unified Silla dynasty, Korea. Gilt bronze, h. 20.6 (8⅛)

By the eighth century they may have contributed to the growth in popularity of images of the seated Buddha, portrayed in the gesture of enlightenment, recalling the event that took place at Bodh Gaya, the most important of pilgrimage sites.

Silla Buddhism reached its apogee by the middle of the eighth century; after that time, political struggles and the Buddhist persecutions in China weakened the status once enjoyed by the faith. In art, youthful, gentle faces were replaced by pensive, at times

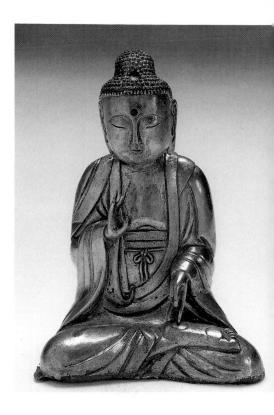

119 (*left*) Amitabha and Eight Great Bodhisattvas, 14th century, Koryo dynasty, from Korea. Hanging scroll, ink, colours and gold on silk, 151.1 × 88.7 (59½ × 34⅞)

120 (*above*) Head of the Buddha, 10th century, from Korea. Iron, h. 33.5 (13¼)

121 (*right*) Amitabha Buddha, 13th–14th century, Koryo dynasty, from Korea. Gilt-repoussé silver, h. 19 (7½)

unique, gilt-silver seated Amitabha, exhibited the same characteristics seen on monumental stone or iron images. While the decorative sash and delicate gestures link it to the taste of the royal court, the overly large head and hands and abstract details, especially of the face, are consistent with earlier images and lend this figure a monumentality and directness that belie its small size.

121

The Choson dynasty (1392–1910)

Later Korean Buddhist art, especially following the Japanese invasions at the end of the sixteenth century, became identified with what has come to be known as 'folk art'. This shift was hastened by the subordination of Buddhism to the revived Confucianism of an anti-Buddhist court; the Buddhists retreated to the mountains and, artistically, away from royal patronage and towards the unpretentious immediacy of folk traditions. These later works, too often omitted from studies of Korean art, captured the traditional,

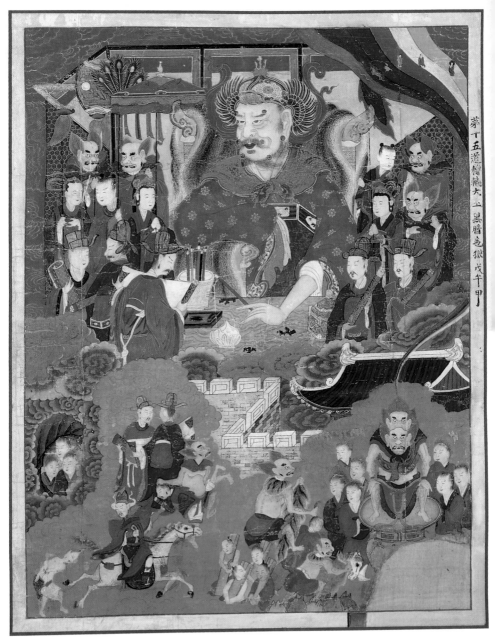

122 King of the Hell of Darkness (from a set of the Ten Kings of Hell), 19th century, Choson dynasty, from Korea. Hanging scroll, ink, colours and gold on silk, h. 178.4 (70¼)

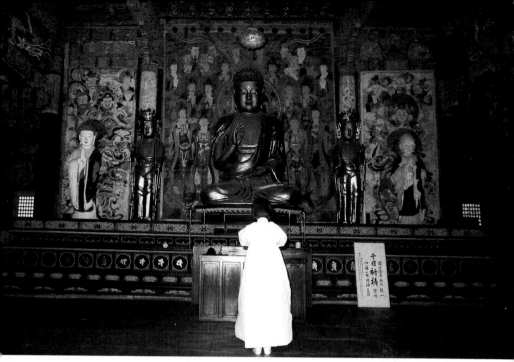

123 Interior of the main hall of the Pulguksa temple, 8th century, Kyongju

shamanistic heritage of the Korean culture, with a bold directness and powerful colours replacing the earlier courtly refinement. The results can be seen in the massive rebuilding of Buddhist temples, with entire image platforms composed of later paintings and sculptures, at times garish in colour but always with the powerful simplicity typical of folk customs and executed with great variety and imagination. What remains of the art of the majority of Korean temples today is a dynamic Buddhist art, largely expressed within Korea's exceptional folk art tradition.

 This potent art is revealed in a colourful version of one of the Ten Kings of Hell, the King of the Hell of Darkness, a popular Buddhist subject and a reminder of the retribution awaiting those who fail to pursue the path to salvation. This theme was known in Indian literature and appeared in Central Asian and Tang Chinese paintings, ultimately assuming a place of prominence in Korean and Japanese illustrations of the various levels of existence envisaged by Buddhist thought. By the thirteenth century the graphic depictions of tortures

123

122

137

were a well-established ingredient of East Asian Buddhist art, aimed at those who denied the saving grace of Amitabha.

The popularity of the theme of the Ten Kings of Hell is another example of Buddhism's ability to accommodate itself to native beliefs. The subject is closely related to East Asian popular religion, recalling the concept of retribution for sins found in Daoism and Shinto, as well as traditional Confucian customs involving burial practices, which included periodic expressions of respect for the deceased. In the Korean version of the theme, the individual king is portrayed in the top half of the picture, dressed as a Confucian bureaucrat and surrounded by attendants, mortal, divine and some even comical. Various architectural devices separate them from the scene below, which consists of gruesome tortures, often imposed by complex devices, obviously inflicting appalling pain. As a typical example of folk art, which draws upon contemporary images and events instead of relying upon literary descriptions of the courtly tradition, the Korean painting shows a group of four women locked into their wooden boards, or canques, the well-known and cruelly effective Chinese device for punishing common criminals.

JAPAN

The development of Japanese Buddhist art can be understood as a continuous process involving three major periods. During the early phase, beginning by the sixth century and lasting until the moving of the capital to Kyoto, and the emergence of a more clearly native style around 800, it was a reflection of what was essentially a state-supported religion following the Korean and Chinese examples. This era was followed by a period that saw the rise of esoteric schools and increased worship of Amitabha (Amida in Japan), appealing especially to the aristocracy and culminating with the achievements associated with the refined taste of the Fujiwara court in the eleventh and twelfth centuries. The cultivated elegance of this second era was in turn replaced by new Buddhist ideals, still supported by the rulers, although Kamakura Buddhism benefited from broad support, particularly among lower levels of society. Beginning with the Kamakura shogunate, in 1185, this third epoch extended into the Muromachi period of the sixteenth century. It began with a vigorous programme involving the rebuilding of temples and copying of images destroyed during the civil wars and ended with the dominance of devotional schools and Zen meditative sects. After the fifteenth

century, although Buddhism remained the principal religion of the broad populace it was no longer the primary cultural force and its art lost much of its former vigour and creativity.

The early phase (Asuka and Nara Periods, 552–794)
The major event in Japan's emerging culture was the arrival of the Buddhist faith, beginning by the end of the fifth century. Along with the Buddhist priests came a written language, a sophisticated continental culture and the beginnings of Japan's real contact with the rest of the Asian world, initially through Korea. Buddhism's acceptance was not smooth, with fear and hostility from entrenched interests, mainly the established Shinto cults. However, Buddhism relied upon aristocratic patronage, as it did throughout the rest of Asia, for its initial success. The religion benefited from the inspired leadership of the imperial prince Shotoku Taishi (574–622), a member of the Soga clan and a layman, who led the Buddhist movement from his position at the highest level of society, just as Ashoka had done earlier in India. From the myths and stories surrounding Shotoku's life and his subsequent apotheosis, it would appear that he promoted the Buddhist cause at a time when its survival was much in doubt, but by the time of his death there were over forty Buddhist temples in Japan. His portraits, although highly idealized, remain among the earliest portrayals of a native-born Japanese. In a number of wooden statues from the Kamakura period he is shown as a small child and except for the fact that his hands are in a gesture of humble devotion, these could be images of the baby Buddha, also portrayed standing but with one hand raised in triumph.

The best-known of the remains associated with Shotoku's efforts is the Horyuji, the small temple complex outside the city of Nara and location of many of the most important images in Japanese Buddhism, as well as the site of the oldest wooden buildings in the world. The Buddhism that Shotoku promulgated derived primarily from the *Lotus Sutra* and early Japanese Buddhism also adapted quickly to native traditions by dedicating temples and images to the cure of disease or using them to mollify spirits of the dead identified with particular clans, all in the manner of native Shinto cults. So complete did the Buddhist association with native Shinto become that the two appeared at times to have merged, with Shinto deities and practices effectively appropriated into Buddhist ritual.

The earliest Buddhist art dates from the beginning of the seventh century and takes the form of votive bronze images, their high

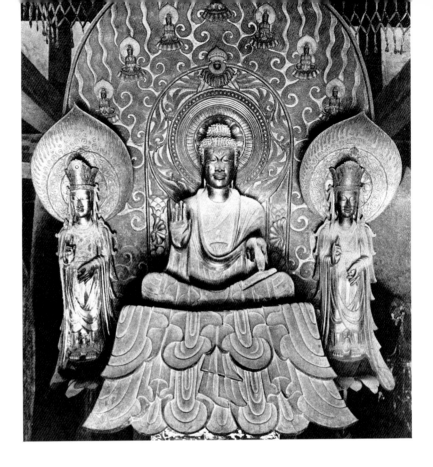

technical quality being the result of continental influence. The famous
triad of the Buddha Shakyamuni and two bodhisattvas is among the
earliest examples of the first phase of the Japanese style. Both the two-
dimensionality of the figures and the elaborate mandorla and stylized
drapery covering the base derive from Chinese sources of a century
earlier, such as the early sixth-century cave-shrine carvings at
Longmen. Due to the growing traffic between Japan and the
continent, by the beginning of the eighth century Japanese Buddhist
art would no longer repeat Chinese styles of a century before but
would begin to mirror contemporary work from the mainland.

In addition to the hieratic, icon-like quality of the Shaka triad, there
also appeared a softer, more innocent image, related to Korean
Paekche sources and created during the second half of the seventh
century in the Hakuho era (645–710). The close similarity of a

124

83

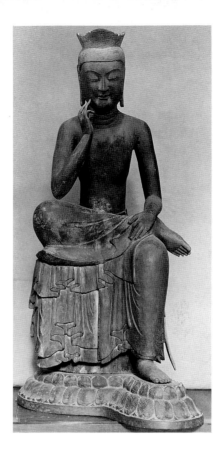

124 Shaka triad, 623, Horyuji *kondo*, Nara, Japan. Bronze, h. of Buddha 86.3 (34), attendants *c*. 91 (35⅞)

125 Meditating bodhisattva, 620–640, Asuka or Hakuho period, Koryuji, Kyoto, Japan. Red pine, h. 123.5 (48⅝)

meditating bodhisattva figure to Korean works, as well as its material, a wood indigenous to Korea, suggest that, if not originating in Korea, it was probably carved in Japan by Koreans. This gentle face and delicate gesture occur at a time when Japan was in the throes of its own civil disturbances, leading some to interpret such engaging delicateness and purity as a conscious rejection of the cruelties and suffering of the time, an effort by Buddhism to create an emotional bond with the worshipper that transcended the unpleasant realities of daily life.

126

One of the most interesting documents of late-seventh-century Buddhist art, for it includes both architecture and painting, is the miniature Tamamushi shrine now in the Horyuji. The proportions of the hip-and-gable roof and its bracketing system are the most authentic, unaltered examples of the period's architecture and have provided a model for modern-day temple rebuilding, while the

lacquer panels and doors bear the best-preserved early Japanese paintings. One of the panels illustrates a popular *jataka* tale, a story featuring an earlier existence of the Buddha, as a bodhisattva, when his compassion led him to sacrifice his own life to save that of another. The bodhisattva is shown responding to the cries of a starving tigress and her cubs, trapped in a deep canyon, removing his clothes, then casting himself into the canyon where the tigers devour his body. The gathering of three separate events in one scene recalls the pictorial methods encountered at Bharhut in the earliest examples of Buddhist narrative imagery. Such narratives, an essential element in Buddhist art, would achieve their greatest sophistication in the handscrolls of the Kamakura and Muromachi periods. The depiction of the *jataka* tale of the starving tigers also reveals the extent of Korean and Chinese influence, not only repeating the flowing draperies and plant forms of the sixth-century art of those regions, but also recalling earlier Chinese bronze-age motifs in the stylized, curving rocks along the left side. The pastel colours and general lyrical feeling for the landscape

126, 127 Tamamushi Shrine, *c.* 650, Horyuji, Nara, with a *jataka* scene in oil on lacquered cypress on the left panel from the base. Shrine h. 233 (91.7), panel 65 × 35.5 (25⅝ × 14)

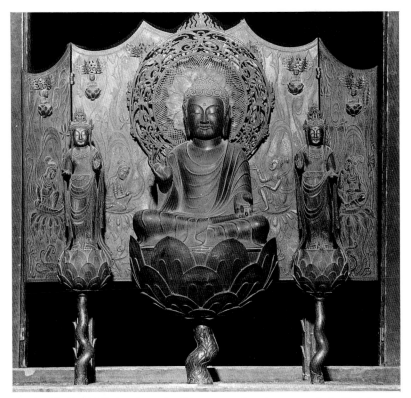

128 Amida (Amitabha) and two bodhisattvas, early 8th century, Lady Tachibana's Shrine, Horyuji. Gilt bronze, h. 33 (13)

remained in the Japanese tradition, especially after the reliance upon Chinese sources weakened in the ninth century.

The worship of Amitabha, with its goal of rebirth in the material splendour of the Western Paradise, was evident in Japan by the late seventh century, although the fully mature Pure Land school developed later. The earlier images of Shakyamuni, such as the 623 triad at Horyuji, gave way to ones of Amitabha, as Japanese Buddhism followed the Mahayana emphasis upon celestial deities and heavenly rewards rather than stories of the earthly events of the Buddha's lives. The Tachibana triad is a sculptural version of a subject well known in Chinese Buddhism and especially prominent among the wall paintings preserved at Dunhuang. All three figures are raised upon lotus flowers surrounded by aquatic motifs, including octopus tentacles along the bottom. The figures also indicate the shift towards

128

94

the mature Tang Chinese style, with their rounded forms and more naturalistic drapery. By the middle of the eighth century, with the increased contact between the two countries, the latest Chinese styles appeared almost immediately in Japanese art, and the determination of the Japanese to match the achievements of Buddhist schools on the continent led them to national undertakings of enormous expense and labour.

The grandest achievement of the early period was the dedication of the great Todaiji complex, in 751, with its array of monumental architecture, including the image hall (kondo), that remains the world's largest wooden building, despite fires and rebuildings that have reduced its size by almost a third. Unfortunately, the centre-piece, the colossal bronze and gilded Buddha, was almost totally destroyed and its reconstruction has not been faithful to the original eighth-century style. So much material was required in the initial casting that bronze practically ceased to be used for centuries. A complete sense of Nara period Buddhist art can be gained from portions of Todaiji and from nearby temples, likewise damaged over the centuries but often retaining original images, paintings and architectural elements of what may be remembered as East Asia's greatest century for Buddhist art.

The finest paintings, the early-eighth-century murals that once
96 covered the walls of the Horyuji kondo, discussed in Chapter Two, followed in the Tang Chinese tradition, as did most eighth-century Japanese art, and their loss in modern times is especially unfortunate, given the wholesale destruction suffered by Tang art during China's ninth-century persecutions. The earliest body of Japanese Buddhist painting belongs to the next century, and was produced under the influence of the growing popularity of esoteric schools by artists who began to base their inspiration less on continental models than on an emerging native aesthetic.

Evidence of the popularity of esoteric schools can be found in
129 eighth-century monuments, such as Toshodaiji, like Horyuji another of the temples on the outskirts of Nara. Despite its rebuilt roof, raising the original height and changing the building's profile, the kondo remains essentially intact and another example of the Tang style in Japan. However, the frontally oriented interior plan is notably different from earlier image halls. Unlike the image platform in the Horyuji kondo, located in the centre of the hall, it is now attached to the shallow rear wall, preventing the worshipper's traditional circumambulation and permitting only a frontal confrontation with

144

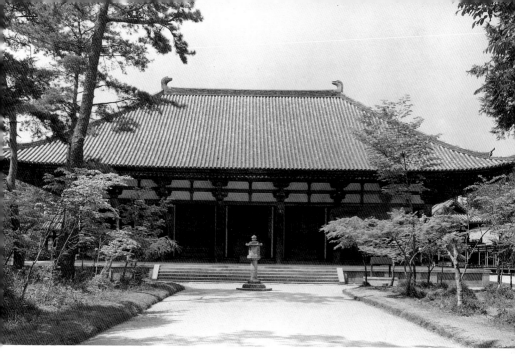

129–31 Toshodaiji *kondo*, mid-8th century, Nara. Entrance front and two statues on the image platform: Vairochana, gilded dry lacquer, h. 303 (134), and eleven-headed, thousand-armed Avalokiteshvara, lacquer on wood, h. 550 (216½)

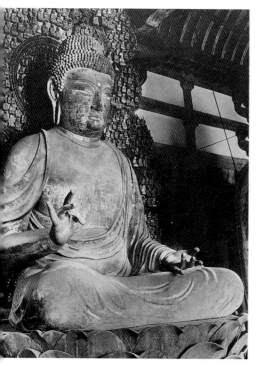

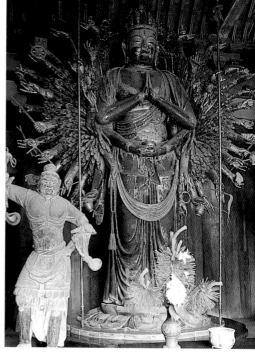

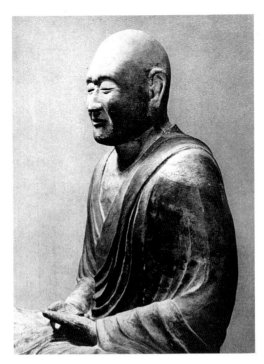

132 Ganjin meditating, late
8th century, Toshodaiji.
Dry lacquer, h. 79.7 (31⅜)

the hieratic assemblage of images, also visible to the approaching
devotee, through the five large entrance bays. The rear area is closed
off, reserved for secret ritual. The three major images, the ultimate
celestial Buddha, Vairochana, flanked by the thousand-armed
Avalokiteshvara and the healing Buddha, Bhaishagjaguru, or Yak-
ushi in Japanese, are backed against the rear of the shallow platform,
behind the smaller guardians and lesser deities. The eleven-headed,
thousand-armed form of Avalokiteshvara (Kannon in Japanese) was
becoming especially important in esoteric worship for the prolifer-
ation of arms and heads was well suited to the mysterious and hidden
rituals of Tantric practices. The central figure, the powerful,
forbidding image of Vairochana, has little in common with the
youthful, benevolent images of the seventh century, projecting
instead a distant and stern impression, far removed from the inviting
visions of the heavens of Amitabha's Western Paradise. Despite being
made of dry lacquer it probably resembled the original, colossal
bronze Vairochana at Todaiji and represented the culmination of
imperial determination to establish Japan as a major Buddhist
country.

130
131

146

Another important aspect of East Asian Buddhist art, especially conspicuous in Japanese culture, is also found at Toshodaiji. The dry-lacquer figure of Ganjin, the eighth-century Chinese monk who founded Toshodaiji, is remarkable in its sensitivity and heightened realism, capturing both his physical blindness as well as his focused devotion. Dry lacquer, a medium unique to East Asia, was made by applying thin coats of the resinous lacquer over layers of cloth wrapped around a clay, or sometimes wood, core, which was removed after the lacquer had hardened into a shell. The use of a clay model and repeated layers of lacquer enabled artists to create remarkably fine details and this image, some 1200 years old, retains its original lifelike realism. As the art historian Sherman Lee has noted, this intensely moving image belongs to a branch of Buddhist art devoted to acts of extreme asceticism, first seen in the Gandharan emaciated Buddha, but of special appeal to Japanese artists, whose devotion could even extend to such techniques as mixing the deceased's ashes with the clay that formed the portrait. The magical realism of such a likeness approached that of a sacred relic, extending the term 'realism' beyond traditional artistic boundaries.

 This expressive naturalism and interest in psychological realism can also be seen in the clay figure of Vimalakirti, from one of the tableaux on the ground floor of the Horyuji pagoda. Vimalakirti was the

132

34

133

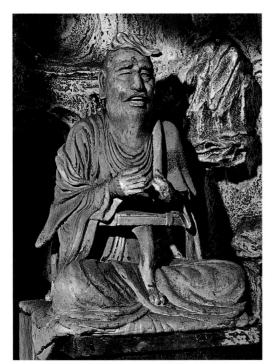

133 Vimalakirti, early 8th century, Horyuji pagoda, Nara. Clay, h. 50 (19⅝)

legendary figure who lived during the lifetime of the historical Buddha and was a layman renowned for his brilliance in debate. His images emphasized human qualities, in particular his age and heaviness. He is portrayed in a secular cap and clothing, and what appears to be a thick neck is actually his beard. This early-eighth-century figure also reveals the Japanese love of humour, at times amounting to caricature, which is often found in the later handscrolls. Realistic images were certainly known in China and Korea but the interest in capturing such psychological depth, applied to individuals of intense devotion, remained a particular Japanese attribute. Few images anywhere equal those of the Kamakura artists in communicat-

142, 143 ing the inner fire that drove the most devout of Buddhists.

The emergence of Japanese style (the Heian Period, 794–1185)
In an ironic twist of history, Buddhism's material success – the tax-free lands, enormous wealth and courtly power – were factors behind the emperor's move to a new capital, which in turn involved limitations on Buddhist activity, such as the exclusion of temples from within the walls of the new city. Nara remained the location of the majority of temples, while esoteric sects moved to mountainous

134 retreats, with the best preserved at Muroji. The changes were not
135 detrimental to the overall growth of the faith, however, for new inspiration continued to come from China, especially with returning monks, often sent by the Japanese rulers. Two such pilgrims remain among Japan's greatest religious leaders: Saicho and Kukai, who established monasteries early in the ninth century, one just above Kyoto on Mt Hiei and the other south of Nara on Mt Koya. The sects that they founded became major Buddhist centres of activity at the same time as Japan was emerging from Chinese cultural domination, and continued as two of the dominant Buddhist schools through the Heian period.

Saicho (767–822) had been influenced by the Chinese Tiantai system, which was based upon the *Lotus Sutra* and included belief in the salvation of Amitabha's Western Paradise. His state-supported visit to China in 804 resulted in a system, known as Tendai in Japanese, that tried to reconcile all beliefs into one doctrine. By including the esoteric practices of other schools in a major synthesis of Japanese Buddhism, Saicho extended the faith to incorporate various means towards salvation, such as charitable work or scriptural study. His broad-based system rapidly assumed national prominence. Saicho's original small monastery, Enryakuji on Mt Hiei, benefited from

148

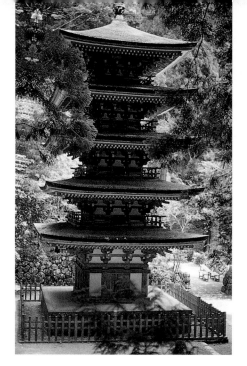

134, 135 *Kondo* and pagoda,
9th century, Muroji, Japan

mannered and stylized, yet often sensuous figures, their drapery folds
rhythmically and arbitrarily arranged. The esoteric rituals of Tendai
and especially Shingon sects closed down the inviting rapport
between image and worshipper with no place for the magical
naturalism of the preceding century, replacing it with images of
transcendent power and inward presence that differed from that of
contemporary Korea and China.

Of the numerous, complex images associated with esoteric
Buddhism, none is more extraordinary than the images of the Five
Kings or Myo-o, the best-known being the most powerful, central
figure of the group, Fudo Myo-o. Such images were the product of 136
Indian Tantric sources, arranged according to the cardinal directions
of a mandala, and they are the energetic and imaginative opposites of
the earlier gentle, often youthful figures of the first phase of Japanese
Buddhism. As with most esoteric Buddhist deities, they were
borrowed from the Hindu pantheon, for Tantric practices influenced
both systems. Although considered a benevolent deity, the Japanese
Fudo derived from the ferocious, destructive aspects of the Hindu god
Shiva. According to the Buddhist texts – and strict dependence upon
textual sources contributed to his often bizarre, at times humorous,

151

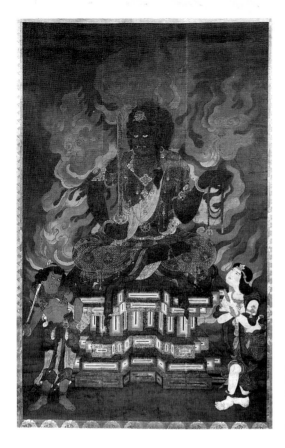

136 Blue Fudo Myo-o with two
attendants, c. 1300, Kamakura period,
from Japan. Hanging scroll, ink and
colour on silk, 183 × 114.3 (72 × 45)

137 Shaka Nyorai, 9th century, Mur-
oji *kondo*. Wood, h. 238 (93⅝)

qualities – Fudo's body should be plump and dark coloured, he should
hold a sword and noose, he should have fangs and bulging eyes and his
intensity should be revealed by biting his lower lip. His fierce
demeanour is enhanced by the use of rocks instead of the usual lotus
base. In this version, his ferocity is diminished by the fascination with
decorative elements, such as the stylized rocks and flames, aspects of
Japanese taste well established by the Kamakura period.

The latter half of the Heian period, known also as Fujiwara after the
dominant family, reveals another dimension of Japanese Buddhist art.
The eleventh and twelfth centuries were shaped by a courtly aesthetic,
emanating from a sheltered culture similar to that of Song China and
Koryo Korea, each introspective, their spirituality joined with a
heightened sense of the elegant refinements of the arts. Across East
Asia, some of the greatest artistic and literary achievements occurred

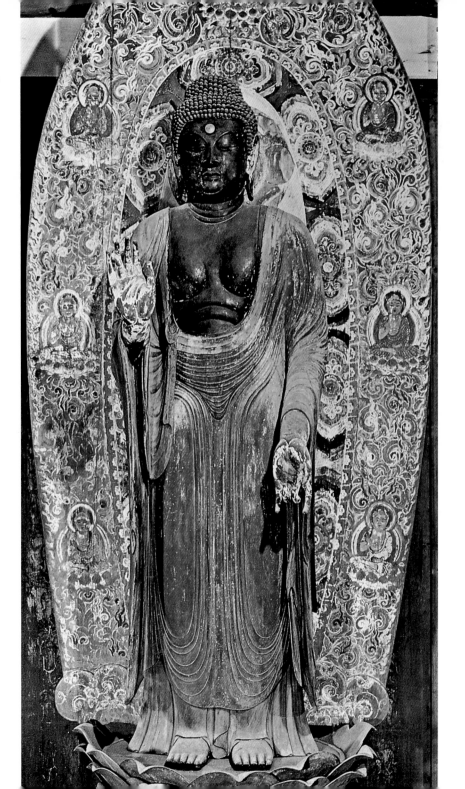

during the early centuries of the second millennium. They are seen today as brilliant and cultured moments in history but unfortunately their artistic attainments did not assist them in dealing with the harsh realities of the political world, for each period ended in warfare.

The first century of the Heian era witnessed the rise of esoteric Buddhism, but the remainder was dominated by followers of Amida, devotional schools whose art portrayed the glories of the Pure Land along with the horrific tortures of the Buddhist hells. This faith in Amida's blissful reward was aided by a growing belief in *Mappo*, literally meaning that 'the latter days of the law' were at hand. It inspired the fear that the current era would end in 1052, to be followed by an even more degenerate epoch. The path to salvation was through total devotion to Amida, and Buddhism came to focus upon ensuring rebirth in the Western Paradise. The art was centred upon visions of Amida, his paradise and the bodhisattvas whose compassion was needed to reach this goal. Such a belief in imminent change and decay, deriving from Buddhist philosophy, encouraged a heightened awareness of the transience of existence, a sensitivity to the passing of life and beauty in all too fleeting a world. This particularly potent concept, called *mono no aware* and closely associated with the Late Heian era, remained as a cultural influence in the arts of Japan to the present time. In another fortuitous circumstance, similar to the rare survival of early architecture and painting in the Tamamushi Shrine, one Late Heian monument still remains that reflects these beliefs.

138 The Phoenix Hall, or Byodo-in, located just outside Kyoto, was originally a Fujiwara villa, which was then converted by the finest artists of their court into a Buddhist temple, a miniature replica of the Western Paradise and a symbol of resurrection and immortality. The architecture has nothing of the colossal size of Nara temples or the austerity of the mountain shrines of esoteric schools. Instead, its scale is human, its feeling inviting and its decoration exquisite. It derives its name from the phoenixes atop the main roof, although the entire building, with symmetrical wings to either side and a projecting 'tail' to the rear, replicates the mythical bird. The thatch roofs of Early Heian have again been replaced with tiles, in the Chinese manner, yet the broad, graceful eaves, reflected in the surrounding lake, present an especially Japanese character of delicacy and refinement, qualities that typify the arts of Fujiwara culture.

The great monument of Heian courtly art is found inside the hall. A
140 seated Amida, surrounded by a dazzling aureole, towers over the worshipper, yet radiates compassion rather than the awesome power

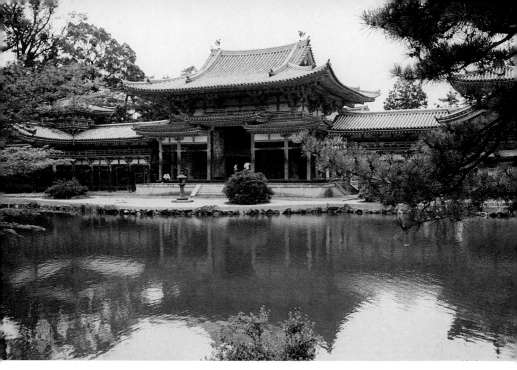

138 Byodo-in, 1053, near Kyoto

of images of Vairochana. The artist Jocho's great statue in the Byodo-
in fully expressed what had been developing within Japanese
sculpture for centuries: a unique balance of strength and delicacy, of
form and decoration, and a subtle sense of colour – qualities that have
come to define Japanese art. Jocho was a pioneer in technical
improvements as well, helping to improve the methods of carving
multiple blocks of wood by the efficient use of teams of craft workers.
However, it is the brilliance of the overall conception that marks this
sculpture as perhaps Japan's most acclaimed single figure, and despite
countless attempts, no subsequent artist has equalled this masterpiece.
As with the finest images of the seated Buddha figure, our gaze is
moved slowly and rhythmically about the balanced, triangular form
between the largest area, the lotus throne, and the serene, attentive
face, and held momentarily by the distinctive hand gesture. The
forms are both powerful and simple, yet with delicate details. Instead
of being diminished by its gilding or by the elaborate halo, the
monumentality of the figure is complemented by their mutual

139 Descent (*raigo*) of Amida
over the Mountain, 13th
century, Kamakura period, Zen-
rinji, Kyoto. Hanging scroll,
colour on silk, 138 × 118
(54¾ × 46½)

140 Jocho, *Amida*, 1053, Byodo-
in, near Kyoto. Gold leaf and
lacquer on wood, h. 295 (116⅛)

splendour. Despite its size, over 2.5 metres high, and rich setting, the
Amida imparts both an invitation to and confidence in the Western
Paradise.

High upon the walls surrounding Amida are painted wooden
figures of celestial bodhisattvas and musicians, the host that serve the
Pure Land. On the doors and walls are murals of the Western Paradise
in the four seasons, an especially popular subject in Japanese painting,
as well as groups of figures, consisting of Amida and his host, called a
raigo ('descent of Amida'). They are not simply awaiting the deceased
but descending to take the devout to their heavenly reward. By the
beginning of the eleventh century, the rewards of the Western
Paradise had become the single dominant subject, popularized by the
writings of priests and illustrated by some of the most elaborate
paintings of the Fujiwara court. In fact, the interior of the Byodo-in,
including Amida and his host, is probably a three-dimensional *raigo*, a
subject usually rendered in painting.

The third phase (Kamakura and Muromachi periods, 1185–1573)
The second half of the twelfth century was a period of destructive civil
wars with tragic consequences for the numerous temples and their
treasures caught in the crossfire. The emergence of military rulers, a

139

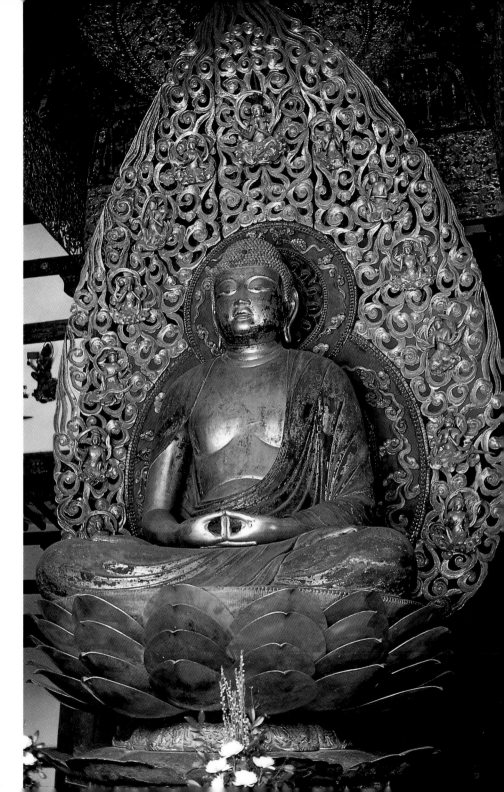

pattern that would continue for nearly seven hundred years, promoted Shinto and Buddhism, and new directions in the arts resulted, with the growth of the Zen, Pure Land and Nichiren schools. Unlike the all-inclusive Tendai and Shingon sects, these three major Kamakura schools moved towards narrower and exclusive interpretations, even to the point of openly denouncing competing schools. The simplicity of their teaching, be it the meditation and monastic life of Zen or the devotional immersion and chanting of Amida's name by other schools, made them accessible to more levels of society. Ultimately, the schools that developed during the Kamakura period rose to dominant positions in Japanese Buddhism – maintained into modern times – and humour, caricature and realism were attractive to a religion with such a broad-based, mass appeal.

The primary artistic achievement of the Kamakura period was the revival of classic traditions, including renewed interest in stories of Shakyamuni's life and the rebuilding of temples destroyed in the civil wars. The primary beneficiaries of this patronage were the great Nara temples that had supported the Kamakura cause, notably Todaiji and Kofukuji. The emergence of the three major schools of Kamakura Buddhism, with their cult of leadership, resulted in a need for halls dedicated to founders, now added to the traditional monastic complex to house likenesses of former leaders. A group of master sculptors led by the famous Kei school, the descendants of Jocho, and inspired by Chinese Tang and Song examples did more than restore former glories: they created what is considered Japan's finest body of sculpture.

The best-known of the Kamakura sculptors was Unkei (died 1223), from whose workshop came a continuous outpouring of brilliant works. His wooden figure of Muchaku extends realism beyond idealistic likeness, suggesting that an actual person provided the inspiration. The subject was an Indian patriarch who lived in the Gandharan region centuries before, yet Unkei has imbued him with a natural pose and facial expression that delves into psychological depth. The face alone is a compelling portrait, with its inset, crystal eyes and penetrating gaze. An interest in realism and in portraiture had long occupied Japanese artists and, inspired by Chinese monk portraits, they took the theme to new levels of achievement.

Unkei's influence can be seen among his many followers, who carried his style to greater heights of expressive power, not by simply creating idealized images of the saints and pilgrims described in literary works but through portraits based on observation of the

devout pilgrims who travelled to temples across the country. Unkei's
follower Tankei was responsible for the masterpiece of Basu-ten, in 143
the Sanjusangendo in Kyoto, which remains a moving expression of
artistic skill that captures the passionate devotion of the wandering
pilgrims of the age. Tankei's close observation of those around him
resulted in such details as deep staring eyes and gnarled fingers,
testifying to an intensity of religious devotion. The Late Heian
refinement and melancholy mood is replaced by the focused intensity
born of passionate conviction. Such images struck a responsive chord
among the expanding, popular-based schools of Kamakura
Buddhism.

As part of the rebuilding of Todaiji, Unkei's workshop created two
guardian figures to occupy the newly rebuilt South Gate. Such paired
door guardians appeared in Indian art, although most of their martial
attire and ferocious poses derived from Central Asia. Called *dvarapala*
in Sanskrit, Nio in Japanese, they had long been prominent in Chinese
Buddhism, and Unkei's colossal wooden images, each over 8 metres 141
tall, with their scowling faces and threatening poses, stand at the end
of the long Asian tradition of guardians. Such colossal wooden figures
were made possible by technical innovations that had appeared in

141 Unkei, *Nio*, 1203,
Kamakura period, South
Gate, Todaiji, Nara. Wood,
h. 8.08 metres (*c.* 26 feet)

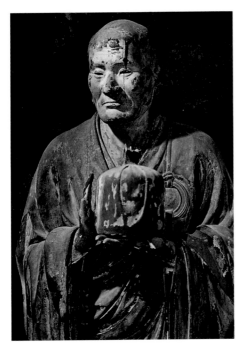
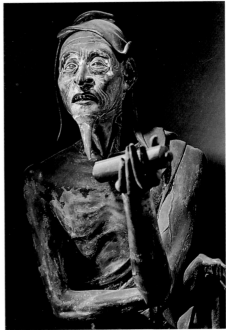

142, 143 Kamakura portraiture: Unkei's *Muchaku* of 1208–12, painted wood, h. 188 (74), and Tankei's *Basu-ten*, a follower of Avalokiteshvara, early 13th century, polychromed wood, h. 154.7 (60⅞), Japan

144 *The Flying Granary*, detail from the first *Shigisan Engi* handscroll, *c.* 1156–80, Japan. Ink and colours on paper, h. 31.5 (12⅜)

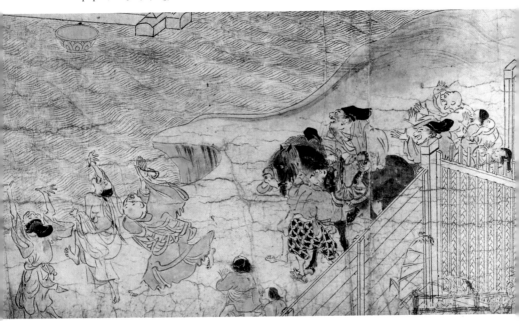

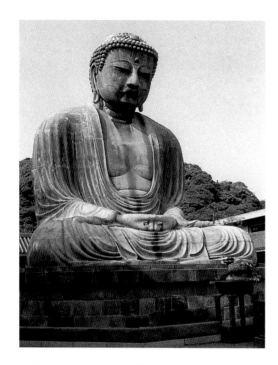

145 Seated Amida,
13th century, Kama-
kura period, near Ka-
makura, Japan.
Bronze, h. 11.4 metres
(37½ feet)

Jocho's workshop in the eleventh century. Multiple, hollow blocks of wood were joined together, enabling the astonishing size as well as mass production, for the demand for images was enormous: one temple alone required one thousand nearly life-sized wooden images of Kannon.

The affluence of popular-based schools also resulted in major artistic commissions through the donations of a broad range of donors. The colossal, hollow bronze Amida near Kamakura, sitting today in the open but once housed in its own temple, was the result of private donations to the Pure Land creed. It is second only to the Todaiji seated Buddha in size and despite some formalizing details, due in part to Song Chinese influence, its proportions and equanimity recall the best traditional imagery from the Nara period and Tang China. It was common practice to insert sacred charms, scriptures and relics inside Buddhist statues, but, in this case, worshippers could physically enter the statue itself. A ladder also leads up into the head, where a small image and shrine could be worshipped. 145

From the last years of the twelfth century there remain a number of illustrated handscrolls with Buddhist themes, a form of art expressing what have been described as the vital elements of the Kamakura 144

period: spontaneity, raw energy and motion. The handscroll first appeared in Japan in the eighth century, borrowed from the Chinese. It provided a miniature format well suited to storytelling. In Kamakura, the handscroll was often used to relate temple histories and episodes from the lives of important monks. At other times it provided opportunities for humorous, even scatological portrayals, for example representing Buddhas as frogs and monkeys as priests, in a brushwork that is dynamic and fluid and that extended creative opportunities for artists and calligraphers beyond the story itself. The Flying Granary scroll, actually a tale of retribution for failing to make proper donations to the faith, has been presented in comical fashion with caricatures of the distraught granary owner chasing after his storehouse as it is abducted by a monk's golden begging bowl.

Important differences between Japanese and Chinese taste are revealed in such handscrolls. In Chinese hands, they tended to be Confucian morality plays, while the Japanese extended the subject-matter deeper into daily life and human nature. This is clear in another late-twelfth-century scroll, the *Gaki Zoshi*, or scroll of the Hungry Ghosts. Related to Pure Land worship and the levels of existence in Buddhist belief (*rakudo*), these illustrations portray the fate that awaits those who fail to recite Amida's name properly or waver in their devotion. The guilty are portrayed as hideous ghosts, their bellies distended and bones protruding, forced to scavenge about, unable to enjoy one moment of comfort and able to feast only on residue or on faecal matter, while the living go about their ordinary lives oblivious to the suffering of these wretched, invisible beings. Here the Japanese interest in genre subjects and caricature is fully revealed. Yet the portrayals are done without malice, rather with affection for the humble worker who endures the difficulties of everyday life, in stark contrast to the grotesque sufferings of the damned or the biting, satirical depictions of corrupt priests.

The appearance of Japanese Zen Buddhism occurred rather late: the Rinzai sect was established in 1191, and Zen was most successful during the late Kamakura and Muromachi periods. It was given impetus by renewed visits to Chinese Chan temples and the Japanese shift in values from the delicacy and courtly refinements of the Late Heian period to the pragmatic, austere taste favoured by the Kamakura rulers. Despite its adherents' cultivated aversion to images and ritual paraphernalia, Buddhist art remained important in Zen temples. Instead of images of Amida and his paradise or the multi-limbed figures of the esoteric schools, the art of Zen emphasized

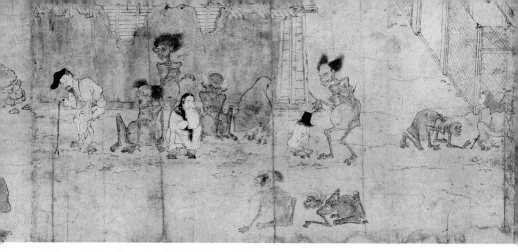

146 *Hungry Ghosts* from the *Gaki Zoshi* scroll (Kawamoto version), late 12th century, Kamakura period, Japan. Ink and colours on paper, h. 27.3 (10¾)

portraits, austere ink paintings, calligraphy and direct aids to meditation, including the well-known sand and rock gardens. Their choice of subjects and emphasis upon intuition and direct learning resulted in a body of works different from those of other schools, although the goal of understanding, of liberation, remained consistent with Buddhist practice. Instead of the painting or sculpture having a special magic or embodying a cult force, Zen works functioned as a stimulant, an activator of one's spiritual growth. Zen objects generally rely on suggestion and intimation, demanding that the devotee should play a greater role in the search for personal enlightenment.

149

Of central importance were the portraits of Zen masters, and temples featured image halls with both sculptures and paintings, for the monk portrait, or *chinzo*, served as an emblem of the unspoken bond between master and pupil. As one moved towards enlightenment, a portrait of the master served to document the intuitive link between the two, and was often given an added personal meaning by the addition of the master's calligraphy. One of the most popular portraits was that of Bodhidharma, the fifth-century monk from India and founder of the Chinese Chan school who was the legendary patriarch of the major line of Zen masters. In keeping with Zen's irreverent strain, Bodhidharma is often portrayed humorously, a further assault upon traditional Buddhist practices. The technique of applying black ink spontaneously to white paper also emphasized the importance of immediate understanding, the foundation of Zen

148

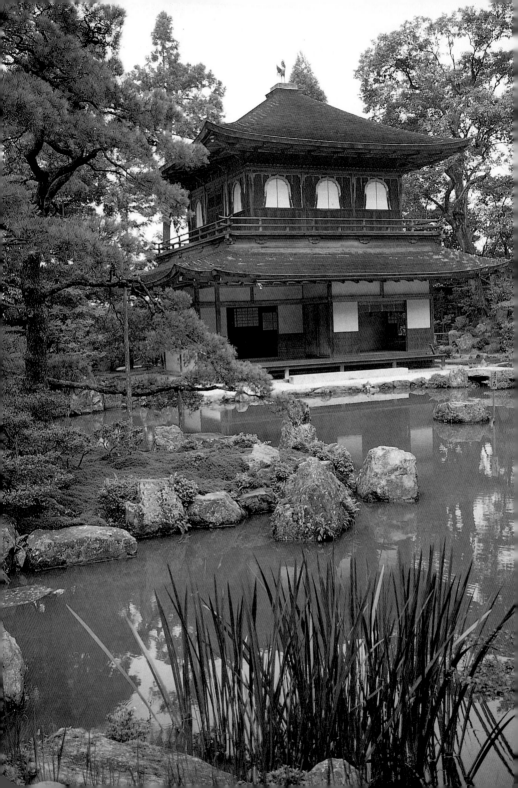

147 Ginkakuji (Silver Pavilion) and pond, completed 1489, Muromachi period, Kyoto

148 Hakuin Ekaku, *Bodhidharma* (Daruma in Japanese), mid-18th century, Edo period, Japan. Hanging scroll, ink on paper, 126 × 55 (49½ × 21½)

practice. Such ink painting derived from China, especially during the Yuan period, although the spontaneity, humour and details of nature are elements of the Japanese artistic tradition.

The art of garden building had long been practised in the Far East and Muromachi shoguns continued the Heian pattern by placing pavilions amidst sand and water gardens. The building provided both a private temple for worship and an austere room for meditation and drinking tea. Such an arrangement is found in the Ginkakuji, or Silver 147 Pavilion, a mixture of native and foreign motifs, with its sand and water gardens intended to replicate the Pure Land. The cedar roof recalls Shinto and Buddhist shrines of the Early Heian period, the second-floor windows repeat the Indian *chaitya* motif and the bronze phoenix at the peak is a reference to the famous Byodo-in. However, its overall simplicity and modest size conformed with the Zen love of understatement, readily apparent when it is compared with the opulent Fujiwara masterpiece, the Byodo-in. 138

It was among Zen temples that garden art achieved its most extensive application. Most temples favoured smaller, abstract gardens, suggestive rather than literal, with raked sand and a few stones, arranged in front of a meditation platform and meant to be viewed from a fixed location rather than entered. The most famous of all rock gardens is Ryoanji, in Kyoto. With its fifteen artfully placed 149 stones, carefully raked sand and limited vantage points, along two of the four sides, it invites contemplation and analysis, and its

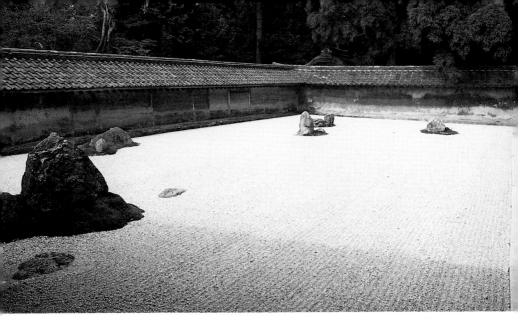

149 Rock and sand Zen garden, constructed 1480s, Muromachi period, Ryoanji, Kyoto

interpretation continues to challenge Buddhists and visitors alike. As a monk suggested, at one point in time we see ourselves like the fifteen individual stones, large and important, appearing to be going somewhere, to be moving ahead, an illusion created by the raked sand. Yet one day we will each be no larger and no more important than the countless small pieces of gravel (each of which had once been a large, important stone) that make up the gravel that surrounds the fifteen at best momentarily important stones. The cycle will repeat itself, endlessly, and therein is the lesson of the impermanence of things.

By the end of the Muromachi period, Buddhism had assumed a broad-based yet secondary position in the general life of the country. With its diminished role also went the artistic fervour that had been so much a part of its history. The calligraphy and ink paintings of Zen masters continued to provide artistic stimulation, but Buddhist sculpture and painting otherwise became a matter of replacing older forms, without renewed vigour. The decorated screens and walls of temples and palaces began to merge into a national style, at times similar to earlier Buddhist ink painting but now serving patrons with growing secular interests. What emerged was a national style, no longer a Buddhist style, of art.

South-East Asia

The migration of peoples and ideas from India was the major influence upon South-East Asian culture, shaping cultural expression, from art, mythology and written language to religion, mathematics and science. Seldom in history has one culture been so thoroughly yet peacefully transferred to another region. Only the northern half of Vietnam, due to proximity to China and active Chinese colonization, evolved largely outside the Indian sphere of influence.

South-East Asia comprises two large areas: part of the Asian mainland, and the nearby Indonesian islands of Java and Sumatra. In the first millennium, the mainland region came to be dominated by three ethnic groups: the Cham peoples along the south-east coast, where the northern area became Vietnam; the Cambodians in the central Mekong valley, an area known earlier by the Chinese names of Funan and Zhenla; and the Mon peoples to the west, who largely controlled the Menam and Irrawaddy valleys, an area ultimately to become Thailand and Burma.

Hinduism preceded Buddhism in the region, especially among the ruling classes in the eastern areas of the mainland. Although Buddhism was introduced by the second or third century, it did not become established in the central areas until the sixth and seventh centuries, enjoying most success among the Mon peoples. Mahayana and Vajrayana systems were reported by Chinese pilgrims in the seventh century, but Theravada Buddhism ultimately came to dominate most of the region, a position that it holds to the present time in Thailand and Burma but, due to modern political events, to a lesser extent in the other regions. The earliest Buddhist images were the sculptures carried from India by monks and traders, known today from several large bronzes discovered at widely differing sites, from the Celebes Islands to Vietnam, Thailand and Java. Although 150 differing in stylistic details, these first statues, possibly dating as early as the fifth century, appear to have originated in Sri Lanka or south-eastern India. The religion became so widely accepted among the

167

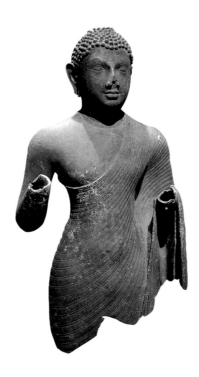

150 Sri Lankan-style Buddha, 8th century, from West Sulawesi (Celebes Islands). Bronze, h. 75 (29½)

diverse cultures that probably more Buddhist images have been produced in this area than in any other region of Asia, and surely no single country has produced more temples and stupas than Burma.

In the broadest terms, the development of South-East Asian Buddhist art can be grouped into three stages. The introductory period lasted about five hundred years and was important for the acceptance and growth of the religion and the settling of the area's political boundaries. The earliest indigenous Buddhist works of art date from before the eighth century and are close derivatives of Indian models, resulting from the area's position along the international east-west trade route. The seventh-century Chinese pilgrim Xuanzang was able to relate stories of Buddhist activity in Cambodia, Burma, the Malay peninsula and the Dvaravati kingdom in Thailand, and his remarks about Vajrayana practices in Sumatra provide evidence of the close contact with contemporary Buddhism in India.

Of greater importance for Buddhism were the eighth to tenth centuries, when powerful kingdoms, such as the Shailendra in central Java, produced some of Asia's greatest Buddhist monuments, most 174–7 notably the Borobudur. At the same time, the largely Hindu

kingdoms of the southern mainland, Funan and Zhenla, succumbed to the emerging Khmer kings, also Hindu but often supportive of Buddhism. In the central area of Indochina, Mon peoples established Theravada Buddhism by the seventh century, forming the Dvaravati kingdom. Meanwhile, in Burma, the elements for the first great kingdom at Pagan were in place by the tenth century. Thus, by the year 1000, Buddhism was well established in areas of the Mon peoples, in what would become Thailand and Burma. In Java, Buddhism had already enjoyed its greatest success, but it was yet to realize its finest achievements in Cambodia.

The last major period of South-East Asian Buddhist history, between the tenth and fifteenth centuries, marks the peak and then decline of Cambodian power, the waning of Javanese influence and the end of Cham independence, the latter due largely to wars with Cambodia and pressure from Vietnam to the north. From their beginnings in the twelfth and thirteenth centuries, following the decline of the earlier Dvaravati, the Thais emerged to prominence and assumed an increased regional role. By the end of the fifteenth century, Thailand and Burma were often at war, and Cambodia was losing most of its political influence and some of its territory to stronger neighbours. In modern times, Thailand and Burma have remained the most viable Buddhist areas; Cambodia and southern Vietnam are still actively Buddhist, but their relative lack of political strength in the face of more powerful neighbours limited artistic development.

REGIONAL FEATURES

Distinct national styles developed in most areas late in the first millennium — even later in Thailand, in the thirteenth century at Sukhothai. However, by the sixth century, common regional features in the Buddhist art clearly different from Indian models were appearing, despite the variety of ethnic and cultural differences and the eventual development of national styles.

One of the area's shared concepts was the belief in the cosmological role of Meru, the sacred mountain. This Indian ideal of the temple as the centre of the universe appeared early in the first millennium, in Funan (which means mountain), and came to direct the arrangements of complex religious monuments, Hindu and Buddhist, resulting in some of the grandest architectural displays in the Asian world. With the main shrine at the centre, the temple complex was oriented to the

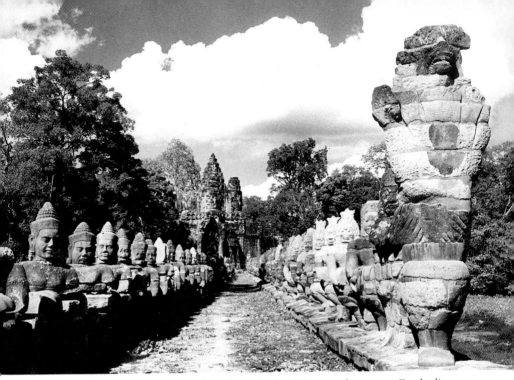

151 Naga (serpent) balustrade to Angkor Thom, 13th century, Cambodia

cardinal directions, with various other components used to express
the linkage between the human world and that of gods, between
heaven and earth. For example, Cambodian builders placed serpent
balustrades along the bridges that crossed the surrounding moats, for
as water symbols, serpents linked heaven and earth. This illusion of
passing from one world to another was also repeated with arched
entrance gates, the passage through which indicated transit between
the two worlds. Heaven's blessings then flowed outward from the
temple, the centre of the universe or world of the gods, through the
arched gate and across the serpent-railed bridge, to the benefit of
humankind. Likewise, in Thailand the central tower dominated the
temple complex, reaching high into the sky, and in Java the concept of
the sacred mountain was so pervasive that not only temples but even
villages were organized as microcosms of this universal vision.

 Another important regional feature was the cult of the god-king,
the identification of a ruler with the deity, which served to elevate the
king to semi-divine or even divine status. Although known in India, it

151

was developed in South-East Asia to ever more sophisticated levels, especially in Cambodia, Java and Champa. The portrait of Cambodia's Jayavarman VII captured both the physical likeness and wisdom 172 of a human king and the omnipotence and serenity of the bodhisattva Lokeshvara (a form of Avalokiteshvara), a combination perfectly suited to the theocratic government of the Khmers. Divinity is brought to the human form but not at the expense of its humanity. The merging of royalty and the divine was even to affect traditional portrayals of the Buddha, with jewelry and crowns added to the images.

The customary Buddhist practice of embracing elements of native, pre-Buddhist religious traditions was also followed. The Indian legend of the protective serpent Muchalinda serving the Buddha during meditation was readily understood in mainland South-East Asia. Minor variations identify local artistic treatments of the theme, such as the arrangement of coils or the placement of the Buddha's legs, but the image remained dominant in the region. Khmer and Thai examples added a crown and jewelry to the Buddha, linking the 157 subject with the concept of the universal monarch. In the case of 171 Cambodia's greatest Buddhist patron, Jayavarman VII, the image was placed at the centre of his largest temple, the Bayon, and was possibly even rendered in his own likeness.

An important feature of stone carving in the region was the tendency towards full, three-dimensional form. Unlike in India, where most stone sculpture was in high relief, large figures, fully modelled on all sides, can be found as early as the sixth century in Cambodia and shortly thereafter at Si Thep in northern Thailand. Javanese guardians, from Chandi Sewu and the Borobudur, are 178 among the most impressive of such three-dimensional images. In addition, the area was known from early times for its abundance of gold. Chinese records report receiving thousands of pounds, shipped in the form of ingots, perhaps one of the reasons for the paucity of gold images remaining today. One of the most vivid impressions upon modern-day tourists to Bangkok is made by the 'solid gold' Buddha, and in shrines across the land devotees still purchase small, thin sheets of gold foil to press upon the surface of auspicious images, eventually obscuring the facial features.

One of the notable architectural motifs in South-East Asia is the decorative treatment of the temple doorways, which often become a primary area for relief sculpture. With the Buddhist temple functioning as both a residence for the deity and an earthly example of

the heavenly realm, the entrance, which included gateways and processional paths, assumed increased significance. Cambodian temple doorways were distinguished by elaborately carved lintels, the adjacent panels enriched with figures and vine scrolls and the entire ensemble framed by rows of balusters. In the early Khmer temples the entire door, including its frame, sill and decorative panels, was cut from a single monumental stone and this was further enhanced by overlaying a second set of wooden doors, also richly carved and painted. The Javanese amplified the Indian demonic mask, the *kirtimukkha*, into expansive displays over doors and niches. With the widespread use of stucco and terracotta, often in conjunction with stone carving, these decorative areas could be readily enlarged and the details increased.

152

As in other parts of Asia, the stupa assumed a variety of regional forms. For example, the tall, majestic Thai and Burmese stupas followed Sri Lankan styles, a continuing influence upon much of the area's art. However, in Vietnam and Cambodia, the separate stupa rarely appears, except in small, votive examples inside the complex, as Buddhist temples were designed on the temple-mountain plan, an arrangement without a place for the free-standing stupa. Countless small stupas adorn the terraces of temples in Java, such as the Borobudur (although some view the entire monument as a giant stupa), often becoming more a decorative addition than separate entities. Instead of a free-standing stupa, it often became the crowning element of the temple, as found at Chandi Sewu. In the later Javanese syncretic Shiva–Buddhist temples, this crowning stupa is the sole Buddhist aspect of an otherwise Hindu monument.

THAILAND

Thai Buddhist art can be separated into two distinct periods. The first, shaped by Mon peoples and called Mon or Dvaravati, emerged by the fifth century and lasted until the Khmer invasions five hundred years later. For the next two hundred years, the Khmers exercised authority over the region, until the continuing build-up of migrating peoples from south China, aided by Mongol pressure from the north, resulted in a fresh mix of peoples and finally in the formation of a new state. From that point the modern Thai nation emerged, with the most important of the early capitals at Sukhothai, and the primary influence upon its dominant Theravada Buddhism coming from Sri Lankan monks, evident from the early monuments at Sukhothai.

152 Doorway with *kala* (demon) mask and *makaras* (mythical beasts), 8th century, Chandi Kalasan, Java, Indonesia

The first Dvaravati images may well be the earliest original Buddhist sculptures of South-East Asia, as the French art historian Boisselier has noted, and their facial features suggest a Mon ethnic 156 type, despite their Gupta and south-east Indian antecedents. The particular themes and variations in iconography were of importance for subsequent imagery, for the same group of subjects remained popular in later Thai art. It is interesting that the most popular Dvaravati subjects were those most readily related to indigenous, pre-Buddhist beliefs and chosen from those events occurring within a succinct period of time in the story of the Buddha's life, beginning with his final meditation, prior to enlightenment, and ending with his first sermon in the Deer Park at Sarnath. An event such as the Miracle 154 at Sravasti was appealing because of the traditional Thai fascination with magic and the spiritual world; while the theme of the Buddha sheltered by Muchalinda, an episode that occurred weeks after the 157 Enlightenment, recalled indigenous, animistic beliefs. Despite being celebrated in Buddhist literature, the protective serpent theme was infrequently portrayed in India. However, it remained consistently popular in Thailand and Cambodia, a region well suited to the subject, with its rivers, jungles and snakes.

154 Miracle of Sravasti, relief, Dvaravati period, from Ayudhya, Thailand. Stone, h. 129 (50¾)

Among the favourite Dvaravati subjects was the Enlightenment, when the Buddha's superior powers of intellect and yogic control enabled him to overcome the temptations of illusion and evil, personified as the demon Mara. The *maravijaya* pose, with the seated

159 Buddha reaching down to touch the earth, in the *bhumisparshamudra*, was to become the most frequently portrayed Thai image. A second

155 distinctive Dvaravati type was the standing Buddha, with both hands held chest-high, with palms forward, in what appears to be a variation of the *vitarkamudra*. The scholar Alexander Griswold, among others, has claimed that this particular image and gesture is actually a variation of the gesture of teaching or exposition, *dharmachakramudra*,

42 as seen in the famous Gupta Buddha from Sarnath. If so, the Thai figure would refer to the First Sermon, following the Enlightenment,

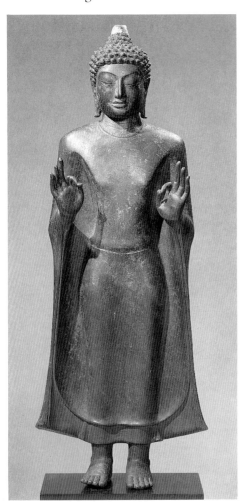

155 Standing Buddha, 9th century, Dvaravati period, from Thailand. Bronze, h. 68 (26¾)

156 (*below*) Bodhisattva (detail), 7th–8th century, from Ratchaburi, Kua Bua. Terracotta, h. *c.* 90 (35⅜)

157 (*right*) Buddha Muchalinda (the serpent), 12th century, from Thailand. Gilding on stone, h. 184 (72½)

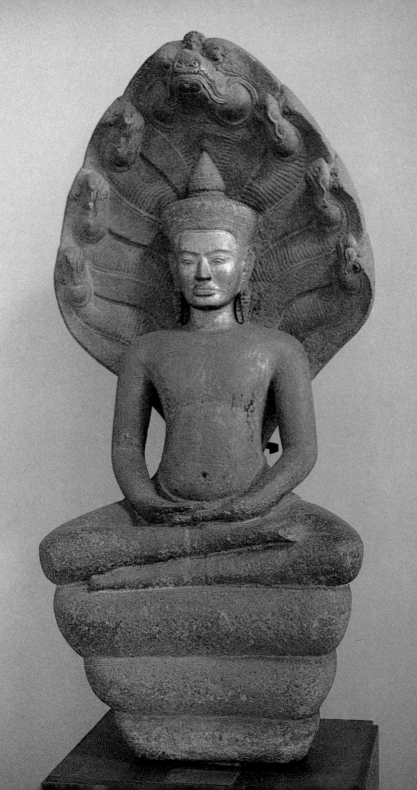

for despite the significance of the teaching gesture, a *mudra* unique to Buddhism, images in the *dharmachakramudra* are not found in Thailand or Cambodia.

Another distinctive Dvaravati stone image was a wheel, at times alone, in some instances accompanied by deer, and in a few examples placed behind the seated Hindu sun god Surya. Originating from the Ashokan wheel-topped pillars, this theme achieved its greatest popularity in the Dvaravati period, and some forty examples remain today. Beyond its obvious reference to the First Sermon in the Deer Park and the act of setting the wheel of Buddhist law in motion, this emblem is another instance of the variations and adaptations conceived by Buddhist artists in different cultures. The Dvaravati artists also worked in terracotta and stucco, often using moulds, applying figures and architectural elements, such as finials and small surface details, to the outside walls of temples and stupas. Despite the fragile nature of the material, enough remains to indicate considerable skill, as well as creative variations. The latter are due especially to the malleable nature of clay, and the medium continued to be widely utilized in later Thai art.

The emergence of the Thai style (from the 13th century)
The end of the Dvaravati period is marked with the Cambodian invasions of the tenth century, and the art is modified by Khmer styles until the establishment of an independent kingdom at Sukhothai, beginning around 1240 and lasting until 1438.

The Sukhothai-style Buddha, the most distinctive of Thai images, appeared in the thirteenth century and, despite subsequent political events and artistic changes, it remained Thailand's best-known style, represented in two specific images, one seated and the other walking. The seated figure, in the *maravijaya* pose first seen in Dvaravati, now assumed a more distinctive Thai manner, with greater stylization of the hands and proportions of the body and the addition of the flame *ushnisha* on top of the head. A remarkable image, which combines Thai ethnic features with yogic tranquillity and inner power, it records the auspicious moment in a unified blend of grace and abstraction. The extended proportions and high level of abstraction derive from Indian written descriptions of the Buddha, in similes that describe the physical forms of the gods by relating the various parts of the human body to characteristic aspects of nature. For example, his eyes should appear as lotus buds, his nose like a parrot's beak and limbs as smooth as those of a banyan tree. The Sukhothai Buddha is the most

156

159

abstract of the images of the Buddha, a tribute to the Thai ability to blend religious meaning and literary descriptions with a sophisticated artistic sensibility to produce a remarkable and original creation of transcendent spirituality in a human form.

The other major Sukhothai image is the walking Buddha. This 158 arresting and unique image is equally stylized but exhibits the delicacy and grace of the dance rather than the typically iconic frontality of most Buddhist images. Throughout Asian art, when meant to be shown walking, the Buddha is instead presented standing, both feet firmly upon the ground, with little more than a glance to suggest movement. It is appropriate that a truly walking Buddha image appears in a Theravada context, for the begging, mendicant monk remained crucial in the daily ritual of the traditional Buddhists. This figure may also be one of a general group of images that convey the belief in the inevitability of the Buddhist message, such as the inexorable turning of the Wheel of the Law or the irresistible force of the Vajrayana emblem of the thunderbolt. In this instance, the walking Buddha indicates the steady and resolute victory of the Buddhist law, reflected in this confident, striding figure.

158, 159 Sukhothai sculpture of the 14th century in Thailand: Walking Buddha, bronze, h. 220 (86⅝), and Buddha subduing Mara, bronze, h. 122 (48)

The later sculpture of Thailand favoured bronze over stone, exploiting technically brilliant casting skills that permitted extremely thin surfaces. It tended to repeat, with local variations, the Sukhothai model, achieving increased delicacy and greater stylization.

Sukhothai architecture, deriving in part from that of the preceding Khmer occupation, retained the earlier Dvaravati use of brick construction, stucco niches and terracotta figures. Much of the Sukhothai style also resulted from renewed contact with Sri Lanka.

160, 161 Thai painting: mural, probably 18th century, and illuminated manuscript showing the birth of the Buddha, 1776. Manuscript h. 23 (19)

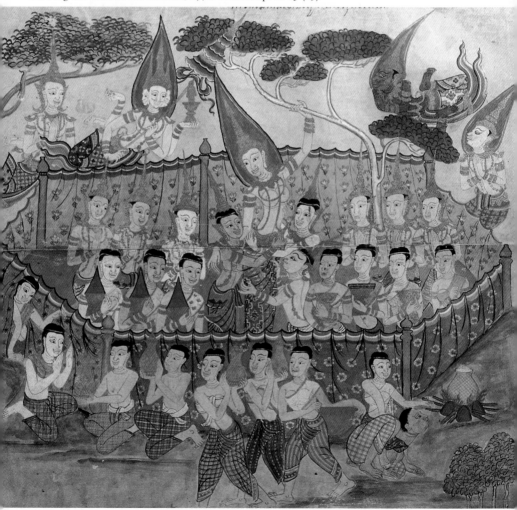

162 Brick and stucco stupa, *c.* 15th century, Ayudhya

Unfortunately, nearly all Thai architecture has been damaged, especially during the Burmese wars, although several reconstructed
162 stupas, for example at Ayudhya, indicate the stylistic directions that continued throughout later Thai art. Modern-day Thais point to the lotus bud spire, known also through reconstructions, as the particular contribution of Sukhothai builders. The Khmer tower, or *prang*, a gently curved shape ending in a point, remained popular but outside the main Thai tradition. After the Burmese sack of Ayudhya in 1767, Thai Buddhist architecture came to rely on more decorative elements, especially delicate surface patterns. With the final move to Bangkok came added Chinese influence, and a combination of delicacy and surface decoration, especially in wood, resulted in graceful reminders, if not copies, of traditional styles.

The greatest losses have been to Thai painting, for extant murals
160 rarely date from before the eighteenth century and can only suggest
161 the colourful and imaginative but now lost tradition. The Thai and similar Burmese illuminated manuscripts remain among the largest and most colourful examples of this form of Buddhist art. As with most Thai art after the thirteenth century, and despite Chinese and

182

Islamic elements, the style of these paintings retained a distinctly Thai flavour in their delicate, linear drawing, bright colours, textile patterns and ethnic features. They differed from Indian models in their greater size and in construction, being folded accordion-style, rather than as separate leaves.

BURMA

Despite its proximity to eastern India, Burma (or Myanmar, according to the present government) has historically been more aligned with the cultures of South-East Asia. It shared a Mon ethnic heritage with Thailand and was also strongly influenced by the Theravada Buddhism of Sri Lanka. Although Buddhism occurs in Burma early in the first millennium, the first appearance of the distinct Burmese style and the oldest Buddhist structural remains coincide with the Pagan period (1044–1287). The assumption of the throne by King Aniruddha in the mid-eleventh century began the unbroken dominance of Buddhism and although Mahayana and Tantric practices did continue, the ultimate triumph belonged to the Theravada, cultivated by Sri Lankan influence. The dedication of Burma's grandest temple, the Ananda, in 1105 could be viewed, in chronological and artistic terms, as the first indication of the shift to the Theravada, although influence from the adjacent Pala kingdom ensured continued Mahayana activity.

Burmese art has maintained a consistent and distinctive style, which has often extended beyond the country's borders, for active Burmese patrons have contributed countless statues to temples throughout Asia and to modern shrines in the Western world as well. Although the limited number of subjects in the Theravada system meant repetition, it could also result in an expressive elegance, long associated with Burmese art. Rather than increasing the variety of image types, the Theravada system cultivated a belief that merit could be gained by making yet another image of the Buddha. The sheer number of identical Buddha images inside countless niches and painted upon temple walls became an integral feature of Burmese art. These figures of the Buddha, with the *urna* between downcast eyes, the stylized 163 garment hanging over the left shoulder and the flame-topped *ushnisha*, are the most widespread images in Burmese art.

The theme of the moment of enlightenment, when the Buddha proclaimed his victory over Mara by reaching down to touch the 164 earth, appeared during the Pagan period and became Burma's best-

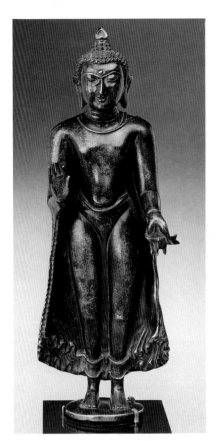
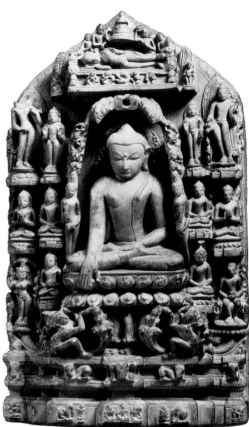

163 Standing Buddha, 11th-12th century, from Burma. Bronze, h. 33.1 (13)

164 Stele with scenes from the life of the Buddha, 12th-13th century, from Burma. Gilding on sandstone, h. 19.7 (7¾)

known image. Although the subject is found throughout Asia, the Burmese invested it with particular significance. While artists elsewhere made the Buddha merely point towards the earth, or barely touch it, the Burmese artists turned this gesture into a commanding signal, a proclamation that dominated entire scenes. Even when the Buddha is surrounded by other figures, as on the small plaques that illustrate events from his life, this gesture remains the dynamic, visual centre, the focal point around which all else revolves. Despite the variety of poses of the surrounding figures, the other seated images remain visually linked to the central Buddha. Repeating the posture

164

of the central Buddha, each figure leans slightly forward, with eyes downcast, providing an even, rhythmical balance, a visual unity within a complex composition, helping to focus attention upon the figure in the centre, who provides the most emphatic example of the *bhumisparshamudra* in Asian art.

In the fourteenth century, there appeared another version of this subject, and one that continued to be popular in Burmese art, with the Buddha adorned with jewels and an elaborate crown. Unlike in Cambodia, where this enriching of the image of the Buddha was often the result of the ruler's desire to be identified with the deity, in Burma the transformation of the traditional, robed Buddha into a wordly monarch involved a story from the life of the Buddha. In this, the Buddha was faced with the task of converting a powerful, earthly monarch who was unwilling to respect the advice of a humble teacher. The Buddha therefore assumed the guise of a universal monarch, overwhelming the proud and materialistic king Jambupati on his own terms, then converted him to the Buddhist path. However, it is likely that the story itself came after, rather than preceded, the appearance of crowned Buddha statues, for these images were well known in Mahayana practice and provided an opportunity for Theravadins to include such resplendent portrayals among their more limited range of subjects.

The favourite material for Burmese architecture is brick, covered by stucco, which is decorated by carving into it and adding terracotta plaques. Covering the brick with stucco created the appearance of stone construction, giving Burmese temples the look of massive Indian stone temples. Thus, the larger temples at Pagan, such as the Ananda, and the multi-tiered Pitakat Taik library, have the heavy, horizontal emphasis of Indian shrines. Only when viewed closely do the Burmese surface decoration, the finials and acroteria, and ultimately the brick and stucco construction become visible. In this regard, Burmese architecture differs from that of most of South-East Asia, where wooden styles generally continued to be followed despite the shift to more permanent materials.

The Burmese stupa is a distinctive, multi-tiered combination of both Indian and Sri Lankan sources, continuing the traditional three-part division, with a square, stepped base, bell-shaped body and towering spire. Of brick construction, like the Burmese temple, it also had the appearance of Indian monolithic stone construction. The typical Burmese style is preserved at the Shwedagon in Rangoon, first constructed in the fourteenth or fifteenth century but many times

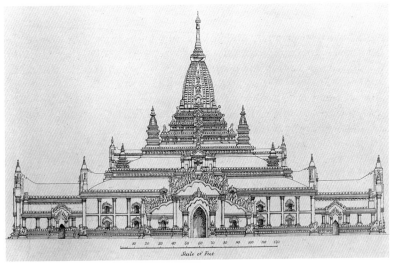

165 Reconstruction drawing of the Ananda temple, 12th century, Pagan, Burma

refurbished and one of Asia's best-known monuments. The beauty of the Burmese stupa lies in the merging of the parts into a single unit, from squared base to round body and finally to the multiple umbrellas and pointed finial. Unlike the builders of many early examples, such as those from Gandhara, where the base, body and spires are clearly demarcated, the Burmese achieved a coherent unit, distinguished by its smooth profile and tapered tower. This was aided by eliminating the *harmika*, a prominent element in Indian and Sri Lankan stupas, in favour of a slender column of umbrellas (*chhatraveli*), and by multiplying, but not widely separating, the horizontal elements. This effect is aesthetic whether it occurs on colossal structures, as with the Shwedagon, on the small votive stupas carried home by pilgrims or on the countless versions decorating the terraces of temples. Among the many variations of the stupa across Asia, the Burmese remains one of the most artistically successful, subordinating the parts into a coherent whole that unified the original form while retaining the dignified majesty of its purpose.

CAMBODIA

An area roughly similar to that of modern Cambodia had earlier been known as Funan, until its absorption by Zhenla in the sixth century,

by which time a series of Hindu kings had assumed power. After expelling Javanese interests, Jayavarman II established the first Cambodian kingdom in 802, beginning the 500-year reign of the Khmers. The early Hindu kings, according to Chinese records, had also supported Buddhism, and this patronage increased in the eleventh century, culminating in the achievements of Cambodia's greatest Buddhist king, Jayavarman VII (ruled 1181–1219).

The most distinctive Khmer religious belief was the cult of the god-king, inherited from south India and Funan, but expanded beyond its original scope. The concept of the divine/human king as the focus of the universe influenced the layout of temple complexes, with the primary shrine being the temple mountain, the centre of the universe. The grandest examples were the Angkor Wat, a Hindu monument, and the nearby Buddhist structure, the Bayon, the focal point of the 166 enormous Angkor Thom complex. Thus, Cambodian shrines became elaborate arrangements of walls, moats and bridges surrounding a raised platform, usually with five towers to correspond to the five peaks of Meru and dominated by a single sanctuary, housing cult images of deified ancestors, that further linked the ruler and his family

166 Plan of the Angkor temple complexes, reservoirs and canals, Cambodia

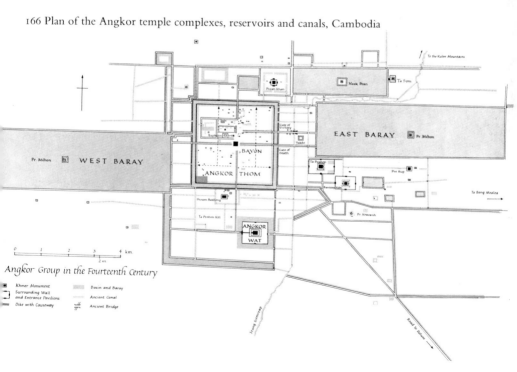

with the divine. In the succinct words of the pioneering Frenchman George Coedès, – 'it was the king who was the great god of ancient Cambodia'. Each monarch constructed his separate temple, resulting in a continuous building programme covering some five hundred years that rivalled those of the Egyptian pharaohs in its magnitude.

A coherent, structured vision of the universe is fundamental to most religions, but seldom has the concept been translated into such a consummate artistic form. As noted in the Introduction, this cosmological vision began with a belief in the proper relationship among all creatures, the natural order of nature and humankind. In a near mirror image of the contemporary literature of medieval Europe, Buddhist cosmology supported a belief in the essential harmony of the universe and a feeling that humankind's creations must conform with that greater plan. In Cambodia, this cosmology was closely linked to belief in the god-king, placing the living Khmer king in the central position, with the temple as the physical presence that symbolized his imperial role. This temple mountain was not a place of group worship but rather functioned as the habitation of the god-king, an earthly palace also suitable for the celestial gods.

Extraordinary engineering feats were needed to re-create this system of beliefs, but, unlike in the case of the tombs and pyramids of the Egyptians, these efforts were also linked to economic needs. In Cambodia, the welfare of society depended upon controlling the rivers, through extensive canal systems laid out with extreme accuracy. One canal, some 65 kilometres long, is almost perfectly straight, while the three-kilometre moat surrounding one temple had an error of less than 5 centimetres. Khmer genius is best understood in terms of this blend of religious belief and practical engineering achievements. It resulted in the elaborate temples and remarkable hydraulic constructions that enabled the civilization both to re-create the grand cosmic vision and to control and utilize the waterways for its agricultural requirements.

Most Khmer Buddhist monuments belong to the thirteenth-century reign of Cambodia's greatest builder, Jayavarman VII. His greatest structure, the Bayon, closely follows earlier Khmer practice with its pyramidal towers, walls of relief carvings and cosmological orientation. The central pillar of the 'world mountain' had to be rooted in the earth to a depth equal to the height of its spire that rises into the sky. (Buddhist belief required the inclusion of entire pillars, including enormous single pillars at the centre of wooden pagodas in East Asia.) At the Bayon, the subterranean aspect is also represented

167
168

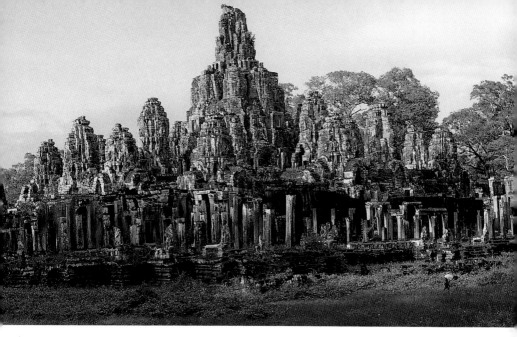

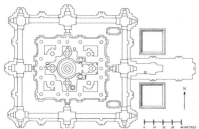

167, 168 The Bayon, 13th century, Angkor, view and plan

figuratively by a giant fish, symbol of the depths of the ocean, sculpted along the base. The complexity of the Buddhist cosmic vision prevented a complete structural re-creation, but the essential elements could be expressed. Most important was the central temple, identified with the mystical Mt Meru; it was the largest of five towers and was centred on top of a series of set-back platforms, the levels entered through arched gates. The surrounding moat, representing the great ocean, with the enclosing wall beyond as the mythical wall of rock, completed the grand cosmological scheme. The surrounding galleries, forming a sort of cloister around the temple mountain, also provided locations for images of various deities such as guardians and apotheosized relatives and ancestors. At the Bayon, these surrounding galleries also contributed to the illusion of the vastness of the universe

189

as one peered through, out across the open spaces that lay beyond the central complex, yet still enclosed within the moats and walls.

It has been suggested that the bridges crossing the moats and connecting the central shrine to the abode of man corresponded to rainbows, which had often been portrayed as a serpent that reared its head towards the sky or drank from the sea. Such serpents typically appear at the ends of the balustrades of bridges and at the entrances to Khmer temples. These long *naga* balustrades also recall the ancient Hindu myth of the churning of the Sea of Milk, as rows of gods grasped a giant serpent to churn the worlds out of chaos, a legend popular with Khmer rulers. At the Bayon, the central temple tower was the pivot, emblem of the king as provider of good fortune, extracting victory from his temple and projecting his goodness across the rainbow bridge and into the grateful human world beyond.

Three monuments in the Angkor area, dating from the reign of Jayavarman VII, display some of the scope of Khmer Buddhist architecture and imagery, from portrayals of episodes in the Buddha's life to complex monuments still not fully understood. The first is Preah Palilay, located a few hundred metres from the Bayon, whose temple pediments feature episodes from the life of the Buddha, such as the defeat of Mara and the taming of the wild elephant of Nalagiri. They are among the few examples of these subjects in Khmer art, a tradition that favoured the Buddha-king and grand cosmological visions over episodes from the life of the Buddha.

The second monument is located on the outskirts of Angkor but joined to the main temples through waterways. This small group of tanks, known as the Neak Pean, is a miniature, simplified model of an aspect of the Buddhist cosmology. Here Jayavarman VII's love of symbolic representations, difficult to discern amidst the scale and complexity of the Bayon, can be more immediately understood. The Neak Pean re-creates a famous site in Buddhist mythology, the southern island of Jambudvipa. This is the home of humans, and at the centre is the Himalayan Lake Anavatapta, the sacred springs visited by Buddhas, bodhisattvas, saints, hermits and afflicted people. The healing waters flowed out from the lake in the cardinal directions, through fountain-heads in the forms of a lion, an elephant, a horse and a bull, the same four creatures found upon the drum of the famous Sarnath lion-capital.

At the centre of the Neak Pean is a square tank, in the middle of which is a small, circular stone tower, on a round, stepped plinth, in turn encircled by two serpents, their raised heads facing east and their

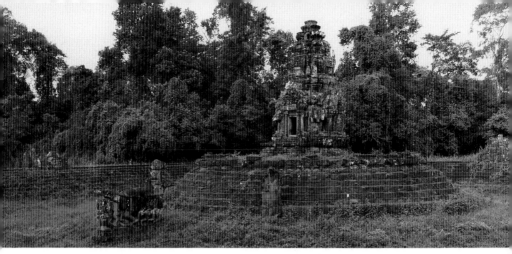

169 Neak Pean's central tower and reservoir, 13th century, Angkor

entwined tails to the west. This whole is surrounded by four smaller tanks, connected by water-spouts which end in the heads of a horse (facing west), an elephant or perhaps a *makara* or mythical beast (facing north), a lion (facing south) and a human being (facing east). The substitution of a human head for that of the bull may be another instance of Jayavarman using his own features, a practice already much in evidence throughout Angkor. It would appear that a Buddhist priest, standing on the steps that enter the central pond, poured the sacred water by hand, into a spout, which then flowed out through the carved heads and down upon the worshipper, who stood below, inside a small stone cave, but not visible to the priest. The devotee stood upon a pair of carved, stone feet, directly beneath the head, to receive the sanctified and healing waters. Two of the pairs of carved feet remain today, one larger than the other, perhaps indicating male and female sizes.

The eloquent Neak Pean, a miniature version of the mythical Himalayan lake, with its channels representing the healing waters of the four great rivers, is dedicated to the lord of compassion, Lokeshvara, the form of Avalokiteshvara favoured by Jayavarman VII. In the main tank is a colossal stone horse with figures clinging to its sides, portraying the saving of drowning sailors by the compassionate bodhisattva. Excavations have revealed fragments of three other statues, completing the symmetry of Jayavarman's vision.

The third monument is the Bayon, the only complete Khmer Buddhist temple and a majestic tribute to Jayavarman VII, with his

insatiable appetite for construction. He administered a massive building campaign, including hospitals, homes, shrines and shelters for pilgrims, to associate himself with good deeds. So exhaustive was his building and rebuilding that most of Angkor today is his work or is modified to his taste. He became a devoted Mahayana Buddhist, but also added a new concept not previously espoused by Khmer rulers, that reached out to the populace and even solicited its involvement. The people now entered the sacred precincts to find a vast pantheon overseen by Lokeshvara, known as the compassionate 'Lord of Worlds.' Jayavarman's largest construction was the completion of Angkor Thom, surrounded by an enormous moat, over 90 metres wide and 16 kilometers long. The colossal gate towers at the 170 entrances, crowned by what is possibly his own visage, as the bodhisattva Lokeshvara, served both to indicate the cardinal directions and to suggest the unlimited expanse of his domain, for he incorporated the older roadways, extending his grand vision into the distance.

Jayavarman's Bayon was constructed on top of an earlier shrine, parts of which have been excavated. Unfortunately, the overall plan 168 of symmetry and order is difficult to appreciate, due to the addition of galleries to accommodate ever more statues of deified relatives, which obscure the original mandala-like scheme. During the Hindu reaction following Jayavarman's reign, images and reliefs were defaced, also contributing to the monument's present complexity. However, criticism of the quality of the panels of relief carvings should be tempered, for while the overall quality is uneven, as it was at Angkor Wat, portions of the Bayon reliefs are of high artistic achievement. Most notable are the battle and genre scenes portrayed along the walls of the outer gallery, reliefs of charm and perception, befitting the compassion that the Buddhist king felt for his subjects.

Many of the rough stone surfaces of the Bayon were once painted and gilded, its barren doors were enriched by wooden decoration and the towers were capped with gold and silk banners, the entire effect being one of colour and reflection. Unfortunately, by aligning the vertical joints in their stone-work, instead of staggering them for greater stability, Khmer builders hastened the eventual collapse of their temples, including the Bayon. Despite these structural problems and its several rebuildings and additions, the present Bayon still radiates a mystical aura. Particularly intriguing are the many face-towers, the colossal stone heads visible from throughout the temple complex, that continue to gaze across the monument and into the

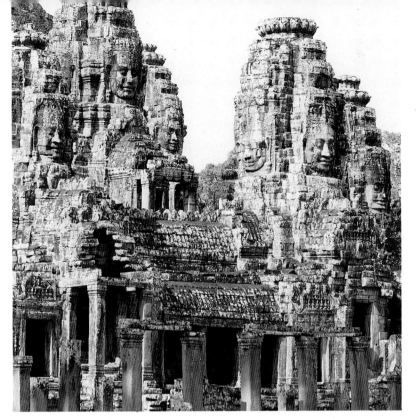

170 Face tower at the Bayon, 13th century

distance. The sense of mysticism is increased if one begins to see in these enormous, haunting images the face of Jayavarman VII, and they do appear similar to his portrait sculptures, bringing together the Buddhist spiritual world and the omnipotent power of the ruler. 172

Khmer brick, and ultimately stone, architecture continued to follow its wooden origins, with only limited allowances for the demands of lithic building, resulting in what has been called 'light' construction, or stone building that adhered to wooden models. The extensive use of balusters provides the most obvious connection with wooden prototypes, but even the Bayon's wall reliefs are arranged section by section, as if each were a panel of wood. This results in images that favour close examination, for a comprehensive reading is difficult from even a short distance. The reliefs invite comparison with Angkor Wat, but, unlike the stories there with their epic scope, the

subjects at the Bayon were meant to be followed, episode by episode, with the repetition of individual scenes, numerous details and events of daily life about the court. Later Cambodian architecture, and notably the Bayon, represents the last stage in the process whereby sculpture gradually assumed an ever greater role. By the time of Jayavarman VII, Khmer sculpture monopolized the buildings that it adorned and turned massive towers, walls and terraces into a network of sculptural programmes and relief carving.

The most intriguing Buddhist sculptures are the portraits of
172 Jayavarman VII. These over-life-sized figures were derived from images of the meditating Buddha, executed in typical Khmer fashion
171 with the legs crossed, and based upon the Buddha Muchalinda, an image that Jayavarman came personally to favour. Seen from the side, the figure is surprisingly naturalistic, with its heavy, thick torso. The most compelling aspect, however, is the face. With its ingenuous features and downcast eyes, it projects both a compelling physical presence and the inward, yogic control befitting a pious king and a
179 deity. This exceptional image and the equally renowned Prajnaparamita from eastern Java form a pair of remarkable South-East Asian portraits, presenting two fundamental aspects of royal, portrait art. The images of Jayavarman retain much of the humaneness of a benevolent ruler, yet are infused with the transcendent spirit and compassion of his patron deity, Lokeshvara. The Prajnaparamita, however, is primarily the goddess of wisdom, more in the Classical Greek tradition, where the gods are represented in human form. Both images portray the union of divine and human, the Khmer ruler more human, the Javanese more idealized and divine, but both masterpieces of portrait art.

The Buddha Muchalinda also occupied a celebrated place in Jayavarman's pantheon. The prominence of this subject can be attributed to traditional Khmer beliefs and to Jayavarman's vision of himself as the living incarnation of the Buddha. The serpent enjoyed singular prestige in Indian mythology, being related to primal origins in both Hindu and Buddhist lore, as well as to the life-giving role of water, the dominant aspect of the Khmer economy. The serpent also protected the Buddha, particularly during periods of meditation. By identifying himself with such Buddhist stories and with native serpent lore, Jayavarman VII was following Khmer traditions that linked stories of the deity with the achievements of the monarchy.

The principal Buddhist image remained that of Lokeshvara, who was most often depicted in human form, with four or eight arms,

171 Buddha Muchalinda, 12th century, Cambodia. Stone, h. 87 (34¼)

172 Jayavarman VII, 13th century, Cambodia. Stone, h. 113 (44½)

holding a flask, a book, a rosary and a lotus bud, but was also portrayed in the form of a five-headed horse or as a horse saving drowning sailors, as at Neak Pean. Jayavarman VII identified with Lokeshvara, and the many faces carved on the stone gateway-towers at the Bayon, and elsewhere in the Angkor area, suggest this syncretic vision. Vajrayana images also appeared during his reign, prompted in part by the disastrous Cham military invasion of 1177, which necessitated more potent religious support. Most impressive was the bronze, multi-armed, dancing Hevajra, a dynamic figure and another form of Avalokiteshvara. With the end of Jayavarman's rule Cambodia declined in political power and, although Theravada Buddhism gradually assumed the dominant role, the absence of imperial patronage effectively ended the era of great Khmer art.

169

JAVA

Three islands play major roles in the history of Buddhism. Sri Lanka is unique for its position in the development and subsequent spread of

Theravada Buddhism across South-East Asia. The other two, Japan and Java, of roughly the same size and both with established pre-Buddhist cultures, received the religion from nearby mainland cultures at about the same time, around the middle of the first millennium. In both cultures, the early success of Buddhism was due to royal patronage, the typical pattern throughout Asia. By the eighth century esoteric practices had appeared on both islands (not surprisingly in the case of Japan, given the nearby Chinese and Korean sources). However, in Java – and the nearby island of Sumatra – continuous contact was maintained with north-eastern India, ensuring an active Mahayana presence. The relationship with the Pala empire provided the sources for the Vajrayana schools, known in Java by the late eighth century. One of the largest, Chandi Sewu, organized in a mandala plan and dedicated to Vairochana, contained 240 shrines – another example of a Buddhist cosmological scheme. The success of these centres on Java and Sumatra attracted students and pilgrims from as far away as India and China.

173

Due mainly to the active trade routes through the region, Indian culture shaped Javanese development, just as it had on the mainland, and the initially Hindu Shailendra kingdom (730–930) produced some of the greatest monuments in Asia, after the eighth century, most of them of Buddhist inspiration. By the sixth or seventh century, a second kingdom, the Shrivijaya, had developed on the island of Sumatra, but despite its influence upon adjacent mainland areas and its fame as a centre of learning, no structural remains have been discovered, probably because wood was used. A few inscribed pillars have been found on outlying islands, but the important Buddhist monuments of the first millennium are all located in central Java, near the seat of Shailendra political power. By the eleventh century, the Sumatran Shrivijayan kingdom had declined, and on Java the

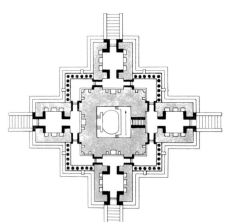

173 Plan of the central shrine of Chandi Sewu, 9th century, Java, Indonesia

political centre shifted to the eastern end of the island, during what is known as the eastern or late classical period. Most temples of this era were Hindu, although most remaining images, especially in bronze, were dedicated to Buddhist worship. By the end of the fifteenth century, Islam was dominating the islands, ending Buddhist and Hindu activity except on Bali (a Hindu enclave to the present time).

Javanese art is dominated by one Buddhist monument, the Borobudur. This remarkable structure, erected around 800, is unlike 174–7 any other temple, stupa or memorial, both in size and decoration. Its sheer scale and the quantity of stone involved is remarkable, but its sculptural scheme, consisting of over five hundred life-sized images of the Buddha and nearly 3 kilometres of relief carvings, make it both structurally and aesthetically astounding. Despite continuous study – the entire structure has been dismantled and rebuilt, most recently in the 1970s – this largest and most complex Buddhist monument has yet to reveal all the sources of its myriad imagery or even its exact purpose. To many, it is a three-dimensional mandala, to others it is a funerary monument; while, for some, it represents another example of the South-East Asian custom of linking a ruler with the divine. To contemporary believers, it remains a place of meditation, one of those traditional Buddhist supports or sources of assistance, be they texts, relic halls, gardens or paintings and statues, designed to bring the believer closer to the Buddhist message. In this case, the support leads one from the mundane world, through examples of exemplary behaviour, ever upwards, to the realm of the celestial Buddhas and finally to the ultimate goal: a single, large but empty stupa. Thus, as one ascends from the lowest mundane world towards the heavenly, the sense of earthly reality is gradually replaced by more abstract images – initially humans, then mingling with heavenly deities, surrounded by meditative Buddhas, then half-seen Buddhas, enclosed in stupas with perforated outer walls, and finally the emptiness at the summit. The visitor is transported by powerful, mystical forces that combine to make this enormous creation a remarkable evocation of earthly and divine worlds.

The Borobudur is located on top of a low, natural hill and is square 175 in plan, with sides 112 meters long. It consists of 9 levels, with most of 177 the 2500 metres of relief carvings and over 400 of the Buddha images, which are carved in the round, within the 4 middle, walled galleries. The 3 circular upper levels contain 72 more statues, each inside a hollow stupa, with the single largest, and now empty stupa at the top, although an unfinished image of the Buddha was discovered inside by

treasure hunters in the nineteenth century. No one text has been found to explain the complex imagery. What is apparent is its division into three parts, described by some as the three worlds: the lowest level, the earthly realm, or *kamadhatu*; then the celestial world, or *ruphadhatu*; and, finally, the upper terraces representing *arupadhatu*, the world of formlessness. The lowest base of the earthly realm of desire consists of a continuous frieze of reliefs illustrating the law of cause and effect, scenes meant to emphasize the karmic results of one's behaviour. However, this portion was covered by a second layer of stone, hiding the relief panels, with only a small section exposed for modern visitors. This second layer of stone may have been needed to support the enormous weight of the superstructure or have been part of a plan to symbolize the suppression of the world of desire. In later Khmer art, stone carvings of comparable subjects at the Terrace of the Elephants, at Angkor Thom, where structural reinforcement was not an issue, were also enclosed, suggesting a purpose beyond the structural and similar 'hidden' imagery was also found at the Bayon. Such elements were necessary, even when invisible, to express fully the symbolism of these man-made cosmic replicas.

The four square terraces forming the middle section of the Borobudur contain the majority of relief carvings and they do follow known texts, primarily the *Lalitavistara*, portraying events from the Buddha's birth up to his first sermon in the Deer Park at Sarnath, as well as *jataka* tales that illustrate acts of faith in the long journey to

174 Assault of Mara (detail), relief, *c.* early 9th century, the Borobudur

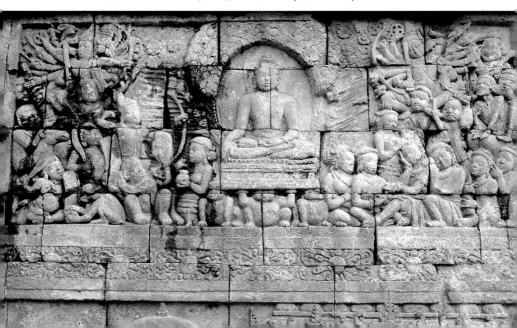

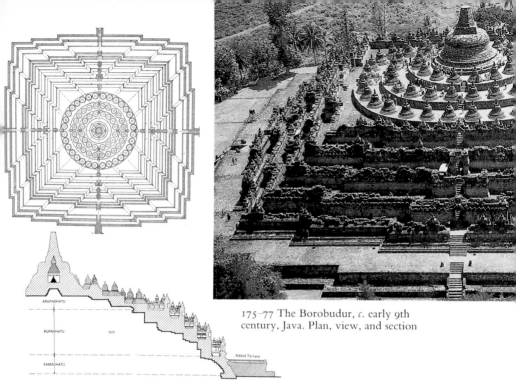

175-77 The Borobudur, *c.* early 9th century, Java. Plan, view, and section

enlightenment. More than three-quarters of the Borobudur's reliefs are devoted to episodes from the *Gandhavyuha*, the story of a young man's search for enlightenment, a process similar to the quest undertaken by the Buddha. The upper third of the monument comprises the circular terraces with their hollow stupas, whose small openings permit the worshipper only a limited view of the seated, celestial Buddhas inside. At the summit is the largest, a sealed stupa, which may have originally held an image or, in keeping with some modern-day interpretations, may have been empty, as a symbol of the formlessness of the highest realm.

Early records suggest that the structure was begun around 770 – according to some scholars, as a Hindu monument. By the end of the eighth century, it had either been modified to suit Buddhist needs or completed in accordance with a unique plan, forming what appears to be both a stupa and a mandala. This would link the Borobudur to later mandala-plan temples in Thailand and Cambodia, such as the Bayon, likewise microcosms of the Buddhist universe but with Mt Meru at the centre, rather than the stupa of the Borobudur.

168

The Borobudur reliefs portray a range of subjects, from the most banal of everyday human activities to celestial deities of the Mahayana pantheon. The earthly portrayals often involve genre subjects, including household utensils, particulars of dress, architectural details, even sailing vessels that reveal otherwise unknown information such as the use of outriggers on large ships. The panel with the Buddha's triumph over temptation, or Mara, a subject widely known across Asia, embodies the best of both elements: the movement and action of the temptors contrasted with the calm, divine serenity of the meditative Buddha. The parallel with Hindu art cannot be over-looked. The same dramatic contrast is present in scenes of the shaking of Mt Kailasha, between the serenity of the god Shiva and the frantic, but futile, actions of the demon Ravana below.

Vajrayana beliefs, however, appeared in singular, often mysterious images rather than the familiar, episodic stories from the life of the Buddha, and the full effect of Vajrayana imagery is better experienced in smaller, individual temples. Here, the worshipper could be confronted by major, often complex, deities, grouped together without the array of competing images found about the Borobudur. This can be seen at Chandi Mendut, a contemporary temple but with an unusually large cella (interior space), originally housing seven such images, of which only three remain. These monumental, seated figures – images of Lokeshvara, Vajrapani and the largest, a Buddha in the gesture of exposition – still generate a sense of religious awe with their size and transcendent gazes. At the centre of the enclosed space is the compelling Buddha image, rendered in the massive, simplified forms of the Indian Gupta style that express the abstract, celestial qualities of esoteric practice rather than the more naturalistic images of everyday life, such as those found on the panels of the nearby Borobudur. The three images repeat the traditional Indian triad of a central Buddha flanked by two bodhisattvas. However, in this instance, and despite the traditional poses, gestures and identifying marks, the highly abstracted forms of the deities and the complex iconography of the Mahayana texts present a concept addressing not the earthly world but the celestial kingdom. Together the original seven figures belonged to the two Vajrayana mandalas, the *Garbha-dhatu* and *Vajradhatu*, with the large Buddha image central to them both.

One of the hallmarks of Mahayana Buddhism is the use of guardian figures. These formidable images, often portrayed in groups of twelve, eight or four, the *lokapalas*, or as paired door guardians, the

dvarapala, confront the worshipper upon entering a shrine and surround the primary group of images inside. Javanese guardians are notable for their massive simplicity, an effective contrast to the richness of the long relief panels and highly decorative doors and niches of the temple. Seeming still to be on duty, amidst the ruins of Chandi Sewu, a corpulent, kneeling figure, its upper arms and torso encircled by serpents, has little in common with the bare-torsoed, muscular guardians of East Asia. These Javanese versions, of which similar examples were placed around the Borobudur, present a different yet equally formidable visage, while remaining closer to their original source, the traditional Indian *yaksha*. 178 141

Javanese temples are especially admired for their elegant form, the equilibrium of horizontal mouldings and vertical spires and the careful balance between structural proportions and decorative surfaces. Despite their considerable size, the actual cella usually remained small – Chandi Mendut is an exception – and the arch and pillars were not used. Thus, the emphasis throughout was upon mass rather than the creation of space. These stone temples sat on top of a flat, largely unadorned plinth, with the walls of stone broken by numerous projecting entablatures and string-courses to balance the vertical thrust of the spire. The favourite decorative motifs, the *kala* heads and *makaras*, were typically concentrated about the doors and niches, with the *kala* heads often assuming monumental proportions.

178 Guardian at Chandi Sewu, *c.* 9th century, Java

201

152 The *kala* head on the southern face of Kalasan is centred directly over the door, its gaping mouth spanning the space. This detail illustrates the full array of Javanese decorative motifs, dominated by the giant *kala* head, but including paired door guardians, elaborate vine scroll reliefs and the *makaras*, at the bottom. At the time of the late classical style of eastern Java, when most temples were Hindu or syncretic, as in the case of the Shiva-Buddha dedication at Chandi Jawi, the *makaras* were eliminated. However, the *kala* heads, now with lower jaws added and more deeply cut, appear to have been added to the wall rather than to be integrated into the fabric of the building as part of the overall architectural scheme.

Unlike in most of the rest of Asia, Javanese Buddhism did not emphasize the stupa. This ubiquitous monument, known in such a variety of forms, from the solid, simple mounds of Sanchi to the brick, stone and wooden pagodas of East Asia, never assumed a position of prominence in Javanese temples and plans. In fact, the general syncretism of Javanese religion resulted in the stupa being used more as an antefix, a decorative motif upon both Buddhist and Hindu shrines, a pattern seen also in Cambodia, probably with Javanese influence. In late classical syncretic temples, a stupa was placed on top of what would otherwise be a Hindu shrine, providing the only indication of Buddhist involvement. Even the seventy-two stupas upon the upper terraces of the Borobudur are reduced in importance by their repetition and become secondary to the dominant voice of the sculptures. Among the numerous Buddhist shrines in Java, with the notable exception of the Borobudur, none provided a conspicuous place for a primary stupa, such as found in Thai, Sri Lankan or Burmese cultures.

Late classical Java favoured Hindu monumental art and moved further away from the Indo-Javanese styles of the preceding period and, although Buddhist bronzes continued to be produced, including technically superb finials, lamps and ritual bells, monumental Buddhist temples and stone images were rare. The exception, however, is a masterpiece. An early-fourteenth-century portrait of
179 the first Singhasari queen, as the godess of wisdom, Prajnaparamita, blends the transcendent vision of Mahayana Buddhism with the elegant presence of royalty. Much has been written about this work, arguably Java's greatest single stone sculpture, and immediately comparable to the other famous portrait from South-East Asia, the
172 nearly contemporary image of Cambodia's Jayavarman VII. Although less than life-size, it expresses a monumentality through a

number of formal characteristics that recur among the finest examples of sculpture. The taut verticality of the figure, repeated in the crown and again at the very centre by the gesture of the fingers, is balanced against the horizontality of the lotus base, crossed legs and divided throne back, and the combination gives the image a structural integrity akin to that of Javanese temples. The Prajnaparamita is especially effective in its portrayal of the feminine ideal, for it surpasses the idealism of a world of countless Venus, goddess and Madonna images, to project an aura of assurance and power usually reserved for male figures.

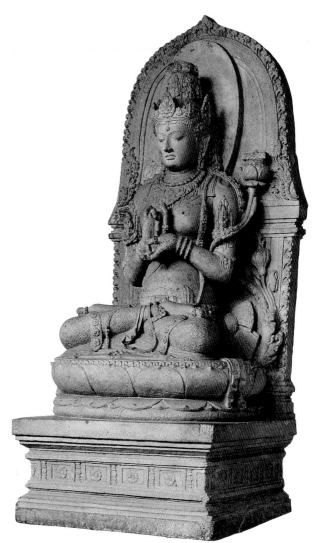

179 Prajnaparamita, *c.* 1300, from Singhasari, Java. Andesite, h. 126 (49⅝)

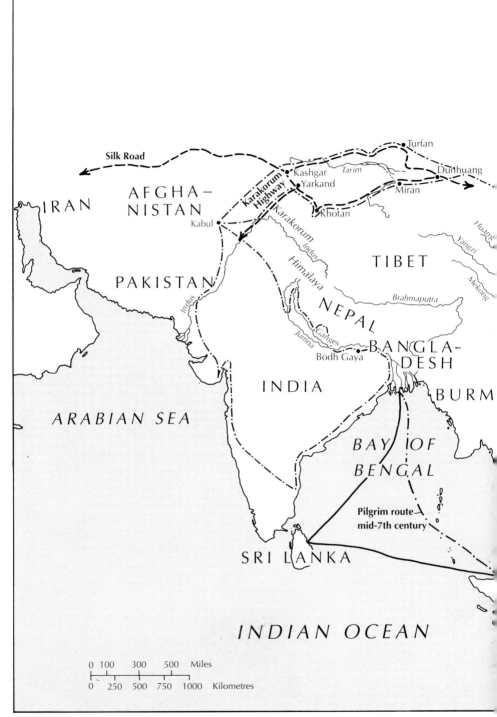

Map of the Buddhist world, showing the main pilgrimage and trade routes

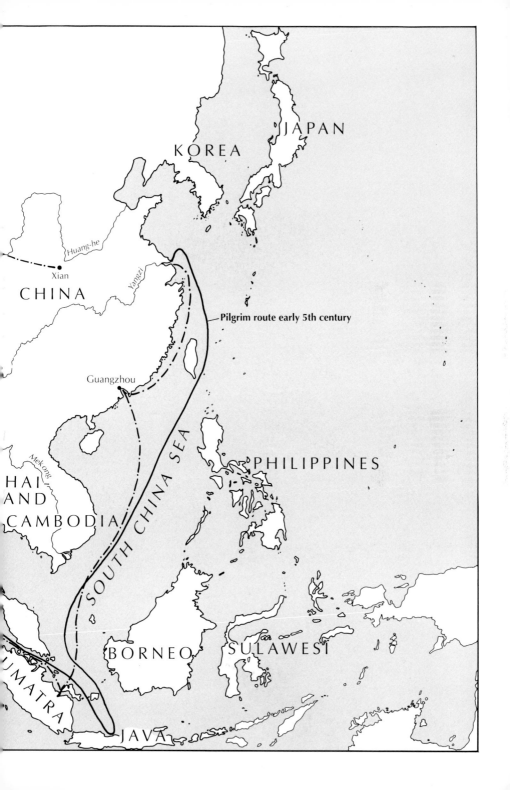

KOREA

JAPAN

Huang-he

Xian

CHINA

Yangzi

Pilgrim route early 5th century

Guangzhou

PHILIPPINES

Mekong

HAI
AND
CAMBODIA

SOUTH CHINA SEA

BORNEO SULAWESI

SUMATRA

JAVA

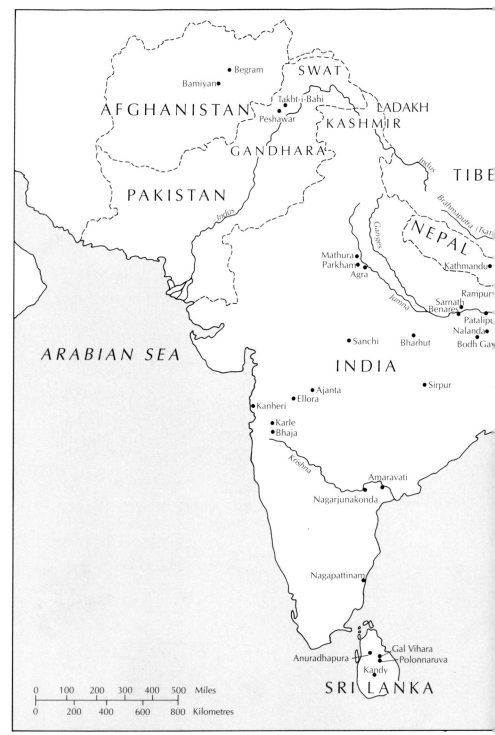

Map of Buddhist sites in India, neighbouring regions and South-East Asia

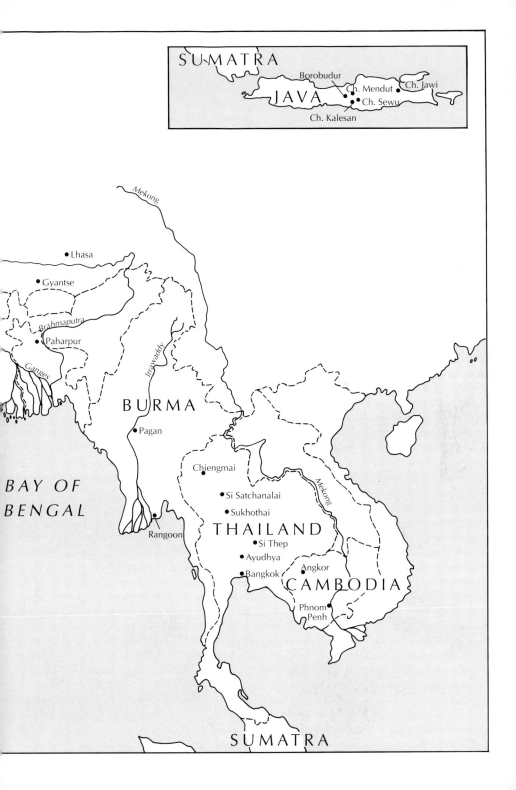

SUMATRA

JAVA
Borobudur
Ch. Mendut
Ch. Jawi
Ch. Sewu
Ch. Kalesan

Mekong

• Lhasa

• Gyantse

Brahmaputra

• Paharpur

Ganges

BURMA

• Pagan

Irrawaddy

BAY OF
BENGAL

Rangoon

• Chiengmai

• Si Satchanalai

• Sukhothai

THAILAND

Mekong

• Si Thep

• Ayudhya

• Bangkok

• Angkor

CAMBODIA

Phnom
Penh

SUMATRA

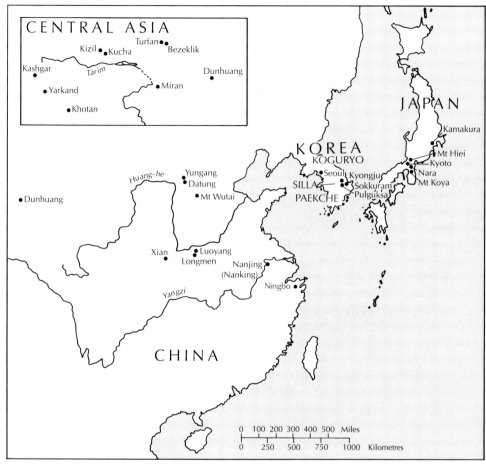

CENTRAL ASIA
Kizil • Turfan • •
• Kucha Bezeklik
Kashgar
Tarim
• Yarkand
• Miran
• Khotan
Dunhuang •

JAPAN
Kamakura
KOREA
KOGURYO
Mt Hiei
Kyoto
Huang-he
Yungang
Datung
Seoul Kyongju
Nara
Mt Koya
• Dunhuang
• Mt Wutai
SILLA
PAEKCHE
Sokkuram
Pulguksa

Xian
Luoyang
Longmen
Nanjing
(Nanking)
Ningbo •

Yangzi

CHINA

0 100 200 300 400 500 Miles

0 250 500 750 1000 Kilometres

Map of Buddhist sites in China, Central Asia, Korea and Japan. Korea is shown in
the Three Kingdoms period (Koguryo, Silla, Paekche), 1st century BC – 7th
century AD

208

Select Bibliography

General

Bechert, H., and Gombrich, R. 1984. *The World of Buddhism*. London and New York

The Crucible of Compassion and Wisdom: Special Exhibition Catalog of the Buddhist Bronzes from the Nitta Group Collection at the National Palace Museum (exh. cat.). 1987. National Palace Museum, Taibei

Dallapiccola, A. L. 1980. *The Stupa: Its Religious, Historical and Architectural Significance*. Wiesbaden

Guy, J. 1982. *Palm Leaf and Paper* (exh. cat.). National Gallery of Victoria, Melbourne

Griswold, A. B., Kim, C., and Pott, P. H. 1964. *The Art of Burma, Korea and Tibet*. London

Kloetzli, R. 1983. *Buddhist Cosmology*. New Delhi

Lee, S. E. 1982. *A History of Far Eastern Art* (4th edn). New York

Longhurst, A. H. 1936. *The Story of the Stupa*. Colombo

Pal, P., ed. 1984. *Light of Asia: Buddha Sakyamuni in Asian Art* (exh. cat.). Los Angeles County Museum of Art

—, and Meech-Pekarik, Julia. 1988. *Buddhist Book Illuminations*. New York

Rowland, B. 1968. *The Evolution of the Buddha Image* (exh. cat.). Asia Society, New York

Seckel, D. 1957. *Buddhistische Kunst Ostasiens*. Stuttgart. Eng. edn 1989, *Buddhist Art of East Asia*. Bellingham, WA (trans. U. Mammitzsch)

—. 1964. *The Art of Buddhism*. New York

Snellgrove, D. ed. 1978. *The Image of the Buddha*. Paris and London

Watters, T. 1904–05. *On Yuang Chwang's Travels in India* (2 vols). London

Zurcher, E. 1962. *Buddhism: Its Origin and Spread in Words, Maps and Pictures*. London

Zwalf, W., ed. 1985. *Buddhism: Art and Faith* (exh. cat.). British Museum, London

India and neighbouring regions

Basham, A. L. 1954. *The Wonder that was India*. London

Bhattacharyya, B. 1958. *Indian Buddhist Iconography* (2nd rev. edn). Calcutta

Boisselier, J. 1979. *Ceylon*. Geneva

Coomaraswamy, A. K. C. 1927. *History of Indian and Indonesian Art*. New York

—. 1980 (repr.). *Origin of the Buddha Image*. New Delhi

Czuma, S. J., with the assistance of Morris, R. 1985. *Kushan Sculpture: Images from Early India* (exh. cat.). Cleveland Museum of Art

Davendra, D. T. 1958. *Classical Sinhalese Sculpture*. London

Dehejia, V. 1972. *Early Buddhist Rock Temples*. London

—. 1990. 'On Modes of Visual Narration in Early Buddhist Art', *The Art Bulletin*, vol. 71, no. 3, pp 374–92

Fisher, R. E. 1989. 'Buddhist Architecture', in *Art and Architecture of Ancient Kashmir* (ed. P. Pal), pp 17–28. Bombay

Foucher, A. 1917. *The Beginnings of Buddhist Art*. London (trans. L. A. Thomas)

—. 1922. *L'art gréco-bouddhique du Gandhara*. Paris

Genoud, C. 1982. *Buddhist Wall-Painting of Ladakh*. Geneva

Getty, A. 1962. *The Gods of Northern Buddhism*. New Delhi

Gordon, A. K. 1959. *Iconography of Tibetan Lamaism*. New Delhi

Govinda, Lama Anagarika. 1976. *Psycho-cosmic Symbolism of the Buddhist Stupa*. Emeryville

Hallade, M. 1968. *Gandharan Art of North India*. New York

Harle, J. C. 1986. *The Art and Architecture of the Indian Subcontinent*. Harmondsworth

Huntington, S. 1985. *The Art of Ancient India: Buddhist, Hindu, Jain*. New York and Tokyo

—. 1990. 'Early Buddhist Art and the Theory of Aniconism', *Art Journal*, vol. 49, no. 4, pp 401–08

—, and J. C. 1990. *Leaves from the Bodhi Tree: The Art of Pala India (8th–12th centuries) and Its International Legacy* (exh. cat.). Dayton Art Institute

Ingholt, H., and Lyons, I. 1957. *Gandharan Art in Pakistan*. New York

Irwin, J. 1979. 'The Stupa and the Cosmic Axis: The Archaeological Evidence', *South Asian Archaeology 1977*, pp 799–845. Naples

Klimburg-Salter, D., ed. 1982. *The Silk Road and the Diamond Path: Esoteric Buddhist Art on the Trans-Himalayan Trade Routes* (exh. cat.). Los Angeles

Knox, R. 1992. *Amaravati: Buddhist Sculpture from the Great Stupa*. London

Lauf, D. I. 1976. *Tibetan Sacred Art*. Berkeley and London

Leoshko, J., ed. 1988. *Bodhgaya: The Site of Enlightenment*. Bombay

Lohuizen-de Leeuw, J. E. 1981. 'New Evidence with Regard to the Origin of the Buddha Image', *South Asian Archaeology 1979* (ed. H. Hartel), pp 377–400. Berlin

Mallmann, M.-T. de. 1975. *Introduction à l'iconographie du Tantrisme bouddhique*. Paris

Marshall, J. 1980 (repr.) *Buddhist Art of Gandhara*. New Delhi

Marshall, J., and Foucher, A. 1940. *The Monuments of Sanchi* (3 vols). Calcutta

Mitra, D. 1971. *Buddhist Monuments*. Calcutta

209

Mus, P. 1935. *Barabudur, Esquisse d'une histoire du Bouddhisme fondée sur la critique archéologique des textes.* Hanoi

Olsen, E. 1974. *Tantric Buddhist Art* (exh. cat.). China Institute in America, New York

Pal, P. 1969. *The Art of Tibet* (exh. cat.). Asia Society, NY

—. 1975. *The Bronzes of Kashmir.* Graz

—. 1982. 'Cosmic Vision and Buddhist Images', *Art International*, vol. 25, nos 1–2, pp 8–40

—. 1983. *Art of Tibet.* Los Angeles

—. 1984. *Tibetan Paintings.* London

Paranavitana, S. 1971. *Art of the Ancient Sinhalese.* Colombo

Rosenfield, J. 1967. *The Dynastic Arts of the Kushans.* Berkeley and Los Angeles

Rowland, B. 1977. *The Art and Architecture of India* (3rd rev. edn).

Sarkar, H. 1966. *Studies in Early Buddhist Architecture of India.* Delhi

Schroeder, U. von. 1981. *Indo-Tibetan Bronzes.* Hong Kong

—. 1990. *Buddhist Sculptures of Sri Lanka.* Hong Kong.

Spink, W. n.d. [1967] *Ajanta to Ellora.* Bombay

Tucci, Giuseppe. 1949. *Tibetan Painted Scrolls* (3 vols). Rome

—. 1969. *The Theory and Practice of the Mandala.* London

—. 1973. *Transhimalaya.* London

Wiener, S. 1977. *Ajanta: Its Place in Buddhist Art.* Berkeley and Los Angeles

Williams, J. 1982. *The Art of Gupta India.* Princeton

Yazdani, G. 1930–55. *Ajanta* (4 parts). London

Central Asia and China

Akiyama, T., and Matsubara, S. 1969. *Arts of China: Buddhist Cave Temples, New Researches.* Tokyo (trans. A. C. Soper)

Bussagli, M. 1963. *Painting of Central Asia.* Geneva

Davidson, J. L. 1954. *The Lotus Sutra in Chinese Art.* New Haven

Dunhuang Research Institute. 1980–82. *Chugoku Sekkutsu, Tonko Makkokutsu* (*Chinese Cave Temples* series: The Mogao Caves at Dunhuang), 5 vols. Tokyo

Fisher, R. E. 1990. 'The Nitta Collection of Chinese Bronzes', *Orientations*, vol. 21, no. 7, pp 39–45

Gaulier, S., Jera-Bezard, R., and Maillard, M. 1976. *Buddhism in Afghanistan and Central Asia* (2 parts). Leiden

Gray, B. and Vincent, J. B. 1959. *Buddhist Cave Paintings at Tun-huang.* London

Hartel, H., *et al.* 1982. *Along the Ancient Silk Routes* (exh. cat.). Metropolitan Museum of Art, New York

Le Coq, A. von. 1922–6. *Die buddhistische Spatantike in Mittelasien* (7 vols). Berlin

Lee, Y.-M. 1983. *The Maitreya Cult and Its Art in Early China.* Ann Arbor

Pelliott, P. 1914–24. *Les Grottes de Touen-Houang* (6 vols). Paris

Rowland, B. 1966. *Ancient Art from Afghanistan* (exh. cat.). Asia Society, New York

Sickman, L. and Soper, A. C. 1978. *The Art and Architecture of China* (3rd edn). Harmondsworth

Siren, O. 1925. *Chinese Sculpture from the Fifth to the Fourteenth Centuries* (4 vols). London

Soper, A. 1959. *Literary Evidence for Early Buddhist Art in China.* Ascona

—. 1960. 'South Chinese Influence on the Buddhist Art of the Six Dynasties Period', *The Museum of Far Eastern Antiquities Bulletin*, 32, pp 47–112

Stein, M. A. 1912. *Ruins of Desert Cathay: Personal Narrative of Explorations in Central Asia and Westernmost China* (2 vols). London

—. 1921. *Serindia: Detailed Report of Exploration in Central Asia and Westernmost China* (5 vols). Oxford

deVisser, M. W. 1923. *The Arhats in China and Japan.* Berlin

Whitfield, R. 1982. *The Art of Central Asia: The Stein Collection in the British Museum.* Vol. 1, Painting. Tokyo

Zurcher, E. 1982. 'Prince Moonlight: Messianism and Eschatology in Early Medieval Chinese Buddhism', *T'oung Pao*, vol. 68, nos 1–3, pp 1–75

Korea and Japan

Best, J. 1980. 'The Sosan Triad: An Early Korean Buddhist Relief Sculpture from Paekche', *Archives of Asian Art*, 33, pp 89–108

Covell, J. C., and Yamada, S. 1974. *Zen at Daitokuji.* Tokyo and New York

Brinker, H. 1987. *Zen in the Art of Painting.* London (trans. G. Campbell)

Fisher, R. E. 1981. 'The Stone Pagodas of Korea', *Korean Culture*, vol. 2, no. 1, pp 8–15

Fontein, J., and Hickman, M. 1970. *Zen Painting and Calligraphy* (exh. cat.). Museum of Fine Arts, Boston

Fukuyama, T. 1964. *Byodo-in and Chuson-ji: Buddhist Art and Architecture of the Late Heian Period.* Tokyo

Goepper, R., and Whitfield, R. 1984. *Treasures from Korea* (exh. cat.). British Museum, London

Hempel, R. 1983. *The Golden Age of Japan: 794–1192.* New York

Ishida, M. 1964. *Japanese Buddhist Prints.* New York

Kidder, J. E. 1964. *Japanese Temples: Sculpture, Paintings, Gardens, and Architecture.* New York

Kim, C., and Lee, L. K. 1974. *Arts of Korea.* Tokyo

Kim, H. 1991. *The Story of a Painting* (exh. cat.). Asia Society, New York

Kobayashi, T. 1975. *Nara Buddhist Art: Todai-ji.* New York

McCune, E. 1962. *The Arts of Korea: An Illustrated History.* Rutland, VT, and Tokyo

Mizuno, S. 1974. *Asuka Buddhist Art: Horyuji.* New York (trans. R. L. Gage)

Mori, H. 1974. *Sculpture of the Kamakura Period.* New York (trans. K. Eickmann)

Murase, M. 1983. *Emaki: Narrative Scrolls from Japan* (exh. cat.). Asia Society, New York

Naito, T. (W. R. B. Acker and B. Rowland, eds). 1943. *The Wall Paintings of Horyu-ji.* Baltimore

Nishikawa, K., and Sano, E. 1982. *The Great Age of Japanese Buddhist Sculpture: AD 600–1300* (exh. cat.). Kimball Museum, Fort Worth

Noma, S. 1966–7. *The Arts of Japan* (vol. 1). Tokyo (trans. J. Rosenfield)

Okazaki, J. 1977. *Pure Land Buddhist Painting.* Tokyo and New York

Ooka, M. 1973. *Temples of Nara and Their Art.* New York (trans. D. Lishka)

Paine, R. and Soper, A. C. 1981. *Art and Architecture of Japan* (3rd edn). Harmondsworth

Rambach, P. 1979. *The Secret Message of Tantric Buddhism.* New York

Rosenfield, J. 1968–9. 'The Sedgwick Statue of the Infant Shotoku Taishi', *Archives of Asian Art*, 22, pp 56–79

—, and ten Grotenhuis, E. 1979. *Journey of the Three Jewels* (exh. cat.). Asia Society, New York

Sansom, G. 1962. *Japan: A Short Cultural History*. New York

Saunders, E. D. 1960. *Mudra: A Study of Symbolic Gestures in Japanese Buddhist Sculpture*. New York

Sawa, T. 1972. *Art in Japanese Esoteric Buddhism*. New York

Soper, A. C. 1942. *The Evolution of Buddhist Architecture in Japan*. Princeton

Sources of Japanese Buddhist Art: Special Exhibition (exh. cat.). 1978. Nara National Museum

Suzuki, K. 1980. *Early Buddhist Architecture in Japan*. Tokyo (trans. and adapted by M. N. Parent and N. S. Steinhardt)

South-East Asia

Aung Thaw. 1972. *Historical Sites in Burma*. Rangoon

Bernet Kempers, A. J. 1957. *Ageless Borobudur*. Wassenaar

—. 1959. *Ancient Indonesian Art*. Cambridge

Boisselier, J. 1966. *Le Cambodge*, Paris

—. 1975. *The Heritage of Thai Sculpture*. New York and Tokyo

—. 1976. *Thai Painting*. Tokyo

—. 1979. *Ceylon: Sri Lanka*. Geneva

Bowie, T. 1972. *Sculpture of Thailand* (exh. cat.). New York

Buriband, L. B., and Griswold, A. B. 1972. *Thai Images of the Buddha*. Bangkok

Devendra, D. T. 1958. *Classical Sinhalese Sculpture: c. 300 B.C. to A.D. 1000*. London

Diskul, M. C. Subhadradis, ed. 1980. *The Art of Srivijaya*. Kuala Lumpur

Dumarcay, J. 1978. *Borobudur*. Kuala Lumpur

Dupont, P. 1959. *L'Archéologie Mone de Dvaravati*. Paris

Fickle, D. H. 1989. *Images of the Buddha in Thailand*. Singapore

Fontein, Jan. 1990. *The Sculpture of Indonesia* (exh. cat.). National Gallery of Art, Washington

Frédéric, L. 1965. *The Art of Southeast Asia: Temples and Sculpture*. New York.

Gomez, L. O., and Woodward, H. W., eds. 1981. *Barabudur*. Berkeley

Griswold, A. B. 'The Architecture and Sculpture of Siam', in T. Bowie, ed. 1960. *The Arts of Thailand*, pp 25–165. Bloomington

Heine-Geldern, R. 1963. *Conceptions of State and Kingship in Southeast Asia*, Southeast Asia Program, Data Paper no. 18. Ithaca

Krom, N. J. 1925. *The Life of the Buddha on the Stupa of Barabudur, According to the Lalitavistara-Text*. The Hague

Lee, S. E. 1969. *Ancient Cambodian Sculpture* (exh. cat.). Asia Society, New York

Lohuizen-de Leeuw, J. E. 1981. *Sri Lanka Ancient Arts*. London

Luce, G. H. 1969. *Old Burma–Early Pagan* (3 vols). Locust Valley, NY

Mus, P. 1937. 'Angkor in the Time of Jayavarman VII', *Indian Art and Letters*, n.s., 11, pp. 65–75

Rawson, P. 1967. *The Art of Southeast Asia*. London and New York

Stern, P. 1965. *Les Monuments khmers du style du Bayon et Jayavarman VII*. Paris.

Strachan, P. 1990. *Imperial Pagan: Art and Architecture of Burma*. Honolulu

Stratton, C., and McNair Scott, M. 1981. *The Art of Sukhothai, Thailand's Golden Age*. Kuala Lumpur

Tambiah, S. J. 1982. 'Famous Buddha images and the legitimation of kings: the case of the Sinhala Buddha (Phra Sihing) in Thailand', *Res*, 4, pp 5–19

Wales, H. G. Q. 1977. *The Universe Around Them: Cosmology and Cosmic Renewal in Indianized South-east Asia*. London

Glossary

Transliteration: for the sake of simplicity, a phonetic system has been followed, e.g. Ashoka instead of Asoka, eliminating diacritical marks. For Chinese, the pinyin system of romanization is used.

Amitabha primary Buddha in the northern, Mahayana pantheon, ruler of the Western Paradise (Amida in Japanese)

anda see *stupa*

arhats enlightened beings, portrayed as mystics or sages, associated mainly with Theravada Buddhism but often illustrated in a Mahayana context, usually in groups of 16, 18 or 500 (luohan in Chinese)

Avalokiteshvara the most important bodhisattva in Buddhist art, primarily viewed as saviour figure and represented in numerous forms (Guanyin in Chinese, Kannon in Japanese)

Bhaishagjaguru the healing or medicine Buddha and member of the primary group of celestial Buddhas, especially popular in Japan (Yakushi in Japanese)

Bodh Gaya site of the Buddha's Enlightenment, in north-eastern India

bodhi tree tree under which the Buddha meditated at the moment of Enlightenment, traditionally believed to be at Bodh Gaya

bodhisattva a being destined to attain Buddhahood after countless rebirths, but who delays that final act to help others in their quest for salvation; essential feature of the Mahayana schools

211

chakravartin world ruler, applied to the Buddha as conqueror of the world

chaitya a sacred place, but most often applied to halls of worship, especially for group worship

Chan meditative schools of Buddhism, based on intuitive insight and sudden enlightenment, originated in China, then spread to Korea (where it is known as Son) and to Japan (Zen)

chandi Javanese name for a commemorative shrine but broadly applied to many monuments, including stupas

chhatraveli see *stupa*

chintamani a wish-granting gem, held by some bodhisattvas (Avalokiteshvara, Kshitigarbha), also found on top of some buildings

chorten a Tibetan stupa

Daoism popular, native religion of China, based upon nature worship and shaman beliefs, aimed at perpetuating mortal existence

dvarapala door guardians, represented in pairs at entrances to temples, gates and stupas or pagodas (*nio* in Japanese)

Gautama see *Shakyamuni*

Guanyin see *Avalokiteshvara*

guru a spiritual guide or teacher, often outside the orthodox priesthood; especially important in Tantric or esoteric Buddhism

harmika see *stupa*

Hinayana 'lesser path' or 'vehicle'; the older, traditional forms of Buddhism with more limited routes to salvation; the term was created by Mahayanists as a pejorative label; see also *Theravada*

jatakas birth stories, episodes from the former lives of the historical Buddha. Each tale is a morality lesson, designed to communicate the aspects of proper behaviour that will help in accumulating good *karma* (see below), to lead to a favourable rebirth

Jizo see *Kshitigarbha*

Kannon see *Avalokiteshvara*

karma the accumulated good and bad actions that follow one and help shape the next incarnation. In Mahayana worship it is also the accumulated good karma of the bodhisattvas which is available to believers for their salvation

Kichijoten female deity of beauty, good fortune and wealth, derived from Indian goddess Shri Lakshmi; enjoyed greatest popularity in Japan

kirtimukkha also known as *kala* heads, 'face of glory', demonic mask placed over doors and windows, originated in India but best-known in Javanese architecture

kondo primary image hall in a Japanese temple

Kshitigarbha bodhisattva who protects children and travellers and intervenes in Hell for those suffering there (Jizo in Japanese)

lakshanas auspicious attributes or marks on the body of the Buddha, e.g., protuberance on top of his head (*ushnisha*), webbed fingers, tuft of hair between the eyes (*urna*), etc.

lokapalas guardians of the cardinal directions (shitenno in Japanese); see also *Vaishravana*

luohan see *arhats*

Mahayana 'great path' or 'vehicle'; general term for northern Buddhism, founded on belief in salvation by faith and with support of bodhisattvas

Maitreya the Buddha of the Future (Miruk-bosal in Korean, Miroku in Japanese); see also *Shakyamuni*

makara mythical animal, part-crocodile, part-elephant, used

in Buddhist and Hindu temples as a decorative motif about doorways

mandala a diagram, commonly a visual aid for meditation, especially among esoteric shools, but also used as ground-plan for structures

mantra a verbal, mystic chant that evokes the divinity

mudra hand gestures; although a great many are found in esoteric works, most images use a limited number to express, e.g., blessing, reassurance, meditation or teaching

Myo-o fierce bodhisattvas, important in esoteric Buddhism, usually in sets of 5, best-known being the Japanese Fudo Myo-o

nirvana ultimate goal or condition, beyond existence and without form or definition; often likened to a candle's flame, which once extinguished ceases to exist

parinirvana the actual death of the Buddha, in which he is shown reclining, his head supported by one arm and surrounded by grieving figures (nehan in Japanese)

prajna wisdom, the female principle in Vajrayana (see below), portrayed in a passive role with the male as the active partner

raigo illustration of Amitabha and his host approaching to receive and welcome the soul of the deceased to Paradise

Samanabhadra bodhisattva shown riding his 6-tusked elephant, often paired with the bodhisattva Manjusri, who rides a lion; they form a triad with the Buddha

samsara the material world of the senses, as contrasted with the spiritual or metaphysical dimensions represented by *nirvana*

Shakyamuni or Gautama, the historical Buddha, the last in the stream of countless re-births, generally assumed to have lived and preached in the Gangetic basin around 500 BC (Shaka in Japanese). One more reincarnation remains, *Maitreya* (see above)

Shingon one of the two major forms of Japanese esoteric Buddhism

stupa originally a pre-Buddhist, dome-shaped, burial mound; under Buddhism the location of auspicious relics. Known in East Asia as the pagoda. Most important elements include the *anda*, the main body; *harmika*, the square railings at the top that surround the pillar and circular disks, the *chhatraveli*; *toranas*, the 4 gateways in the fence surrounding the stupa, often richly decorated

sutra best-known category of Buddhist scriptures, believed to have been the actual words of the Buddha

tahoto many-jewelled pagoda, Japanese variant of pagoda with stupa emerging from the roof

Tantra traditional texts that emphasize religious practices often associated with sexual imagery and customs usually forbidden in orthodox religious practice; designed to achieve goals more rapidly than do traditional practices

Tendai one of the two major forms of Japanese esoteric Buddhism

Theravada 'path of the elders', general term for the older form of Buddhism; practised in Sri Lanka, Burma and Thailand; also known as *Hinayana* (see above)

Tiantai a Chinese form of Mahayana Buddhism (see above) that emphasized faith and promised salvation in the Western Paradise of Amitabha

torana see *stupa*

upaya 'skilful means', in Vajrayana (see below) the active, male principle in paired figures with the female as *prajna* (see above)

Vairochana the primary cosmic Buddha, represented in heavenly surroundings, often the central figure of a mandala

Vaishravana guardian of the north, and chief of the four lokapalas, especially popular in Japan (Bishamonten in Japanese)

vajra, Vajrayana most often defined as the thunderbolt and path of the thunderbolt; general term for Tantric or esoteric forms of Himalayan and northern, Mahayana Buddhism

vihara a monastery, but within the Indian monastic complex is usually applied to the residence halls for monks as distinct from *chaityas* (see above)

Vimalakirti a devout layman who lived during the Buddha's lifetime; renowned for his brilliance in debate

Vulture Peak mountain on which Shakyamuni preached the Lotus Sutra; especially popular in East Asian Buddhism

yakshi (female) and *yaksha* (male) Indian pre-Buddhist nature or fertility images, associated with wealth and abundance; prominently displayed on early Indian stupas

Location of objects and acknowledgments

Numbers refer to illlustration captions. For locations of objects and monuments *in situ*, see also captions. All photographs by the author unless otherwise specified.

Aichi: Shojuji 148. Bangkok: National Museum 154, 157, 160; Wat Benchamabopit 158. Berlin: Staatliche Museen Preussischer Kulturbesitz, Museum für Indische Kunst 161. Calcutta: Indian Museum 4, 9, 19, 20, 29, 32, 33, 41. Cambridge, MA: Courtesy of the Arthur M. Sackler Museum, Harvard University 77 (Bequest of Grenville L. Winthrop). Jakarta: Museum Nasional 150, 179. Kabul: Kabul Museum 10, 24. Kansas City: The Nelson-Atkins Museum of Art (Nelson Fund) 73 (44–18), 91 (32–52), 106 (34–10), 110 (34–6). Kathmandu: Kathmandu Museum 59. Kyoto: Daitokuji 14; Kozanji 108; Sanjusangendo 143. London: British Museum 95, 97–9. Los Angeles: Los Angeles County Museum of Art 49 and 61 (from the Nasli and Alice Heeramaneck Collection, Museum Associates Purchase), 71 (Gift of Mr and Mrs Harry Kahn). Madras: Government Museum 27. Lahore: Lahore Museum 34. Mathura: Mathura Museum 26, 31. Minneapolis: Minneapolis Institute of the Arts 7 (The Augustus L. Searle Fund). Nara: Kofukuji 142; Mt Shigi, Chogosonshiji 144. New Delhi: Museum of Central Asian Antiquities 72, 74; National Museum 36, 50; President's Palace 15. New York: Asia Society 51, 62, 136 (Mr and Mrs John D. Rockefeller 3rd Collection), 164; Metropolitan Museum of Art 5 (Purchase, the Christian Humann Foundation Gift, 1987, 1987.218.9), 155 (Fletcher Fund, 1959). Newark: Newark Museum 63 (Gift of C. Suydam Cutting 1950), 64 (Crane Collection), 68. Paris: Musée Guimet 37, 85. Patna: Patna Museum 28. Peshawar: Peshawar Museum 8, 35. Phnom Penh: Phnom Penh Museum 171, 172. Robert Wm Moore Collection: 120–22. San Francisco: Asian Art Museum of San Francisco, The

Avery Brundage Collection 6 (B65 S11), 13 (1989–4 Gift of Walter and Phyllis Shorenstein), 78 (B60 B1034), 107 (B60 S279), 109 (B60 S208), 111 (B60 J13), 119 (B72 D38), 163 (1191.4 purchased with funds from the City Arts Trust Fund). Sarnath: Archaeological Museum 18, 30, 42. Seoul: National Museum of Korea 113, 118 (Kim Don-won Collection). Sukhothai: National Museum 159. Siem Reap: Depot for the Preservation of Angkor 1. Tokyo: National Museum 146; M. Nitta Collection 112. Washington, D.C.: Smithsonian Institution, Courtesy of the Freer Gallery of Art 92. Private collections: 60, 117.

Photographs courtesy of: American Institute of Indian Studies 15, 19, 20, 25–9, 32, 33, 40, 42. Archaeological Survey of India 72. From *The Art Treasures of Dunhuang* (1981, in Chinese) 76. From P. Brown *Indian Architecture: Buddhist and Hindu* (4th edn, 1959) 16. Stephen Markel 23, 45, 156. From *The Mogao Caves at Dunhuang* Chinese Cave Temples series (1980–82, in Japanese) 94. Lance Moore 120–22. Otto E. Nelson 136. Newark Museum 66, 69. Josephine Powell 114. From Benjamin Rowland *Art and Architecture of India: Buddhist, Hindu, Jain*, The Pelican History of Art, Yale University Press (1953) 11. W. A. Swaan 151. From D. Tokiwa and T. Sekino *Buddhist Monuments in China* (vol 1, 1925–38, in Japanese) 102. Charles D. Weber 53, 114, 123, 129, 141, 143. Doris Wiener, Inc. 70. From H. Yule *Narrative of the Mission* (1858) 165.

Maps drawn by Annick Petersen.

Index